CREATIVE COLOR FOR THE OIL PAINTER

BY WENDON BLAKE A New Edition of Creative Color Paintings from THE NATIONAL MUSEUM OF AMERICAN ART Smithsonian Institution Washington, D.C.

For Miriam, who started it all.

First published 1983 in New York by Watson-Guptill Publications, a division of Billboard Publications, Inc., 1515 Broadway, New York, N.Y. 10036

Library of Congress Cataloging in Publication Data

Blake, Wendon.

Creative color for the oil painter.

Previously published as: Creative color. 1972.

"Paintings from the National Museum of American Art,

Smithsonian Institution, Washington, D.C."

Bibliography: p.

1. Painting—Technique. 2. Color in Art.

I. National Museum of American Art (U.S.) II. Title.

ND1490.B55 1983

751.45

83-6477

ISBN 0-8230-1036-8

All rights reserved. No part of this publication may be reproduced or used in any form or by any means—graphic, electronic, or mechanical, including photocopying, recording, taping, or information storage and retrieval systems—without written permission of the publisher.

Manufactured in Japan

3 4 5 6 7 8 9/86 85 84 83

Acknowledgments

This new edition of *Creative Color*—with the new title, *Creative Color for the Oil Painter*—owes an enormous debt to the National Museum of American Art, which provided the magnificent color transparencies that illustrate this book. All the paintings in *Creative Color for the Oil Painter* come from that superb museum, which is one member of the great fleet of museums that sail under the flag of the Smithsonian Institution.

I'm particularly grateful to Marguerite Curtis of the museum's Office of Research Support. Ms. Curtis and her colleagues assembled this massive pile of illustrations and expedited the voluminous permission forms with wonderful efficiency and good humor.

I'm also indebted to Willi Holden for her

tireless help with all those time-consuming jobs that *must* get done somehow. Picture research, manuscript checking, and proofreading were infinitely easier because of her labors.

The original edition of this book was patiently and skillfully edited by Adelia Rabine, whom I thank once again. The second edition was edited by Bonnie Silverstein, whom I thank for the special touch that always improves my writing.

And a final note of gratitude to two other invisible coworkers who contribute so much to any pictorial book: art director Bob Fillie, who created the handsome picture layouts; and Hector Campbell of the Watson-Guptill production department, who patiently rode herd on the printers.

Contents

1. Color Basics, 13

Hue, Value, and Intensity, 13
Color Temperature, 14
Local and Atmospheric Color, 14
Advancing and Retreating Colors, 16
Primaries, Secondaries, and Tertiaries, 16
Complementary Colors and the Color Wheel, 16
How Tube Colors Behave, 16
Tints and Shades, 17
Permanence, 17
Tinting Power, 20
Opacity and Transparency, 20
Brands of Colors, 20

2. Colors for Oil Painting, 24

Manufacturers' Color Charts, 25
Blues, 25
Reds and Oranges, 29
Yellows, 32
Greens, 36
Violets, 36
Browns, 37
Blacks, 40
Whites, 41
Starting with a Basic Palette, 44
Testing Color Behavior, 44
Adding More Colors to Your Palette, 48

3. How Colors Behave in Mixtures, 49

Recording Colors, 49
Broadening the Range of Blues, 56
Broadening the Range of Reds, 60
Broadening the Range of Yellows, 61
Oranges, Pinks, and Off-Reds, 64
Creating Greens, 65
Creating Violets, 68
Diversifying the Browns, 69
Alternatives to Black, 72
Black Is a Color, 72
White Is a Color Too, 73
Discovering the Grays, 73
Flesh Tones, 76
Hair Tones, 77

4. Color Mixing and Color Control, 81

Nine Principles of Color Mixing, 81
Mixing on the Palette, 85
Loose Versus Thorough Mixing, 88
Mixing on the Painting Surface, 89
Some Experiments in Mixing
on the Painting Surface, 93
Lightening Colors, 100
Darkening Colors, 100
Intensifying and Graying Colors, 101
Warming and Cooling Colors, 104
Color Against Color, 104
Correcting Colors, 105
Mediums and Varnishes, 108

5. Applying Color with Brush and Knife, 112

Brushes, 112
Painting Knives, 113
Painting Surfaces, 116
Thick and Thin, Rough and Smooth, 117
Blending, 120
Broken Color, Drybrush, and Pointillism, 121

6. Palettes and Color Schemes, 132

Simplified Palettes, 132
Palettes for Landscape and Seascape, 133
Palettes for Portrait and Figure Painting, 137
Colors for Underpainting and Overpainting, 140
Colors for Knife Painting, 140
Mixing Your Own Palette, 141
Achieving Color Harmony, 141

7. Observing and Painting the Colors of Nature, 146

Observing Local and Atmospheric Color, 146 Color Perspective, 147 Developing an Eye for Color, 148 Trees and Greenery, 148 Spring and Summer Color, 148 Autumn Color, 149 Winter Color, 149 Skies and Clouds, 150 Water, 151 Shoreline Colors, 151 Sunny Days and Gray Weather, 152 Sunrises and Sunsets, 152 Faces and Figures, 153

Bibliography 154

Index, 156

Paintings

FROM THE NATIONAL MUSEUM OF AMERICAN ART SMITHSONIAN INSTITUTION

Mary Cassatt, Sara in a Green Bonnet, 18

Mary Cassatt, Spanish Dancer Wearing a Lace Mantilla, 19

Guy Wiggins, The Quiet Valley, 22

Henry Ward Ranger, Bradbury's Mill Pond, No. 2, 23

Childe Hassam, The South Ledges, Appledore, 26

Winslow Homer, High Cliff, Coast of Maine, 27

Preston Dickinson, The Hills, 30

Edward Hopper, Ryder's House, 31

Walter Elmer Schofield, The Rapids, 34

Abbott Handerson Thayer, Cornish Headlands, 35

William Merritt Chase, Shinnecock Hills, 38

Thomas Moran, The Grand Canyon of the Yellowstone, 39

Jasper Francis Cropsey, Catskill Creek, 42

Childe Hassam, Ponte Santa Trinità, 43

William Sergeant Kendall, An Interlude, 46

Ivan Olinsky, The Serviceman's Wife, 47

Irving Ramsey Wiles, Her Leisure Hour, 50

Irving Ramsey Wiles, Russian Tea, 51

Albert Bierstadt, The Sierra Nevada in California, 54

Alexander Helwig Wyant, Housatonic Valley, 55

Maria Oakey Dewing, Garden in May, 58

Raphaelle Peale, Melons and Morning Glories, 59

Walter Stuempfig, The Falls of the Schuylkill, 62

Leon Kroll, Scene in Central Park, 63

John Singer Sargent, Elizabeth Winthrop Chapman, 66

Cecilia Beaux, Man with the Cat (Henry Sturgis Drinker), 67

Alexander Brook, Summer Wind, 70

Walter Shirlaw, Water Lilies, 71

James Abbott McNeill Whistler, Valparaiso Harbor, 74

John Henry Twachtman, Fishing Boats at Gloucester, 75

Dwight William Tryon, Midsummer Moonrise, 78

John Fabian Carlson, Brooding Silence, 79

Albert Pinkham Ryder, *Moonlight*, 82 Henry Ward Ranger, *Entrance to the Harbor*, 83 Theodore Robinson, *La Vachere*, 86

Childe Hassam, Marechal Neil Roses, 87

Edmund Tarbell, Margery and Little Edmund, 90

Mary Cassatt, The Caress, 91

Eastman Johnson, The Lord Is My Shepherd, 94

Thomas Wilmer Dewing, The Spinet, 95

Chauncey Foster Ryder, Smugglers' Notch, Stowe, Vermont, 98

Fairfield Porter, Forsythia and Pear in Bloom, 99

George Bellows, Mr. and Mrs. Phillip Wase, 102

Moses Soyer, Artists of WPA, 103

John Singer Sargent, Betty Wertheimer, 106

Sidney E. Dickinson, Portrait of Paul P. Juley, 107

George Inness, Sundown, 110

John Henry Twachtman, End of Winter, 111

Asher B. Durand, Dover Plain, Dutchess County, New York, 114

Julian Alden Weir, Upland Pasture, 115

Paul Dougherty, Sun and Storm, 118

Frederick Judd Waugh, Southwesterly Gale, St. Ives, 119

George Luks, The Polka Dot Dress, 122

Raphael Soyer, Two Girls, 123

Abbott Handerson Thayer, Girl Arranging Her Hair, 126

Edwin Dickinson, Self-Portrait in Gray Shirt, 127

Maurice Prendergast, Summer, New England, 130

William Glackens, Beach Umbrellas at Blue Point, 131

Jasper Francis Cropsey, Indian Summer, 134

Edward Willis Redfield, The Brook at Carversville, 135

Ernest Leonard Blumenschein, The Gift, 138

Irving Ramsey Wiles, John Gellatly, 139

John Frederick Kensett, Along the Hudson, 142

Daniel Garber, Tohickon, 143

CREATIVE COLOR FOR THE OIL PAINTER

Color Basics

Like most working painters, I generally find color books a bore. I simply tune out when I see all those charts and diagrams and scientific data-not much help when you've got to paint a snowdrift or an evergreen or a head of red hair. These are practical problems, the kind of problems you learn to solve by experience.

This is a practical book for the working painter, based on my own experience and that of other working painters. You'll find nothing revolutionary in these pages: no "color system"; no rules or formulas that guarantee instant success; no discoveries for which I can claim any special credit. The guidelines presented here are simply the common sense which painters have accumulated over the centuries.

With just one exception-the terribly important color wheel-I'll spare you all the usual charts and diagrams. However, before you go any further, it's important for you to know what certain terms mean, since you'll be running across them throughout the book. Let's begin with some definitions.

Hue, Value, and Intensity

When you describe a color to someone, you begin by naming it. The name of a color is its hue. In other words, when you describe the color as a blue or a red-orange, you're naming the

When you describe that blue as very dark or that red-orange as pale, you're moving on to the subject of value. Imagine that you've squeezed all your colors out on the palette and then photographed them with black-and-white film. In the photograph, each color shows up as a shade of gray, some darker, some lighter; a few look almost black, and a few others look almost white. The photograph eliminates the hue and lets you see only the relative darkness or lightness of the color: this relative darkness or lightness is called value. When I speak of a very light or very high value, I mean a color that would photograph almost white. When I speak of a color that's very low or very dark in value, I mean that it would photograph almost black. Of course, most colors fall somewhere in between.

The brightness or intensity of a color is the hardest of all to visualize, but here's an analogy that may help. Imagine that each little mound on your palette is a colored light bulb. When you pump more electricity into the bulb, the color becomes brighter, more intense. When you turn down the current, you reduce the intensity. By turning the current up or down, you don't change the hue or the value-just the intensity.

Color Temperature

Painters are constantly talking about cool colors and warm colors. No one seems to know why-this is an unsolved problem for the psychologists-but most people feel that some colors are warm or even hot, while others are cool or quite cold. Reds, yellows, oranges, and violets are generally placed in the warm category. Blues and greens are usually classed as cool. However, it's not that simple.

Even within the category of warm colors, some seem hotter or colder than others. If you place two reds side by side, you may discover that one has a slightly purple tone; the red contains a touch of blue which makes it seem cooler than the other. Yellows often have a hint of green which justifies describing them as cool yellows. And violets can lean in either direction: a reddish violet seems hot, while a bluish violet seems comparatively cool.

This also happens with the cool colors. Some blues have a faintly purplish tinge, suggesting warmth, while others seem positively icy. Some greens seem almost yellow, and you wonder whether they belong in the cool category at allthey seem warm, like grass under a hot sun.

Why are hue, value, intensity, and temperature important? These aren't mere words, but four basic qualities of color which you must learn to recognize. These are the four main characteristics you look for when you study the colors of nature. And these are the characteristics that you try to match—or adjust—when you mix colors on the palette and apply these colors to canvas. In Chapter 4, "Color Mixing and Color Control," you'll find certain guidelines for adjusting the hue itself, darkening or lightening its value, heightening or reducing its intensity, and cooling or warming its color temperature.

Local and Atmospheric Color

If you could pull a green leaf off a tree and place this leaf on a white tabletop in a room with white walls, a white ceiling, and a white floorilluminated with perfectly white light, neither too warm nor too cool-you'd come reasonably close to seeing the local color of the leaf. In this controlled setting, you'd eliminate all other colored objects, colored backgrounds, or colored lights that might distort the actual color of the leaf or distract you from observing the exact shade of green. So then, the local color of an object is what you'd see if the object were removed from all outside optical influences.

But now walk outside and look at the tree from which you plucked the leaf. Some of the leaves are in light and others are in shadow. Still others seem to have sunlight shining through them, making the leaf look translucent. Suddenly a cloud passes before the sun, and the entire color of the tree becomes more subdued. If you wait around long enough, the sun will begin to set, and the reddish rays of the sunset will turn the leaves positively ruddy. As the sun drops below the horizon and the fading light turns cooler, the tree may begin to look blue. Silhouetted against the night sky, the tree may become a ragged, black shape.

In the constantly changing light of nature, I doubt that you'll see one single leaf on the tree that seems to match the color of the leaf in that scientifically controlled white room. It's almost impossible to see local color that's not influenced, in some way, by atmospheric color. Local color is always submerged in a sea of light and air-in an atmosphere which combines a wide range of color influences. Not only does the sunlight change constantly through the day, but colored objects influence one another. Neighboring colors enhance or subdue one another; colored objects literally pick up reflections from one another; and even the dust particles in the air lend their own color to the objects we paint.

The concepts of local and atmospheric color are important because, in the process of painting, we're constantly trying to judge the local colors of things and then analyze how they're influenced by atmospheric color.

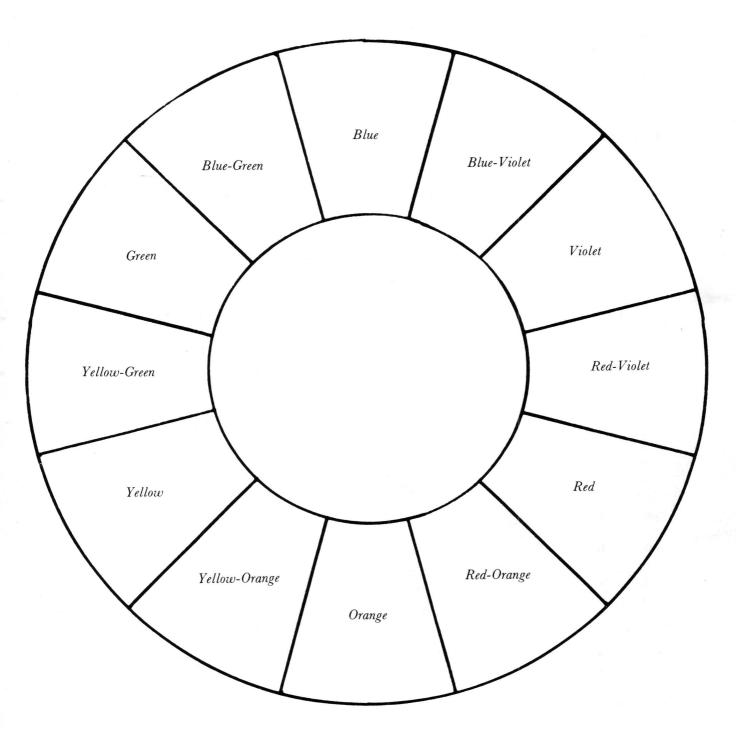

blue - orange fellow Green - Ped violet blue violet - Yellow orange violet - Jellow Red - Green Red Orange - blue green

Hues directly opposite each other on the color wheel are called complements. Placed side by side in a picture, complementary colors brighten each other. But intermixed, they reduce each other's brightness.

Advancing and Retreating Colors

Here's another phenomenon which is hard to explain. For unknown psychological reasons people feel that some colors move toward them while others melt away into the distance.

The hottest, darkest colors seem to move forward most aggressively. Among these are vivid reds, oranges, and purples. Deep, heavy tones are inclined to move into the foreground even if they're not particularly hot—like black, deep brown, dark blues, and greens.

Generally, cooler, paler tones go back into the distance. Pale blues and greens seem to move farthest away. Paler reds, oranges, and yellows also tend to move back, though not as far back as blues and greens of the same value. Yellow is tricky: although it's a light color, it moves forward when it's at its maximum intensity, but it melts away into the distance when it's more subdued.

Of course, there's no law that says that you can't put a pale blue object in the foreground and a bright red one in the distance. There are times when you'll want to do just that. But knowing which colors tend to advance and which ones tend to recede can be helpful in establishing a sense of space in a picture.

Primaries, Secondaries, and Tertiaries

If you've done any painting at all, you know that there are certain hues which you simply can't get by mixing two or three other colors together. Reds, yellows, and blues come straight from the tube, and there's no way of mixing them by combining other tube colors. These three basic colors are called primaries.

If you combine two primary colors, you get a secondary. I'm sure you already know that blue and yellow make green, red and yellow make orange, and blue and red make violet.

Now, if you mix a primary and a secondary, you get what's called a tertiary. Blue and green produce blue-green, while blue and violet give you blue-violet. Red and orange make redorange, while red and violet yield red-violet. Yellow and green combine to give yellowgreen, while yellow and orange make yelloworange. There are six tertiaries, each of them combining the characteristics of a primary and a secondary.

Complementary Colors and the Color Wheel

The concept of primaries, secondaries, and tertiaries provides a rough but useful guide to color mixing. Another useful guide is the color wheel, which arranges these twelve hues in a circle.

The main function of the color wheel is to provide a way of remembering the so-called complementary colors. Directly opposite each hue on the wheel-on the far side of the circle-is its complement. Placed side by side in a picture, these two colors intensify one another. Intermixed, they tend to mute each other.

The most obvious example is red and green. Everyone knows how garish the red-green color scheme looks at Christmas time. The red looks redder and the green looks greener precisely because they appear side by side. But add a touch of green to a pile of red on the palette, and the red quiets down almost immediately. Conversely, a touch of red softens the impact of the green. This is equally true of all the other complementary pairs on the wheel.

At the moment, the color wheel may seem rather theoretical. Its implications will emerge when you get into the practical problems of color mixing later in the book. A good first step is to memorize the complementaries.

How Tube Colors Behave

Having done your homework and memorized the color wheel, you may be in for a shock when you start using the tube colors you buy in the art supply store.

There's just one yellow on the wheel, an ideal, purely theoretical yellow that's neither too warm nor too cool, neither too light nor too dark, neither too bright nor too dim, and absolutely unsullied by the faintest hint of any other color. The same is true of every other color on the wheel. There's a pure, ideal blue, an equally perfect red, and so on. But when you walk into the art supply store, you find as many as a dozen yellows, a dozen reds, and at least half a dozen blues, plus fistfuls of secondaries and

tertiaries. Every single hue seems to come in lighter and darker, warmer and cooler, brighter and duller variations. It's obvious that none of these colors will match that ideal, theoretical hue on the color wheel. Nor will any of them behave-on the palette or in the paintingexactly as the color on the wheel is supposed to behave.

You have every right to ask: "What's the use of a color wheel?" The answer may seem perverse, but it's not. The whole value of the color wheel is that it sort of works, but never exactly as you expect. The wheel provides rough guidelines, but it leaves plenty of room for surprises.

For example, the wheel tells you that blue and orange are complementaries, which means that a touch of blue can be blended in to soften the brassiness of a mound of orange on the palette, while a touch of orange will "gray down" a mound of blue. But try this with all the different blues and oranges you can buy in the art supply store. Yes, blue and orange will mute one another, but you may also be astonished to discover that new colors appear. Some oranges surprise you by pushing blue toward green, and some blues turn orange to a strange coppery tone.

Similar surprises are in store for you when you experiment with the other complementary pairs on the wheel. Theoretically, complements will "gray down" one another, as the expression goes. But they won't literally turn each other gray. Nor is adding a touch of a complement anything like adding a touch of gray to a color mixture. What the color wheel doesn't tell you is that tube colors go beyond the "rules" and transform one another when complementaries are mixed. The color wheel is nothing more than a point of departure for discovering all the unexpected, cockeyed color mixtures that make oil painting so exciting.

You'll learn more about the unexpected possibilities of color mixing in Chapter 2, "Colors for Oil Painting" and especially in Chapter 3, "How Colors Behave in Mixtures."

Tints and Shades

Two other terms in common use-and worth remembering-are tints and shades. Fashion magazines, fabric shops, and housepainters use these words so loosely that the terms need careful definition for the artist's purpose.

The simplest way to define tint is to say that it's something you get by adding white. Add some white to a tube color like viridian, and you get a green tint. Add more white and you get an even lighter tint. Depending on how much white you add, you can produce lighter or darker tints of any color. But a good rule of thumb is that a tint is always lighter than the color that comes straight from the tube because you're always adding white.

Conversely, a shade is something you get by darkening the color that comes from the tube. Whether you darken it with black or with any other color, the essential point is that you're adding something that's darker than the original color. A shade can also be warmer or cooler than the original color, of course, depending on the hue that you add. Thus, if you add a dark brown to a lighter red, you get a brownish shade of red.

Naturally, you can turn any mixture-not just a tube color-into a tint or shade by adding white or by adding a darker color. These points are all worth remembering when you get into the color mixing exercises in Chapters 2 and 3.

Permanence

There are three characteristics of tube colors which you ought to know about before going on to the next chapter, where I'll describe all the major tube colors and how they work. It's important to know just what the painter means by permanence, tinting strength, and opacity or transparency.

Although few of us are likely to paint masterpieces that museums will preserve for posterity, we still like to think that our pictures will endure the passage of years. Over centuries, artists have learned (the hard way) that some colors crack, fade, blacken, yellow, or otherwise lose their identity as a painting ages. Luckily, there are other colors that stand up to the punishment of the years. Here are the characteristics that a permanent color needs to have:

(1) It must be lightfast. Exposed to years of sun-

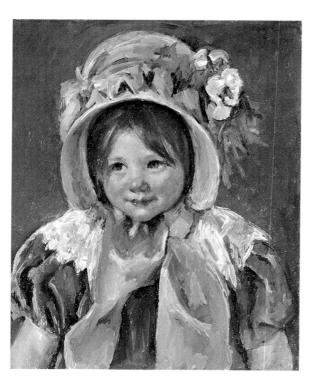

Sara in a Green Bonnet by Mary Cassatt, ca. 1901, oil on canvas, $16^{5/8}$ " × $13^{5/8}$ " (42 × 34 cm), National Museum of American Art, gift of John Gellatly. The color scheme of this charming portrait is simple and effective. The orange dress and the subdued orange of the hair are played against the blue-green of the scarf and hat. They're almost complementary colors, but not quite. The warm tones of the face and hair are framed by the cool tones of the hat and scarf. The more neutral background color is actually what you'd get if you mixed the two dominant hues in the picture. In the closeup of the head, notice how the artist weaves warm touches into the cooler strokes of the hat; the hair color actually seems to be reflected along the inner edge of the bonnet. Study the brushwork in the face. Cassatt resists the obvious temptation to overblend the soft tones of the child's skin. Instead, she blends the colors very loosely, letting all the strokes overlap and fuse naturally as the brush moves over the canvas. Thus, the brushwork creates a sense of soft, flickering light moving over the face.

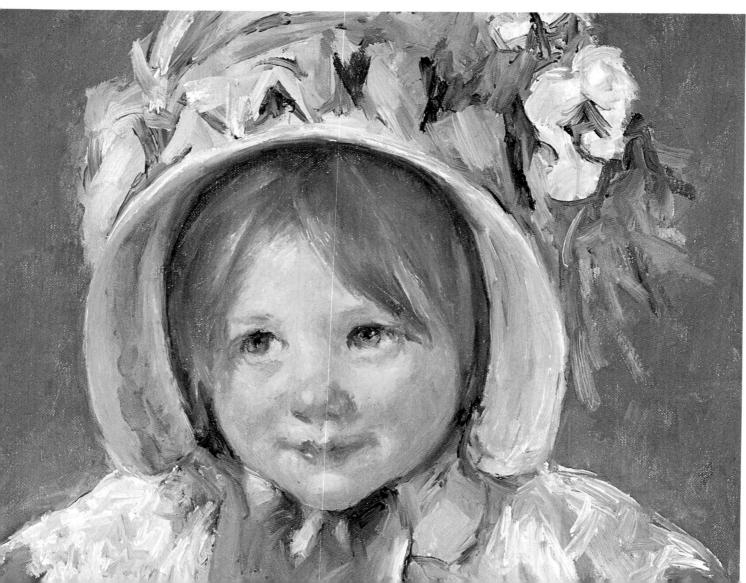

Spanish Dancer Wearing a Lace Mantilla by Mary Cassatt, 1873, oil on canvas, $26^{3/4}$ " × $19^{3/4}$ " (67 × 50 cm), National Museum of American Art, gift of Victoria Dreyfus. Here's a far more subtle contrast of warm and cool color mixtures. What we see at first glance are the warm tones of the head and hand surrounded by the neutral mixtures of the mantilla and the fan—all against a cool, subdued background. But now look more carefully at the closeup. That supposedly white mantilla is actually full of color. The shadows within the mantilla are a variety of warm and cool grays, while the lighter strokes, suggesting the pattern of the lace, are never really white, but tinted with touches of tan, pink, blue, and violet. The head is surrounded by a mosaic of delicate color. Like the child's head on the opposite page, the dancer's skin is built up with many small strokes that overlap, interlock, and "mix" in the viewer's eye without being smoothly blended. Like the not-so-white mantilla, the whites of the eyes are actually delicate grays. The thick highlight on the forehead reminds us that the old masters liked to paint the lights more heavily than the shadows.

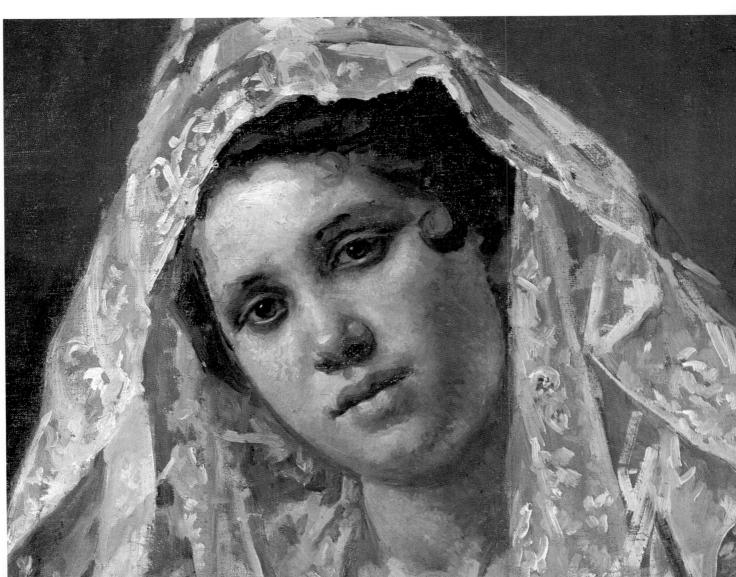

light or artificial light, a permanent color refuses to fade or alter its hue.

- (2) The color should be chemically stable. We all know chemical instability in such obvious forms as iron turning to rust or milk turning sour; as time passes, the original chemical composition breaks down and turns into something else that we don't want. In contrast, the ultimate in chemical stability is gold, which remains unchanged forever. In the same way, a permanent tube color remains intact because its chemical composition refuses to change, while an unstable tube color loses its chemical integrity and turns to some other hue.
- (3) A permanent tube color is also chemically compatible with other permanent colors. Thus, when two permanent colors are blended together to create a third color, they don't produce a *chemical reaction*, a silent explosion in which their original chemical composition is destroyed and a new, unstable chemical emerges—along with a new color that you never expected. Each of the original permanent colors retains its chemical stability within the mixture, and the mixture is as stable as its components.

So a permanent color is a color that's light-fast, chemically stable, and chemically compatible with other permanent colors. Luckily, there are plenty of tube colors that fit this description.

Tinting Power

Once you've selected a palette of permanent colors, you can stop thinking about chemical compatibility. That problem is over. But *tinting power* is another kind of compatibility problem that you've got to think about whenever you mix two colors. Sometimes called *tinting strength*, this means the power of one color to influence or even overwhelm other colors in a mixture.

For example, there are a couple of blues which are amazingly strong: just a touch of one of these blues cools down (or turns blue) almost any mixture in an instant. On the other hand, there are several delicate yellows, browns, and greens which hardly show up until a great deal

is added to a mixture. The latter are considered *low* in tinting strength.

Knowing the tinting strength of your tube colors is a matter of experience. By trial and error, you'll learn how much of each color to add.

Opacity and Transparency

As you work with tube colors, you'll find that some are dense and opaque, covering up other colors as completely as a sheet of colored cardboard. Other tube colors are transparent, acting like a sheet of colored glass and allowing underlying colors to shine through. Between these two extremes, there are many degrees of opacity and transparency; however, it's convenient to talk about semiopaque colors, which are almost opaque, but still allow just a bit of the underlying color to come through, and semitransparent colors, which aren't as clear as colored glass but function more like a colored haze.

To take full advantage of the color possibilities of oil paint, there are times when you'll want to use opaque, semiopaque, semitransparent, or transparent colors. There will also be times when you'll want to modify a transparent color by adding a touch of opaque color or vice versa. Thus, you must know the relative opacity or transparency of each color on your palette.

Brands of Colors

When you walk into the art supply store, you'll probably see several well-known brands of oil paints. I have no intention of rating them in this book. In my experience, all the well-known brands are good. Among the first rate American brands I've used are Permanent Pigments, Grumbacher, Bocour, and Shiva. The famous English Winsor & Newton tube colors are widely sold in the United States. Talens is an excellent Dutch color manufacturer whose products are sold in the United States and Britain.

The differences between brands are not so much in quality as in the way the color looks. One manufacturer's ultramarine blue may be a bit warmer or cooler than another's. Some manufacturers make a raw umber-a very soft brown-that has a distinctly yellow tone, while other-raw umbers tend more toward gray. These are subtleties which may not bother you for awhile, but as you develop distinct color preferences, you may prefer one manufacturer's version of a particular hue and turn thumbs down on another. Nor is there any reason why you should stick to just one manufacturer. Many painters use several brands and intermix them freely.

When you scan the various brands of colors available in the art supply store, you might wonder why most of the leading manufacturers produce two different "grades" of colors in two different price ranges. Traditionally, each major manufacturer once produced an expensive line of colors for professionals and a less expensive line of colors for students. The student grades were less expensive because they contained cheaper pigments and various colorless fillers which made the paint go further but cut down the brilliance of the hue. In recent years, however, most leading manufacturers have upgraded the so-called "student colors" so that they're really suitable for professional use after all. The less expensive line of colors may still use some cheaper pigments for certain hues, with a slight loss in tinting strength, but there's absolutely no loss in the permanence or handling quality of the paint. The difference between the two grades of oil colors is really very slight, and the words "student colors" no longer appear on the label.

Thus, when any leading manufacturer offers you two grades of professional colors, you can buy the cheaper grade with absolute confidence. There are certain subtle differences that make the "top of the line" worth buying if you can pay the price, but both grades are equally suitable for permanent painting. If that's all you can afford, don't be embarrassed to buy the less expensive colors. They'll do the job.

I'm told that certain European manufacturers still produce a genuine "student grade" for the painter on a stringent budget. If a tube of color is actually marked "student grade," this does mean that there's a significant difference between the cheaper colors and the professional grade. These inexpensive tube colors are excellent for the beginner and will save you money, but you should plan to switch to the professional grade as soon as you can afford it.

The Quiet Valley by Guy Wiggins, 1922, oil on canvas, $34'' \times 40'/8''$ (86 \times 102 cm), National Museum of American Art, bequest of Henry Ward Ranger through the National Academy of Design. Confronted by a subject that's dominated by cool color, the artist establishes his center of interest with just a few warm touches on the trees in the upper left. And to provide some relief from the overall coolness, he warms the snow slightly, adds some more warm touches to the tree trunks, and even suggests a pink house on the snowy hilltop at the right. In the closeup, you can see how the more distant landscape is painted with soft, scrubby brushwork that blurs the warm and cool tones of the wintry foliage on the hills. Only the foreground tree trunks are rendered in sharp focus. The warm color of the dead leaves isn't a single mixture, but a variety of warm touches, relieved by a few hints of green at the top of the picture.

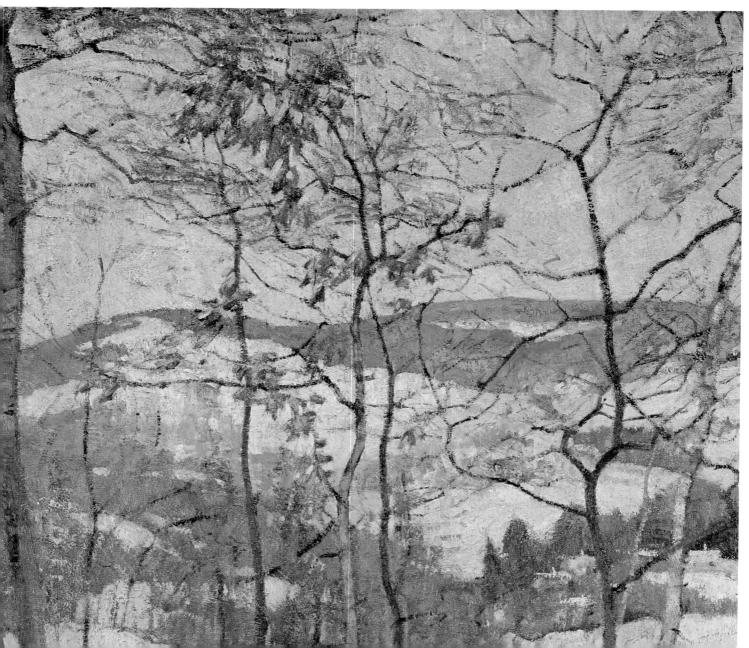

Bradbury's Mill Pond, No. 2 by Henry Ward Ranger, 1903, oil on canvas, $28^{1/4}$ " $\times 36^{1/4}$ " (72) × 92 cm), National Museum of American Art, gift of William T. Evans. In contrast with the Wiggins landscape on the opposite page, here's a picture that's dominated by warm color—or seems to be. But the artist has actually interwoven a great deal of cool color with the warm mixtures, particularly in the shadow areas. Like Wiggins, Ranger saves his strongest warm-cool opposition for the center of interest: the big, shadowy trees and the cluster of foliage just off to the right. And to reinforce the point, Ranger adds two tiny figures, one with a red shirt and the other with a red cap, alongside the large trees. The closeup shows how the artist has built up a rich mosaic of rough brushstrokes: varied touches of brown, orange, red-orange, gold, and green. The texture of the paint and its color convey the texture and detail of the forest.

Colors for Oil Painting

Although I've never counted them, I imagine there must be close to a hundred different oil colors on sale in any well-stocked art supply store. I've never heard of a painter who used them all. In fact, two dozen colors is about the largest selection I've ever seen on one artist's palette. Ten or fifteen colors seem to satisfy many painters, and I know some who get along fine with just six or eight.

There's no ideal palette of colors that will be perfect for every purpose and for every subject. Each artist is a unique personality, after all. He develops his own work habits, his own style, and his own color preferences. Over the years, painters try out a lot of different colors. Eventually, they settle on certain favorites which stay on the palette for a lifetime. Other colors are discarded and still others may be tagged "optional," which means that they're kept in a drawer for occasional use. In short, no one can select a palette for you; you've got to do it yourself, by trial-and-error.

In this chapter, I'm going to review all the widely used oil colors. I'll also comment on some others that strike me as useful, though they may not be as widely used as certain workhorse colors that you'll find on almost every painter's palette. I'll describe how each color looks, and I'll talk about opacity and transparency. I'll describe how these colors behave when they're mixed with white-since almost every color on your palette will be mixed with white in the process of painting—and how they look when they're thinned out with painting medium. When a particular color is unusually high or low in tinting strength, I'll mention this too. I won't talk about permanence, however, since all the colors listed in this chapter are lightfast and chemically sound. As you read these comments, bear in mind that there's often some difference between various manufacturers' versions of the same hue.

So then, this chapter surveys all the colors that I think you might want to use, although I must admit that I'm bracing myself for those inevitable letters from painters who'll complain that I've left out their favorite offbeat color. But the facts in this chapter will be nothing more than words until you put them into practice; you've got to try the colors out and

observe their behavior first hand. No, I don't urge you to rush right out and buy every color listed in this chapter. I know that oil colors cost money. At the end of the chapter, I'll suggest a basic palette for beginners-not a universal palette by any means, but a reasonable "starter" palette-and a series of tests which you can conduct to learn how these colors behave. Finally, I'll suggest additional colors to buy so you can broaden your range of experiments and finally determine your own color preferences, based on experience.

In developing your own personal palette, you'll also find help in Chapter 3, on "How Colors Behave in Mixtures," where you'll learn how various colors react when they're blended. And in Chapter 6, "Palettes and Color Schemes" I'll describe a variety of color selections for different subjects and painting techniques. But the final color choices must be yours, not mine.

Manufacturers' Color Charts

Every good manufacturer of artists' colors has a chart that shows the colors he produces. The larger art supply stores usually carry a stock of these charts, which they'll give you without charge, so you can select the colors you want to buy. Some charts not only carry color samples-to let you see what the paint actually looks like-but also information about relative permanence, opacity and transparency, and even how a color behaves when you add white or thin it out with painting medium.

Three manufacturers have charts which I've found extremely helpful. Grumbacher has a chart that shows how the color looks straight from the tube, with a separate sample of the way the color looks when it's mixed with white. The Permanent Pigments, chart shows how the color looks when it comes straight from the tube, how it looks when mixed with painting medium to a transparent glaze, and how it looks when mixed with white. Permanent Pigments also has a fascinating booklet called Enduring Colors for the Artist, which you can get at your art supply store. Winsor & Newton has a particularly fascinating chart which shows how the color looks when it comes straight from the

tube and then shows the color gradually thinned out with painting medium so you can see how the hue behaves when it gradates from dark to light and becomes more transparent. I might add that I'm indebted to these three manufacturers for providing background material for this chapter.

Blues

In this survey of oil colors, it makes sense to begin with the three primaries: blues, reds, and yellows. Let's start with the blues. Although I think there are ten blues worth mentioning, it's unlikely that you'll ever use more than three or four. I'll start out with the ones that seem more useful and then go on to the ones that strike me as optional.

Ultramarine Blue. Judging by the work habits of my friends, ultramarine blue is more widely used than any other blue. It has a faintly warm tone and behaves well in mixtures because it doesn't overpower other colors with the violent tinting strength of phthalocyanine or Prussian blue. Ultramarine blue is fairly transparent, a quality which makes this color good for glazing (you'll learn more about this process in Chapter 4, "Color Mixing and Color Control"). Ultramarine is also valuable because it's not particularly intense. Usually you'll want blue to hold its place in the picture, not pop out at you. Like most transparent colors, ultramarine looks blackish and murky when piled on thickly, straight from the tube. The color reveals itself only when mixed with white or thinned to a glaze. Mixed with a touch of white, ultramarine becomes a deep, warm, dignified blue. With more white, ultramarine remains warm but also becomes airy and delicate. Thinned to transparency, ultramarine retains its softness and never takes on that electric quality you find in a glaze of phthalocyanine blue. As you can see, ultramarine is a workhorse, a solid citizen who never calls attention to himself but is always ready to help when you need him.

Ultramarine Blue Deep. In a well-stocked art supply store, you'll find not only ultramarine blue but also a variation called ultramarine blue deep. As the name implies, it's just a bit darker and a bit richer while just as warm and trans-

The South Ledges, Appledore by Childe Hassam, 1913, oil on canvas, $34^{1/4}'' \times 36^{1/8}''$ (87) × 92 cm), National Museum of American Art, gift of John Gellatly. A sunlit seascape, like this one, is apt to be a study in blues—blue sky, blue water, blue shadows-and the painter's challenge is to find some variety within all this cool color. Hassam begins by building his design around the contrast between the cool waves and the warm rocks at the right. Then, as he builds up the lights and shadows on the rocks, he pays particular attention to the reflected colors, noting how cool notes appear among the warm rocks and warm notes appear among the cool rocks. This is most apparent in the closeup. Now we can see that the brown rocks aren't brown at all, but a fascinating patchwork of colorful strokes that are coolest and darkest in the shadow planes. In the same way, the cool rocks and figure are punctuated with warm strokes.

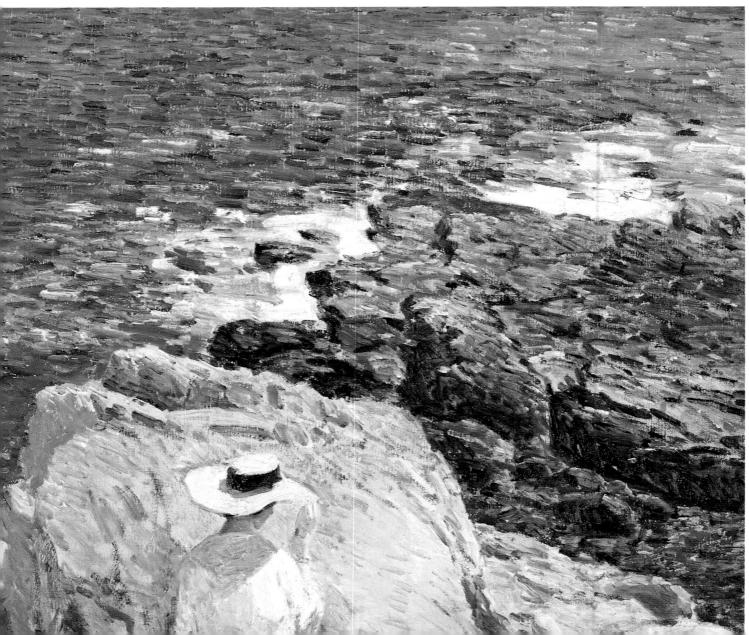

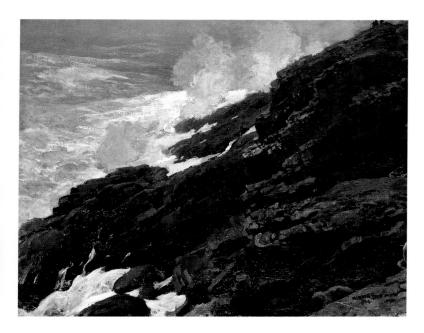

High Cliff, Coast of Maine by Winslow Homer, 1894, oil on canvas, $30^{1}/8'' \times 38^{1}/4''$ (77 × 97 cm), National Museum of American Art, gift of William T. Evans. Homer, like Hassam, builds his pictorial design around the opposition of cool sea and warm rocks. But this is an overcast day, and Homer emphasizes the remote, mysterious tones of the waves by exaggerating the paleness of the water and the darkness of the shore. The drama of the painting is created by the contrast in values: dark against light. But the artist must also avoid the danger that this contrast will be so great that sea and shore seem unconnected, splitting the picture. In the closeup, we see how he solves this problem. At the top of the picture, he blends delicate touches of the warm rock mixtures into the water. In the same way, he works the sea colors into the lighted tops of the rocks—most obvious in the lower right. To paint the lighted edges of the rocks near the water, Homer actually mixes the sea and rock colors.

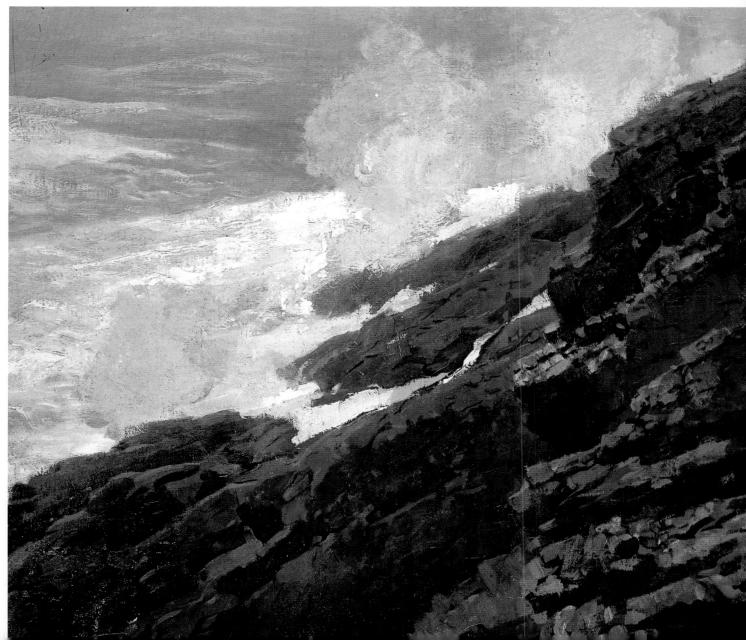

parent as ultramarine blue. Blended with white or thinned to a glaze, it's pretty hard to tell ultramarine deep from the regular ultramarine. The one you choose is a matter of taste. However, most painters prefer the regular ultramarine.

French Ultramarine. Still another variation is French ultramarine, whose main virtue is that it yields a particularly soft, dusty tone when mixed with white. When it's thinned to a glaze, I can't tell French ultramarine from the other two. It's just as warm and transparent and has the same dignified quality that makes the others so useful.

Permanent Blue. So far as I can tell, this is just another name for ultramarine blue. On some manufacturers' color charts, permanent blue fills the slot of the regular ultramarine. On others, it fills the slot of ultramarine deep. Permanent blue has all the same useful characteristics of both.

Phthalocyanine Blue. The perfect foil for ultramarine is phthalocyanine blue, which is cool and brilliant. Sometimes abbreviated to thalo blue-a term coined by Grumbacher-this vivid color has exceptional tinting strength. When you add it to a mixture, you've got to be extremely careful: just add a touch unless you want a pile of blue paint. Thalo blue is so transparent that it seems to radiate light when thinned to a glaze. Straight from the tube, it's practically black of course, but a touch of white yields a vivid, rich blue. Mixed with a lot of white, thalo gives you a bright, clear sky blue. Just as ultramarine is the most useful warm blue, thalo is probably the most widely used of the cooler blues. Winsor & Newton calls this Winsor blue, by the way.

Cobalt Blue Light. This blue is really a special purpose color. It has a particularly lovely, delicate tone-soft and airy with a touch of warmth. Some painters like it for skies since cobalt yields particularly delicate tones when mixed with white. Because cobalt blue has rather limited tinting strength, some painters like it for cool notes in flesh tones, where the blue yields silvery grays without overpowering the warm colors. Cobalt is in the semitransparent category and produces a very soft glaze when thinned with painting medium.

Cobalt Blue Deep. Although cobalt is never a very strong color, there is a deep variety which seems a trifle more vivid when mixed with white or thinned to a glaze. Both cobalt deep and the regular cobalt have that special softness which many painters treasure.

Cerulean Blue. This is another special purpose color, favored mainly by landscape painters. It's cool and opaque and makes splendid skies. Cerulean mixed with white gives you a clear, atmospheric blue which has the brightness of a sunny sky, without the dazzling intensity of thalo blue. Cerulean holds its place in the picture and melts back into space nicely. Its tinting strength is limited, and there's not much point in thinning cerulean to a glaze, since this is the only really opaque blue.

Manganese Blue. This might be called a more brilliant, transparent version of cerulean. Manganese is cooler and produces a striking, electric blue when mixed with a bit of white. When mixed with a great deal of white, manganese gives you a very cool, very delicate sky tone which has a hint of green. It also makes an exceptionally clear, vivid glaze. This certainly isn't an all-purpose blue, but it's useful to the landscape painter for atmospheric effects.

Prussian Blue. Although a great many painters have dropped Prussian blue-once an old standby-in favor of thalo blue, there are some who still can't get along without the older color. This cool, transparent hue is still the deepest and most sonorous of all the blues, very rich when used by itself, producing vivid glazes when thinned with painting medium and producing strong, clear tones when mixed with white. Perhaps Prussian blue has gone out of fashion because of its tremendous tinting strength, which makes this color hard to control in mixtures. There's also some evidence that Prussian isn't quite as permanent as the more recently developed thalo. Painters still argue about whether Prussian blue is outmoded or not. I do know that certain deep, dark forest greens are hard to get with any other color. So let's call Prussian blue an optional color.

Reds and Oranges

Although I said I'd begin by surveying the primaries, I'm going to lump the reds and oranges together for two reasons. First of all, certain reds shade off imperceptibly into the orange family, and it's often a matter of habit whether you call such a color red or orange. Second, there are very few oranges worth having on the palette since you can mix this secondary color so easily. So it hardly seems worthwhile to have a separate category for the oranges.

As you read on, you'll see that I've also moved the so-called earth reds into the brown category because they're really reddish browns. The list of reds and oranges is naturally dominated by the cadmiums, which have replaced the once long list of fascinating but impermanent colors that included vermilion and the various chrome colors.

Alizarin Crimson. For glazing, this rich, transparent hue is the basic red. Alizarin has a slight hint of violet, making it a perfect foil for the warmer cadmiums. Turned semiopaque with a touch of white, alizarin crimson produces a rich, pinkish violet; lots of white gives you an extremely delicate, cool pink. The special charm of alizarin crimson is the fact that it's bright without being garish. Nor is its tinting strength overwhelming, so it behaves well in mixtures.

Cadmium Red Light. All the cadmiums are intense, opaque, definitely on the warm side, and very powerful in mixtures. Cadmium red light, as the name tells you, is the lightest in value of the three cadmium reds. It's also the warmest. Thinned to a glaze, this opaque color turns semitransparent and retains its vivid warmth. White cuts down its brilliance and seems to make cadmium red a bit cooler, producing a strong pink. Because this is the brightest and clearest of the cadmium reds, it's the one that most painters use.

Cadmium Red Medium. This color looks a bit cooler and perhaps less intense. The general tone is darker, as the name implies. When you place cadmium red light and cadmium red medium side by side, the lighter tone looks distinctly closer to orange, while the medium hue seems cooler and more restrained-it has more weight. With white, cadmium red medium produces a pink that has a distinctly violet undertone. The glaze is rich and luminous. Watch out for the tinting strength of this color.

Cadmium Red Deep. This is a dark, heavy red. On some manufacturers' charts, it's practically maroon. Cadmium red deep is definitely cooler than the other two; this is particularly apparent when you add white, producing a pink with a distinct violet tinge. The darker cadmiums are rich glazing colors when thinned with painting medium; opaque colors often lose their punch when thinned to a glaze, but the powerful cadmiums hold their own even when strongly diluted. Once again, watch out for the great tinting strength of this color when you add it to a mixture. Frankly, I list this color here just as a matter of completeness since few painters use it. Most prefer the warmer, lighter cadmium reds; if you want to darken one of these to produce something like cadmium red deep, it's easy enough to do.

Cadmium Scarlet. This is a hot, brilliant redorange which has replaced vermilion. Like the other cadmiums, this hue is opaque, but it produces vivid glazes when thinned with painting medium. The red-orange hue fades when mixed with white, and the tint moves in the direction of pink. Cadmium scarlet has the same powerful tinting strength as the others, so mix it with care. It's sometimes called cadmium vermilion.

Cadmium Orange. This has the same basic characteristics as all the other cadmiums: intensity, opacity, great tinting strength, richness in glazes, and a tendency to lose its vigor when mixed with white. This is certainly an optional color, since it's easy enough to mix cadmium orange by combining cadmium red light and cadmium yellow light. One final point about the cadmiums-they may vary slightly from one manufacturer to another. As I look at the color samples from various manufacturers. I see that there are distinct variations in value and in color temperature. Scan the charts carefully to see which brand you want.

Quinacridone Crimson. Just recently developed,

The Hills by Preston Dickinson, ca. 1910–1930. oil on canvas, $24'' \times 27''$ (61 × 69 cm), National Museum of American Art, gift of Mrs. Robert F. Shawan. Dickinson interweaves subdued versions of all the primaries and secondaries: varied reds, yellows, blues, oranges, greens, and violets. The colors of nature are there, but he takes liberties with them to create a picture that's both lively and unified. His strategy is to carry each color throughout the painting, so that each area of the composition echoes the others. Thus, the cool sky color reappears in the hills and rooftops, and even in the sunny foreground. The warm color of the big barn reappears in the soil, the hills, and even the trees. As you study the closeup, you can see how the loose brushstrokes pull one color over and into another. There's just enough blending to model the shapes and make them look three-dimensional, but each color remains distinct.

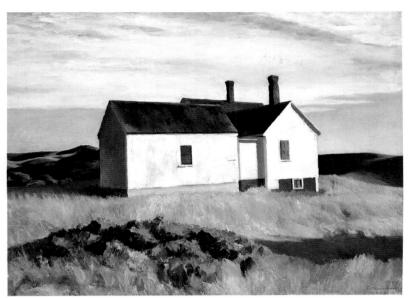

Ryder's House by Edward Hopper, 1954, oil on canvas, $36^{1/8}$ " × 50" (92 × 127 cm), National Museum of American Art, bequest of Henry Ward Ranger through the National Academy of Design. Comparing this Hopper landscape with the Dickinson on page 30, you can see that Hopper also designs with distinct primaries and secondaries—blue, red, yellow, green, and muted orange—but gives each color area a sharply defined shape. The most brilliant color in the picture is actually the sunlit white of the house, which the artist frames with the darks of the roof and the hills to establish the center of interest. The blue sky is pale and remote, pushing the house forward. The small red shapes draw our attention to the white walls. The closeup reveals that the darks of the house contain more color than we might expect, and so does the white. The roughly applied color in the foreground serves to dramatize the flat colors of the house.

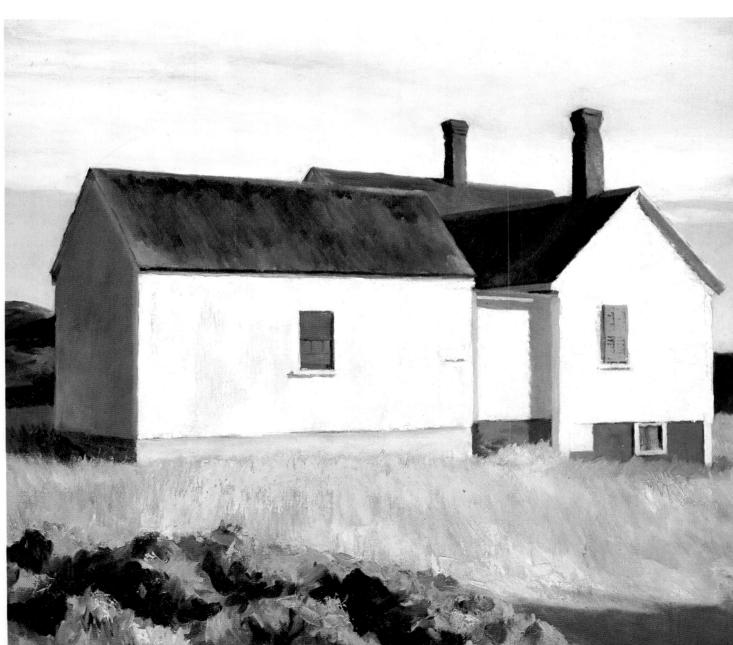

this transparent color is stronger and more vivid than alizarin crimson. The newer color still has a hint of coolness, but it doesn't look quite as cool as the older one. Alizarin crimson doesn't have the tinting strength of its new competitor, so alizarin is easier to handle in mixtures. But quinacridone crimson makes particularly stunning glazes when thinned with painting medium, and white yields a bright, slightly cool pink. The name quinacridone is a jawbreaker, so various manufacturers attach names of their own, like acra crimson coined by Permanent Pigments.

Quinacridone Red. Just as brilliant as its crimson counterpart, quinacridone red is a trifle warmer. It's an excellent glazing color because of its innate transparency, though white turns it much cooler than you might expect of a powerful color. Neither of the quinacridone colors is a "must," but their transparency makes them worthwhile optional colors. At one time there were a great many transparent reds available, but most of these proved to be impermanent. The quinacridones restore some brilliant transparent reds to the palette. Grumbacher calls this hue thalo red rose; Permanent Pigments calls it acra red; Winsor & Newton lists it as permanent magenta.

Yellows

The yellows, like the reds, are dominated by the cadmiums, though the choice of yellows is surprisingly large. The list also includes some so-called earth yellows, although they fall into that vague territory between yellow and brown. Despite the range of possibilities, three or four yellows are usually enough for most painters.

Cadmium Yellow Lemon. Like the cadmium reds. the yellows are in a spectrum that ranges from very pale to very deep, the latter verging on orange. The palest of these is cadmium yellow lemon, sometimes simply called cadmium lemon. Despite its pale hue, cadmium yellow lemon is a standout—an intense, sunny tone. It's opaque and powerful in mixtures and retains its brightness even when mixed with a great deal of white or thinned to a glaze.

Cadmium Yellow Light. One short step closer to orange is cadmium yellow light-distinctly darker and warmer than cadmium vellow lemon-though certainly still yellow. It's the most widely used of the cadmium yellows, opaque and intense with great tinting strength. Add enough white and you come pretty close to cadmium yellow lemon, which is just a trifle cooler. One of the special characteristics of the cadmium yellows is that they retain their identity and their brightness when mixed with white or thinned with painting medium-unlike the reds, which are muted by white and by dilution. Here's an interesting case of manufacturers not agreeing on a color. The cadmium yellow light marketed by Winsor & Newton and by Grumbacher is distinctly darker than the cadmium yellow light made by Permanent Pigments (theirs actually looks more like the paler hue which Winsor & Newton calls cadmium lemon). These are all first-rate brands, so it's not a question of quality. You've simply got to check the manufacturers' color charts before you decide which cadmium yellow light you want.

Cadmium Yellow Medium. With this color, the cadmium series moves toward yellow-orange. It's darker and warmer than the others and just as opaque, intense, and powerful in mixtures. Adding white cuts down the orangeness and produces a very rich but delicate yellow. Like the other cadmiums, this is fine for glazing. However, that hint of orange makes it less popular than cadmium yellow light.

Cadmium Yellow Deep. This hardly looks like yellow at all when it comes straight from the tube; it's really an opaque, light orange. However, it turns to a strong, sunny yellow when mixed with white, but the orange tone remains when cadmium yellow deep is thinned to a glaze. Tinting strength is great, as usual. I think this is the least useful of all the cadmium yellows; if you want yellow, you don't want orange.

Yellow Ochre Light. It's hard to find a painter who feels that he can get along without this one. This subdued yellow looks like a dusty, yellowish tan when it comes from the tube and turns more yellow as you add white. White brings out the full beauty of the color, which is a dusty golden tone that many portrait and figure painters consider indispensable for flesh. Although yellow ochre is opaque, it thins out to a glaze which is both subdued and luminous. Like ultramarine blue, this is one of those subdued colors, limited in tinting strength, that lends itself to far more purposes than more vivid, more powerful colors. Yellow ochre will warm and vitalize all kinds of mixtures without dominating them-like one of those indispensable supporting actors whom every star needs by his side.

Yellow Ochre Deep. This darker, tanner version looks sombre when it comes from the tube, but it comes to life when it's mixed with white. A little white produces a golden tan, while a lot of white produces a dark, dusty gold. Despite its opacity, yellow ochre deep can be thinned to a glaze. But it's yellow ochre light that most painters prefer. The deep version is just a bit too close to brown, unless that's what you want.

Raw Sienna. This is another tannish yellow color, both earthy and semitransparent. It looks like a darker version of yellow ochre, and many painters prefer it for that added darkness. White yields a lovely golden tan, and painting medium produces a muted golden tone.

Gold Ochre. Available in opaque and transparent forms, gold ochre is darker than yellow ochre light and a bit sunnier, as if it contained a touch of orange. Some painters prefer it for that additional hint of warmth, though most prefer vellow ochre light precisely because it's more subdued. Like the other yellow ochres, gold ochre needs white to reveal its full character.

Mars Yellow. Really a member of the same family as the ochres, Mars yellow is more powerful in mixtures and a bit stronger in color. White brings out a particularly rich, golden tan. Painting medium brings out a surprisingly luminous glaze. Frankly, I have difficulty telling vellow ochre light and Mars yellow apart, except for tinting strength. And one of the virtues of yellow ochre light is its limited tinting strength.

Strontium Yellow. This color may be important to you if you want a somewhat colder yellow than you can get among the cadmiums. Placed side by side with cadmium yellow light, for example, strontium yellow has a remote suggestion of green. It grows icier as you blend it with white and turns to a fascinating, almost ghostly tone with a lot of white. Although it's opaque, strontium yellow produces a lovely, delicate glaze when thinned with painting medium. Since it's virtually impossible to cool down a warm yellow (like cadmium) without destroying it, it may be wise to have a cool yellow on hand, if only for occasional use.

Hansa Yellow Light. This color deserves to be "discovered" by many more painters. Like strontium yellow, hansa yellow light is on the cool side, but it has a very valuable additional feature: it's clear, transparent, and exceptionally luminous-radiating inner light. It's excellent for glazing, of course, and white produces a particularly fascinating, delicate tone. But there are also many mixtures in which hansa yellow light, despite its moderate tinting strength, really outshines the more powerful cadmium yellow light. In contrast with the opaque cadmium, the transparent hansa lends a special glow to greens and oranges.

Hansa Yellow Medium. Warmer than the light version, hansa vellow medium is darker but still luminous and transparent, and it produces a glowing glaze. Mixed with white, it yields a warmer tone than hansa yellow light. Since the two most widely used yellows-cadmium yellow light and yellow ochre-are both opaque, a transparent yellow can be a particularly valuable addition to the palette. Although most painters would call the hansa yellows optional, you might find one of them essential once you get used to having it within arm's reach.

Naples Yellow. This beautiful, neglected hue comes under the optional heading, but it's habit-forming once you try it. Used straight from the tube or mixed with white to a very pale tone, Naples yellow has a combination of richness and softness which is hopeless to describe. In landscape painting, for example, when you want a rich color that stays in its

The Rapids by Walter Elmer Schofield, oil on canvas, $50^{1/4}$ " \times $60^{1/4}$ " (127 × 153 cm), National Museum of American Art, bequest of Henry Ward Ranger through the National Academy of Design. Because water takes its color from its surroundings—especially the sky—an overcast day means subdued color in the water. In this winter landscape, the stream reflects the cool tones of the sky, the warmer hues of the river bottom, and the darks of the shoreline—punctuated by the pale snow. The artist works within a very narrow range of colors, but there's far more diversity than you might think. The closeup reveals a surprising variety of delicate greens, blues, yellows, and browns, along with warm and cool grays, all interwoven with brushstrokes that follow the lively movement of the rushing water. Notice that the snow is never dead white, but tinted with the same mixtures that appear in the water. Snow, after all, is just crystallized water.

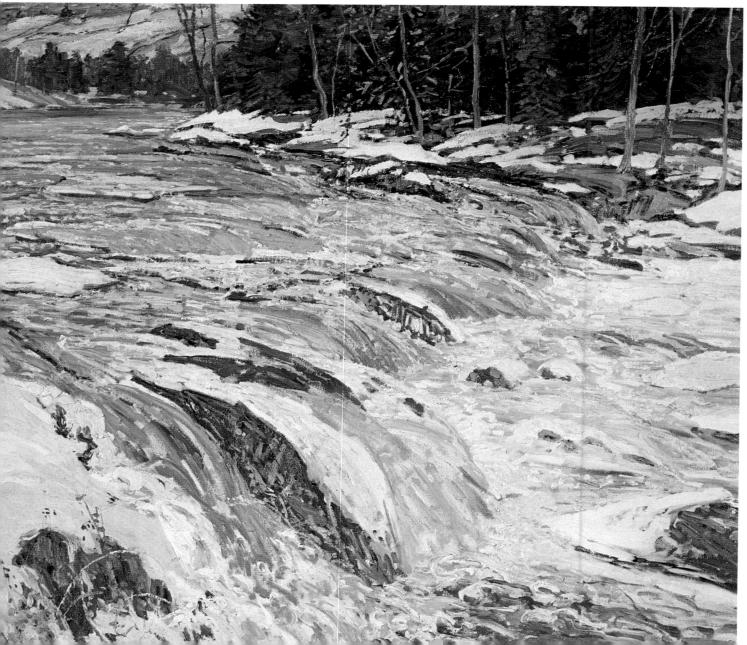

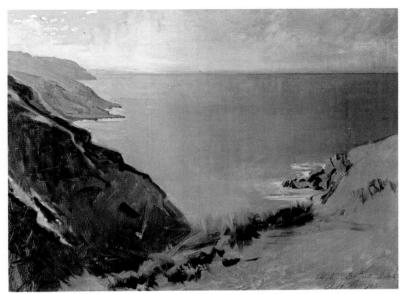

Cornish Headlands by Abbott Handerson Thaver, 1898, oil on canvas, $30^{1/8}$ " $\times 40^{1/8}$ " (77) × 102 cm), National Museum of American Art, gift of John Gellatly. A clear, sunny day means a bright, blue sky and a similar hue in the reflecting surface of the sea. The artist notes that the sky is darker at the right and therefore so is the sea. This coastal landscape is an interesting example of aerial perspective: the nearest headland is darker and warmer than the more distant headlands, which are paler and cooler. However, Thayer makes a surprising decision about the most distant headland at the upper left: he brightens the color with a hint of pink to accentuate the contrast with the cooler tone of the sea. The artist paints the sea and shore very simply, with flat strokes of fluid color applied rapidly and not overworked. The sea and sky are a fairly smooth, even tone, but the headlands are painted more roughly.

place, this opaque hue may be exactly what you need. It also lends a wonderfully soft warmth to other colors. Bear in mind that this is a lead pigment, toxic if you get it into a cut on your hand, so handle it with care.

Greens

Some painters believe in buying greens and some don't. Perhaps because landscape painters want them, color manufacturers produce a fair number of greens, but I'm on the side of the painters who say you can mix more interesting greens than you can buy. The only greens that may be worth buying in tubes are those that have some special quality which is hard to mix. I think there are four worth considering.

Viridian. A bright, cool, transparent green, viridian is excellent for glazing. Because its tinting strength is considerably less than the powerful phthalocyanine green, viridian behaves well in mixtures, and it's easy to control. Although it's a blackish green when it comes straight from the tube, a bit of white converts it to a clear but not too intense tone: more white makes it both lighter and brighter. However, viridian looks most vivid in a glaze because of its natural transparency. Too many ready-made greens look garish or sour; viridian avoids all extremes. It's probably the most useful green you can buy in a tube.

Chromium Oxide Green. This green is opaque, earthy, and perhaps a bit smoky looking. It's a grayish olive tone which lends itself beautifully to atmospheric landscape effects. Chromium oxide green has surprising tinting strengthsomething you don't expect because of the subdued color-and you've got to be careful about how much you add to a mixture. Adding white produces a variety of smoky greens, all of them fairly grayish and a bit mysterious. There's not much point in thinning chromium oxide green to a glaze because this destroys its essential character. It's hard to mix such a subdued green without producing mud, so a lot of painters like this tube color.

Phthalocyanine Green. This color is in the same family as phthalocyanine blue and quinacridone red-all very bright, transparent, stunning colors with great tinting strength. Unlike so many other colors, phthalocyanine green retains its brightness even when mixed with white, though it's even more brilliant when used transparently. Because of its ferocious tinting strength, this green can be hard to control in mixtures, and this unpredictability gives a certain edge to viridian. But certainly phthalocyanine is the most spectacular green you can buy. Grumbacher calls it thalo green, a term now in general use, while Winsor & Newton calls it Winsor green.

Green Earth. Often called by its French name, terre verte, this green is valuable precisely because of its limitations. It's a soft, very subdued, transparent green with unusually limited tinting strength. Add white and you get a very remote, atmospheric, grayish green which many painters find useful not only in landscape painting but also in cool flesh tones. Used as a glaze, green earth is a delicate olive. Its exceptionally low tinting strength is often a virtue: there are many times when you want to soften a bright color without destroying the hue, and green earth can be good for this purpose.

Violets

The tube color you're least likely to see on most painters' palettes is violet. Most ready-made violets look cheap and garish, I'm afraid, in contrast to the far more subtle and diversified tones you can get by mixing various blues and reds. But if you feel strongly about having violet on your palette, here are some that you might want to try.

Cobalt Violet. Semitransparent cobalt violet leans a bit toward the red side as it comes from the tube, and it grows cooler as you add white. When you add a great deal of white, the mixture leans much further in the blue direction. Thinned with painting medium, cobalt violet produces a clear, not too garish glaze.

Cobalt Violet Deep. This is a darker, bluer version of the same color. The blue tone becomes more apparent as you progressively add more white. A lot of white gives you a very clear, delicate blue-violet. Because cobalt violet deep is semitransparent, it lends itself reasonably well to glazing.

Manganese Violet. Similar to cobalt violet deep, manganese violet is just a bit warmer, particularly when you add white. It's semitransparent and produces an attractive glaze when you thin it with painting medium. Like both of the cobalt violets, manganese is bright and clear without being gaudy.

Quinacridone Violet. This recently developed, transparent, brilliant color is in the same family as quinacridone red and quinacridone crimson. It produces a vivid, luxurious glaze and yields bright, opaque tones when mixed with white. The color is so strong that white doesn't demolish its brilliance unless you add a great deal. This is one of the warmer violets, though it has the same tendency to cool down when a lot of white is added.

Thioindigo Violet. Here's another recently developed color which behaves in pretty much the same way as quinacridone violet. It's bright, transparent, vivid in a glaze, and fairly intense even when mixed with white. The hue definitely leans toward the red side.

Mars Violet. Because it's so subdued, Mars violet is particularly interesting in contrast to the brilliance of the other violets. At first glance, Mars violet looks almost brown, or perhaps a grayish lavender. The violet tone comes up more distinctly when you add white. Although Mars violet is opaque, it produces an interesting, smoky glaze quite unlike any of the others in this color family. Like all the Mars colors, this one has more tinting strength than you might expect, particularly in view of its subtlety. If you've been looking for a restrained violet, this is it.

Browns

Perhaps this category should be called browns and red-browns, since certain colors on this list could just as easily be placed in the red category. The colors below could also be lumped together under the heading of earth colors. All of them were once dug out of the ground, though they're now made in the modern chemical laboratory. Even the recently developed Mars colors are generally classed as 20th century equivalents of the ancient earth hues.

The earth colors are so inexpensive and so versatile that it's tempting to have lots of them on the palette or in the drawer for occasional use. They were the basic colors of the old masters, who knew that they were the most permanent pigments available at the time-and you could still get along almost entirely with earth colors if you had to. More about this in Chapter 6, "Palettes and Color Schemes."

Burnt Umber. This brown is the one most widely used by oil painters. It's dark, opaque, neither too warm nor too cool, and ideal for your basic brown. Straight from the tube, it's so dark that it looks almost black, but adding various degrees of white produces all sorts of warm, subdued shades. When you thin burnt umber to a glaze, it surprises you by becoming much warmer and more luminous. Its tinting strength is just enough to lend itself to all sorts of mixtures without overpowering them.

Raw Umber. Although it looks blackish straight from the tube, this color turns out to be a particularly subtle brown when mixed with white. I find that there are great differences between the raw umbers of various manufacturers. Some are decidedly yellowish, while others are grayer or even carry a hint of green. Even though raw umber is opaque, it can be thinned to a glaze which often looks like a subdued yellow. Depending upon the brand you buy, adding white can produce a smoky, yellowish tan or a warm gray. Because of its subdued color and moderate tinting strength, raw umber can be added to a variety of mixtures for subtle color effects.

Burnt Sienna. A brilliant reddish brown, burnt sienna is listed by some manufacturers as transparent and others list it as semitransparent or even semiopaque. The more transparent, the more useful it turns out to be because burnt sienna makes luminous glazes. Por ait and figure painters like it for vital flesh tones. Like all the brighter earth colors, burnt sienna is intense without popping out of the picture.

Shinnecock Hills by William Merritt Chase, ca. 1895, oil on canvas, $34^{1/8}$ " × $39^{5/8}$ " (87 × 100 cm), National Museum of American Art, gift of William T. Evans. Just as Winslow Homer's problem (page 27) was to find a way of linking sea and shore, Chase's problem in this sunny landscape is to find a means of linking the cool tone of the sky with the much warmer hues of the ground below. The clouds become the connecting force. Chase warms the clouds by blending in delicate touches of the ground colors. This is more evident in the shadowy undersides of the clouds, as you see in the closeup. Notice how Chase also brushes warm, wispy strokes into the sky just above the horizon, where the sky is naturally warmer and paler than the zenith. Study the blue patches closely and you make an interesting discovery: there seem to be warm touches peeking through the blue-particularly around the edges of the clouds-suggesting a warm undertone behind the cool sky color.

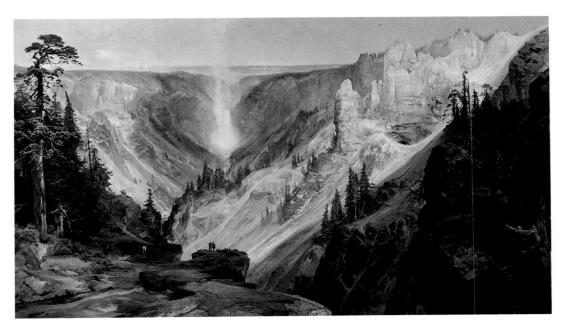

The Grand Canyon of the Yellowstone by Thomas Moran, 1893–1901, oil on canvas, $96^{1/2}'' \times 168^{3/8}''$ (245) × 428 cm), National Museum of American Art, gift of George D. Pratt. Moran uses aerial perspective to compose this vast panorama. The strong darks of the foreground frame the paler, sunlit slopes beyond. The falls are the focal point of the picture, of course, and the artist draws our attention here by contrasts of value and color temperature. He darkens the cliffs on either side of the pale, misty falls to create a strong contrast of light and dark. Then, at the base of the waterfall, he paints the small patch of river with a bright, cool tone that contrasts sharply with the surrounding warmth of the slopes. In the closeup, you see how Moran establishes a clear sense of space in this vast and complex landscape. He divides the landscape into zones of different colors and values: cool darks in the immediate foreground; warmer, slightly lighter tones just beyond; pale, warm tones in the middle distance; and cooler, shadowy mixtures as we approach the horizon.

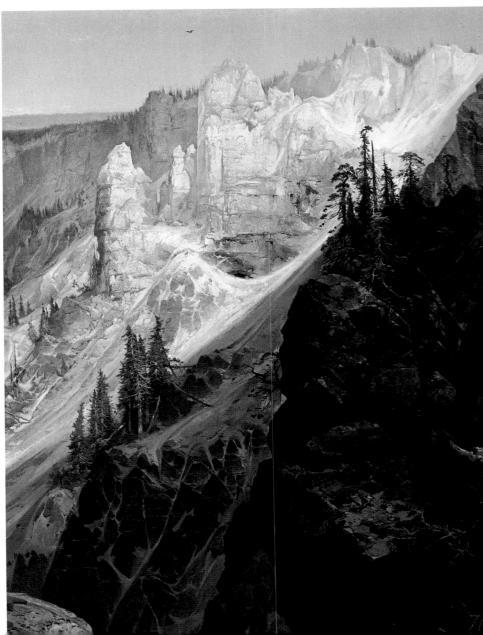

Straight from the tube, burnt sienna looks uninteresting, but white brings out a variety of beautiful coppery tones.

Venetian Red. This rich, opaque red-brown brightens to a coppery tone when mixed with a little white; it turns to a lighter, pink-brown when you add more white. Painting medium produces a glaze which accentuates the red side. In general, the earth colors aren't remarkable for their tinting strength, but Venetian red is an exception. It's very powerful and should be added with care.

Indian Red. Although it looks almost the same as Venetian red when it comes from the tube. Indian red is a bit darker and has even greater tinting strength. When you add white, it moves toward violet; this is particularly apparent when you add a great deal of white. The glaze also has a faintly violet hue. Both Indian red and Venetian red vary from one manufacturer to another.

Light Red. Another opaque red-brown, this color looks like a brighter version of Venetian red when it comes from the tube. White brings out a variety of coppery tones with a slight hint of violet. Light reds vary from one label to another, so some are more violet or more coppery than others. Light red is powerful and opaque, but it makes a somewhat brighter glaze than Venetian red or Indian red when you thin it with painting medium.

Mars Red. Being almost indistinguishable from light red, Mars red is coppery and opaque with a hint of violet when you add a lot of white. Nevertheless, a glaze of Mars red seems richer and more intense. The great tinting power of Mars red may throw mixtures out of whack, so add it gradually.

Mars Brown. Even though it's distinctly warmer than burnt umber, Mars brown is certainly not a red-brown. Depending upon who makes it, Mars brown can be fairly subdued-yielding dusty, slightly violet tones when mixed with white-or somewhat hotter like a murky burnt sienna. Like most browns, this hue brightens when thinned to a glaze. Be careful of the tinting strength of all the Mars colors.

As you can see, the earth browns and redbrowns vary a great deal from one manufacturer to another. Some are hotter, some are colder, and some more inclined to red or yellow. You've simply got to test out various brands before you decide what you want. Luckily, the earth colors are the least expensive you can buy, so you can splurge.

Blacks

There are half a dozen blacks and grays on sale in the larger art supply stores. I think it's silly to buy gray in a tube when you can mix so many fascinating grays with other colors. Some painters even skip black on the assumption that they can mix much livelier blackish tones from the darkest hues on the palette. However, there are times when you want to have black on hand, provided that you don't use it to muddy your other colors. There are just two blacks worth taking seriously.

Ivory Black. This is the one that most oil painters use. Mixed with white, ivory black produces lifeless, steely shades of gray. It's not completely opaque so it lends itself to smoky glazes when you thin it with painting medium. However, the main purpose of ivory black isn't to produce grays or glazes, but to develop interesting mixtures with other colors. Adding black is the worst possible way to gray down another color. Instead, think of black as a powerful, vivid color in itself which yields surprising blends when combined with other vivid colors. Because ivory black has less tinting power than Mars black, it's easy to handle in a variety of offbeat mixtures.

Mars Black. More opaque than ivory black, Mars black has far greater tinting strength, so it can be hard to handle in mixtures. Some painters like it because they say it's a bit warmer than ivory black, but I find it hard to tell the difference. If you want to use black all by itself-for linear accents, let's say-Mars black is preferable because it's denser and more opaque. Although ivory black is permanent when blended with other colors, it has a tendency to crack when applied by itself; a layer or a stroke of Mars black forms a tougher film.

Whites

Painters have been arguing about the various whites for as long as I can remember. There are three basic whites, and all of them have their virtues. Manufacturers have tried to compromise by coming up with various combinations of these whites in hopes of achieving the "ultimate" white. But there's still no agreement on the ideal white, and each artist's choice is a matter of personal conviction. Again, experimentation is the only answer. You'll use so much white in oil painting that you can easily buy a big pound tube of each and exhaust all the tubes in no time at all. By then, you'll know which one you like.

Flake White. The classic white of the old masters was white lead in one form or another. The most common white lead in America is called flake white. There's no question that the handling qualities of flake white are superior to all the others. The paint is heavier, more buttery, and more elastic than the two main competitors, zinc and titanium white. This rich, pliable body is the greatest argument in favor of flake white. Its partisans also claim that it has a warmer, richer tone than the other two-although it takes a pretty discriminating eye to see this. Partisans of flake white also claim that its dense opacity lends an inner light which preserves the brightness of other colors over the centuries. So far as permanence is concerned, flake white does form the most durable and elastic paint film, though it's fair to say that all forms of white lead yellow somewhat more than the competition. It's also true that white lead is toxic, so you should avoid getting it into a cut.

Zinc White. This white has a slightly colder, more bluish tone, so that it seems whiter than white lead. Ralph Mayer says: "If flake white is called milk white, then zinc could be called snow-white." This may or may not be a virtue; it's a matter of taste whether you like a warm white or a cool one. Zinc white is said to be nonvellowing, and it's also nontoxic. On the other hand, its consistency is less receptive to the brush, and it's much less opaque. Zinc white also forms a rather brittle paint film, so cracking could be a problem. In short, even though zinc white won't yellow, it may actually be less permanent than flake white in the long run.

Titanium White. The most opaque of the whites is titanium white, and it also has the greatest tinting power of any white pigment. In other words, when you want to lighten another color, vou'll need less titanium white than zinc or flake white. It's also nonyellowing and nontoxic, but it forms a paint film that's definitely inferior to the tough, resilient layer formed by flake white.

Titanium-Zinc White. Recognizing the limitations of all three standard whites, several manufacturers now produce combinations of zinc and titanium white which are meant to combine the virtues of both and minimize their faults. These combinations are popular and are distinctly better than either titanium or zinc white used alone. The manufacturers claim that the blend forms a nonvellowing, durable film, and the claims appear to be true. The blend also seems to have better brushing qualities and more reasonable tinting strength than titanium white, whose great tinting strength often is a nuisance.

Underpainting White. Many painters like to build up a picture in layers, beginning with a thickly textured underpainting that contains a good deal of white. Several manufacturers have developed a so-called underpainting white that dries quickly and has a particularly rich, pasty body that lends itself to bold brushwork. The white retains the imprint of the brush and can be built up to really dramatic textures. The manufacturers don't always make clear what they put into these special whites, but apparently it's a blend of titanium and zinc white, probably with a turpentine-soluble acrylic medium, which dries rapidly and forms a resilient paint film. For the top layers of the painting, you're then supposed to use one of the regular whites. However, if you paint a picture in one sitting, so it's all one continuous layer, I see nothing wrong with using the underpainting white throughout-that is, if you want bold textures and rapid drying.

Catskill Creek by Jasper Francis Cropsey, 1850, oil on canvas, $18^3/8'' \times$ $27\frac{1}{4}$ " (47 × 69 cm), National Museum of American Art, transfer from U.S. National Museum. In a sunrise or sunset, a little bright color goes a long way. In fact, the whole secret is to surround the bright colors with more subdued mixtures, as Cropsey does here. The luminous patch of sky is framed by the dark hills, shore, and clouds-and looks brighter by contrast. The dark water reflects the dark clouds overhead, not the sunlit sky, so nothing in the sky competes with the golden sky tones. The closeup shows how Cropsey blends warm color into the clouds, which reflect the sun. And just one bit of shoreline foliage (at the right) catches the sunlight.

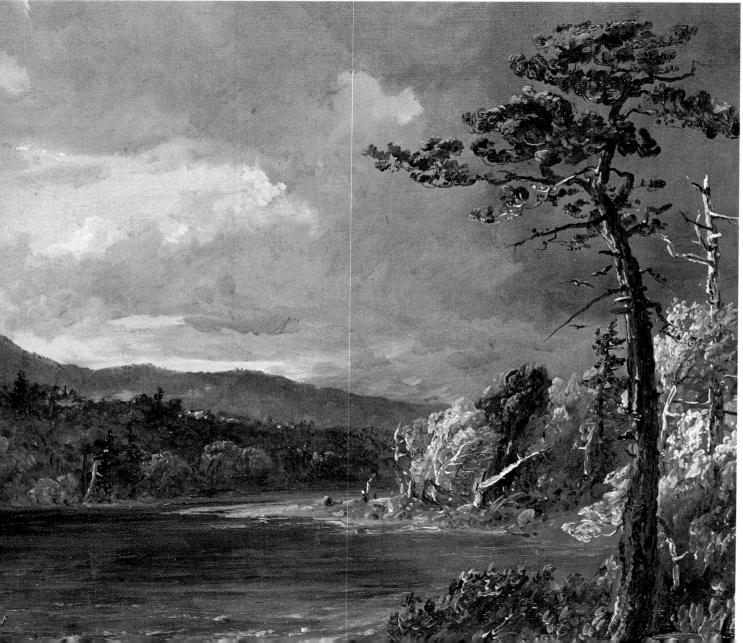

Ponte Santa Trinità by Childe Hassam, 1897, oil on canvas, $22^{1/2}$ " × $33^{5/8}$ " (57 × 85 cm), National Museum of American Art, gift of John Gellatly. Here Hassam captures an effect of early morning light, when the sun seems to filter through a delicate haze. The artist discovers a lovely abstract design in the cool shapes of the bridge and its reflection, enclosing the pale, slightly warmer shapes where the sun shines through beneath the bridge. The flickering, hazy light is conveyed by the brushwork, which you can study in the closeup. Hassam has begun by painting the bridge and water in somewhat darker colors—over which he's brushed paler strokes. The undertones peek through the gaps between the lighter strokes.

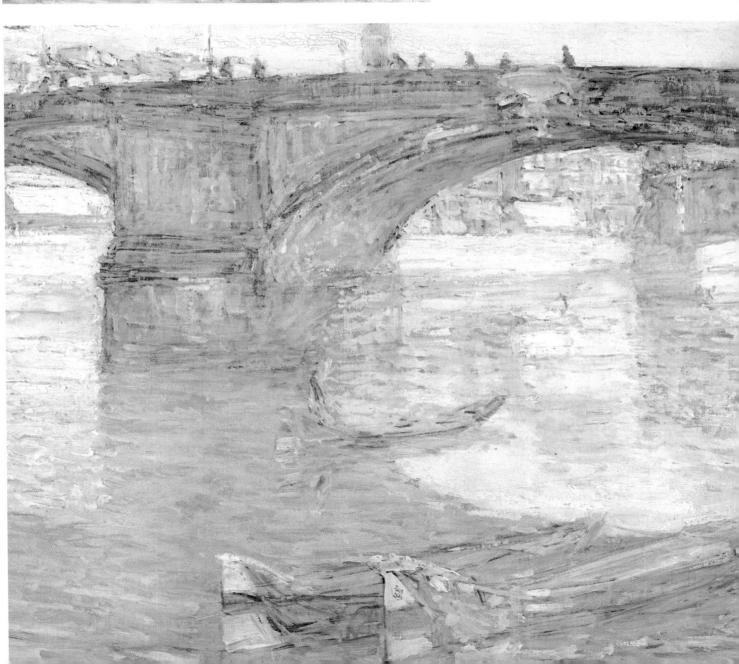

Starting with a Basic Palette

Obviously, I've given you more colors than you're ever likely to use. If you haven't been painting long enough to be sure about which colors you want on your palette, it may be helpful if I suggest a basic starter set.

Let me explain the reasoning behind the palette I'm about to recommend. First of all, every good teacher of painting seems to agree that it's better to start out with the minimum number of colors rather than the maximum, so you're forced to learn as much as you can about what each color will do. Second, if you start out with a limited number of colors and get to know them well, you then have a sound basis for comparison when you begin to add other colors and test them out. Third, it's wisest to have a good selection of primaries-which you can't mix from other colors-and hold down the number of secondaries, so you can learn how to mix them. Fourth, in selecting your primaries, it's useful to have a warm and a cool version of each. In other words, you want a warm blue and a cold one, a warm red and a cold one, and so on. Finally, it's best to begin with the conventional colors that most people use, then branch out to more offbeat colors when you know how to use the standard ones.

At the very beginning, just two blues should be enough. Ultramarine gives you a warm, restrained blue with moderate tinting strength, so you can handle it easily in mixtures with other colors. Phthalocyanine blue is at the opposite pole from ultramarine, cooler, more brilliant, and more powerful in mixtures. They're perfect foils for one another, and many professionals get along with just these two.

Alizarin crimson and cadmium red light form the same kind of pair. Alizarin is on the cool side, bright but not overpowering and easy to handle in mixtures. Cadmium red light is more opaque, more vivid and warmer with greater tinting power.

I think your subdued yellow should be yellow ochre, which leans toward tan and is easy to handle when blended with other colors. Its brassier counterpart should be cadmium yellow light, which is brilliant and has greater tinting strength.

At this stage, all the secondaries strike me as optional, but you might have viridian if you want one green on your palette. If you insist on having an orange, cadmium orange is the best choice. But skip the violets for awhile-maybe forever.

In choosing browns, follow the same logic as you did with the primaries. The best subdued workhorse brown is burnt umber, which is dark and just cool enough. For a hotter brown, burnt sienna looks right to me; it's brighter and more transparent, though its tinting strength is about the same.

Although you may want to experiment with whites later on, I'd start out with flake white because it responds so well to the brush and lends such a buttery consistency to other colors. Ivory black completes the palette.

Testing Color Behavior

You now have a basic palette of a dozen colors-if you decided to include green and orange. You've read my descriptions of various colors and how they behave. Now you're going to see for yourself whether I'm right. All my words won't really tell you what a color looks like; you've got to find that out for yourself. In some cases, you may actually decide that I'm wrong either because you've bought a different brand of color from the ones I've been using or simply because people see colors differently. In any case, don't take my word for it. Try out the following tests with the dozen colors now on your palette.

(1) Squeeze out a dab of each color on your palette. No two painters seem to agree on the sequence of colors on the palette, but one good way is to keep the cool colors at one end and the warm colors at the other. Moving clockwise or counterclockwise (depending upon whether you're right-handed or left-handed), group the blues, greens, yellows, reds, browns, and finally black. Most painters find some special spot on the palette for a big mound of white, either midway between the cool and warm colors or in its own private corner. Though you may like a richly grained wooden palette later on, I'd suggest a white, tear-off paper palette for these

tests since you can see the colors more clearly against white. Now, study all the colors on your palette to get the full feeling of the color range available even within this limited selection.

- (2) Get some scraps of white canvas too small to paint on. Or buy some cheap canvas-textured paper in the art supply store. Now take your painting knife and pick up a glob of the first color on your palette. Make a thick, solid stroke of this color on a scrap of canvas. (The value of the painting knife is that it makes a smooth stroke, uncomplicated by the texture left by the bristles of a brush.) Study this color carefully to see what it looks like before it's diluted with painting medium or lightened by white. Do the same with every other color on your palette. It's important to see that many colors don't look like much-that is, they don't reveal their true nature—as they come straight from the tube. This is particularly true of transparent colors like ultramarine blue, alizarin crimson, and viridian, which look dark and uninteresting at this stage. More opaque colors, like the cadmiums, sing out as soon as they come from the tube. In short, some colors need white or painting medium to come to life, while others don't.
- (3) Still working with the painting knife (wipe it clean before each stroke), mix each color on your palette with just a touch of white. Then knife a solid stroke onto that scrap of canvas once again, compare these new patches of color with those in Step 2. Colors like ultramarine blue and alizarin crimson suddenly reveal themselves, while others, like cadmium red, begin to drop off from their peak of brilliance. In fact, if you look very closely, you'll see that the more brilliant hues actually change color slightly when you add white. Study how each color on your palette changes when that first touch of white is added.
- (4) Now go back and add even more white to each color on your palette. Observe the changes that take place as the percentage of white in the mixture is increased. Some colors actually become more luminous. This is particularly true of cadmium yellow light and the other members of the yellow family. Other col-

- ors reached their peak of brilliance in Step 3 and now begin to taper off, like the blues. And many change color temperature, becoming warmer or cooler. Some reds seem to get cooler while some blues look a bit warmer. White, after all, is a color, and it has its own special effects on every mixture.
- (5) Add even more white to each color to produce a really pale tint of every one. All the colors become much lighter, of course, but further changes take place in hue, temperature, and intensity. The reds look a lot colder, for example. For some reason the yellows look brighter and brighter as you add more white. A cool brown like burnt umber turns grayer, while a hot brown like burnt sienna moves more toward orange. However, at a certain stage the white really takes over, and most colors begin to lose their identity. It's important to know just where this point is for every color.
- (6) Buy a a small bottle of painting medium, preferably a lightweight blend of damar or copal varnish with linseed oil. (I like Taubes copal painting medium light, made by Permanent Pigments.) You'll also need a bristle brush, about 34" or 1" wide. Now, with your brush paint a dab of each color on the canvas, allowing a couple of inches between colors and making sure that the brush is absolutely clean when you shift from one color to another. Pick up some painting medium on the brush and scrub it into the lower half of the pure color, working downward so you get a gradation from dark to light. This gives you a chance to see what each tube color looks like when it's diluted to transparency. (I don't suggest that you use pure turpentine for this operation because your color will look more luminous if you use painting medium.) You'll notice two things: first, most colors look more brilliant when they become transparent, allowing the white light of the canvas to shine through like sunshine through a pane of colored glass; second, delicate changes in the actual color take place as it becomes more transparent.

If you've performed these exercises slowly and watched carefully, you'll know a great deal more about each color than when you started. It's critical to know what happens to a color

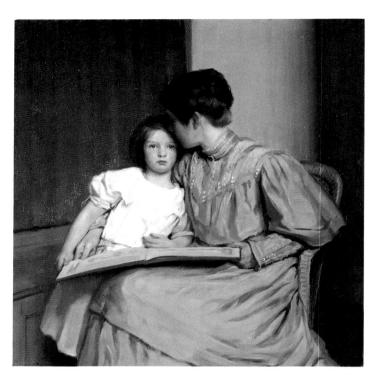

An Interlude by William Sergeant Kendall. 1907, oil on canvas, $44^{1/8}$ " $\times 43^{1/4}$ " (112 \times 110 cm), National Museum of American Art, gift of William T. Evans. The warm but delicate colors of the two heads are dramatized by an extremely subtle color scheme. The background and the mother's dress are so subdued that nothing competes with the blooming skin tones, and so those few warm touches on the cheeks, lips, and ears really sing out. The white dress, framed by the dark rectangle at the left, carries your eye directly to the little girl, who instantly becomes the center of interest. The closeup reveals far richer color than you see at first glance. The mother's dress is filled with varied strokes of warm and cool color—and notice how the artist places a single cool stroke at the neckline to make the skin glow by contrast. The glowing tone of the skin is also heightened by the surrounding darks of the hair and the shadow where the two heads meet. Study how the artist links the figures to the background by working some of the background colors into the hair, the mother's dress, and even the shadows on the child's sleeve.

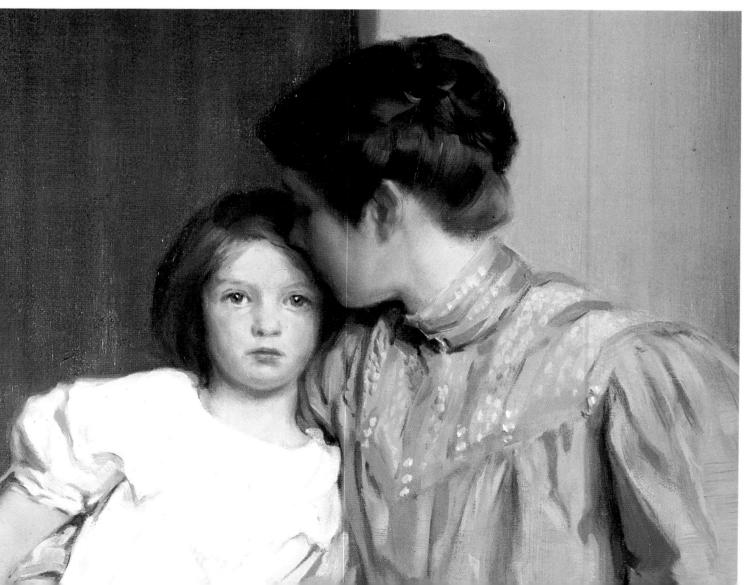

The Serviceman's Wife by Ivan G. Olinsky, ca. 1942, oil on canvas, $36'' \times 30^{1/8}''$ (91 × 77 cm), National Museum of American Art, bequest of Henry Ward Ranger through the National Academy of Design. This portrait consists mainly of warm and cool neutrals, punctuated by a few carefully placed areas of brighter color. The warm tones of the head are heightened by the cooler, more neutral color of the wall and the cool shadows on her blouse. The warm colors of her arms are likewise surrounded by neutrals, as are the vegetables in the wooden bowl, the fruit on the shelf, and the flash of sunlight on her skirt. Notice how the fruits echo the hues of the face, arms, and skirt. The girl's head-which you can see more clearly in the closeup—is also a wonderful combination of warm and cool mixtures. The cool shadows intensify the warmer colors on the lighted side of the face and neck. The color of the blouse is reflected on the shadowy edge of the jaw and on the nostril. Like the white dress of the child on the opposite page, the young woman's white blouse carries your eye directly to the center of interest.

when you add white, since white enters into practically every color mixture in a painting. And it's equally important to know what happens to a color when it becomes transparent because brushstrokes vary in density even when you think you're painting opaquely. These experiments also teach you how to use white and how to use transparency to bring out the maximum color potential of every hue.

Of course you've only scratched the surface so far. There's still a great deal to learn about the behavior of each color in the hundreds of other mixtures that are possible in a painting. I'll talk about color mixing in the next chapter and suggest a series of projects similar to the ones you've just done.

Adding More Colors to Your Palette

Having learned all you can about this basic palette of a dozen colors-which also means trying out the color mixing exercises in the next chapter-you then may want to go back and try out additional colors. Which ones should come next when you want to enlarge your palette or try dropping one color in favor of another?

Among the blues, I'd try cerulean and cobalt next. Cerulean is such a marvelous color for landscape painting that you may find it indispensable once you try it. Cobalt is a bit like ultramarine, though softer and less versatile. It's good to know what cobalt will do, but it won't replace any of the stronger blues. Last, I'd try replacing thalo blue with Prussian just to discover the difference between them; you might actually find that you prefer the older color.

Quinacridone crimson is an interesting alternate to alizarin crimson, and the switch might be instructive. Both are bright, transparent colors designed to do somewhat the same job. If you want to add a transparent red to your palette, quinacridone red is worth trying, though it won't replace the more opaque cadmium red light. Cadmium scarlet (or cadmium vermilion) is occasionally useful for a vivid redorange, one of the rare tertiaries that's helpful to have around.

Strontium yellow with its cool, lemon-yellow tone is unlike either of the basic yellows I've suggested for you; you may find that you'll want to add it permanently to your palette. Naples yellow is worth trying next, particularly for landscape painting. The two hansa vellows are important to try because they provide a transparent yellow for your palette.

It's interesting to substitute thalo green for viridian. Both are bright, transparent colors, but thalo is far more powerful and produces especially vivid mixtures. Chromium oxide green is important to know about for landscape painting.

If you don't think you can get along without violet at this stage, experiment with one of the subdued cobalts and then the more dazzling quinacridone or thioindigo.

You may want to add an opaque red-brown to your palette, since neither burnt sienna nor burnt umber fills this bill. Venetian red or light red would be the best candidate. Also try substituting raw sienna for yellow ochre. Finally, test out raw umber.

All the other colors described in this chapter come under the heading of "to try someday when I'm in the mood." But add new colors one or two at a time. Before you decide how you feel about them, subject them to the six tests I described a moment ago, and then try them out in the mixing tests I'm going to describe in the following chapter.

How Colors Behave in Mixtures

Now you know how your tube colors look when they come straight from the tube, when they're mixed with various quantities of white, and when they're diluted with painting medium. Your next step is to find out how these colors behave in mixtures with one another.

It's not enough to know simple rules like "blue and yellow make green" or "red and blue make violet." As you discovered in Chapter 2, there are lots of blues, reds, yellows, greens, oranges, violets, browns, blacks, and whites. They can be comparatively warm or cool, dark or light, opaque or transparent, subdued or intense, and weak or powerful in mixtures. Thus you'll find that blending blue and yellow yields anything from a clear, bright green to a subdued, earthy green, depending upon which blue and which yellow you choose. The possibilities seem endless. You've got to do a lot of mixing—and be willing to waste a lot of paint before all these combinations are familiar. Eventually, they become second nature and you automatically reach for the colors you want. But this takes time.

The purpose of this chapter is to speed up the process of learning how to mix colors. For each color or group of colors, I'm going to give you some fairly quick ways of learning what your colors can do and actually recording the results for future reference.

Let me warn you that this chapter is essentially a series of projects. If you do the projects systematically as you read the chapter, this could be the most valuable section of the book. On the other hand, if you don't do the projects, you may find this chapter terribly boring. The chapter is a plan of action. Don't just read it; do it! Merely reading about a color is as meaningless as reading about the smell of a rose. You've got to experience the color (and the rose) for yourself.

Recording Colors

In the last chapter, I suggested a series of rather informal tests and said that you could work on odd scraps of canvas. However, for the tests in this chapter, I think it's a better idea to work in a more disciplined way so that the various color combinations really stay in your memory.

Her Leisure Hour by Irving Ramsey Wiles, ca. 1925, oil on canvas, $27^{1/4}$ " × $22^{1/2}$ " (69 × 57 cm), National Museum of American Art, gift of John Gellatly. This is a striking example of a picture constructed with analogous colors—mixtures that have one or two colors in common. In this case, the mixtures tend to contain a fair amount of red and yellow, so the painting is dominated by browns, red-browns, oranges, pinks, and golds. Here and there, the overall warmth is relieved by a cool touch among the books, among the reflections on the floor, or in the curtain at the extreme right. Caught in a flash of daylight that comes through the window, the brilliant figure is the focal point of the picture where the artist places his strongest contrast of values, light against dark. The figure is painted with dashing brushstrokes—as you can see in the closeup—that sweep the analogous colors over and into one another with minimal blending, so that each mixture retains its vitality. As each stroke moves across another wet stroke, the action of the brush blends the colors slightlyand that's all the blending this picture needs.

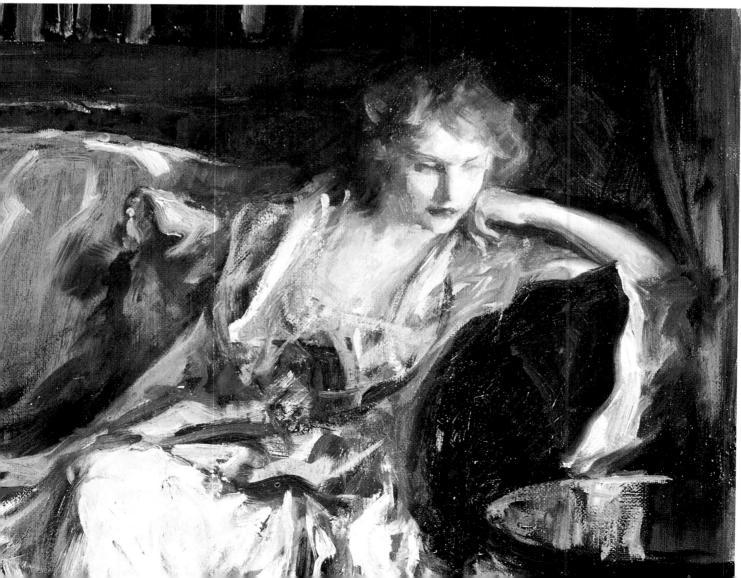

Russian Tea by Irving Ramsey Wiles, ca. 1896, oil on canvas, $48\frac{1}{8}$ " \times $36\frac{1}{8}$ " (122 \times 92 cm), National Museum of American Art, gift of William T. Evans. The figures, lamps, wall, and mirror are all painted in analogous hues—reds, pinks, oranges, browns, and golds-but two figures in green gowns introduce a complementary contrast to all those ruddy mixtures. There are also cool shadows on the tablecloth at the left and on the girl's dress at the right. Without these cooler notes, the warmth of the picture would be monotonous and overwhelming. The samovar on the table provides a link between the warm and cool colors, both of which are reflected in the shining metal. The artist's sparkling brushwork is evident in the closeup. He builds the picture with quick, distinct strokes that seem to express the flickering light of the candles. To capture the soft glow of the skin tones, he blends the women's heads and shoulders slightly. But he renders the hard materials of the lamps, mirror, and tableware with more clearly defined touches. The thick paint intensifies the bright light that bounces off the shiny surfaces.

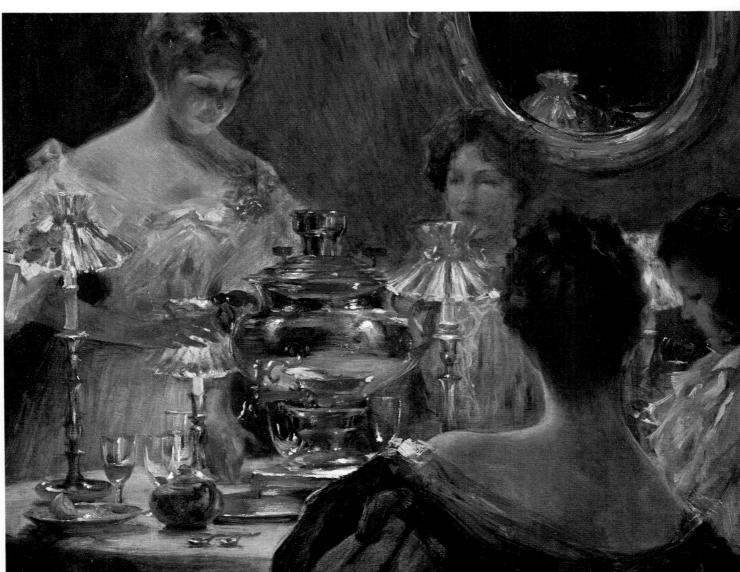

This checkerboard is the color test sheet I hope you'll use for recording the mixtures in this chapter. The actual sheet is a 9" x 12" piece of canvas-textured paper, divided into sixteen boxes. Each mixture is ap-

plied full strength on the left, then with lots of white on the right. The cryptic letters beneath each test sample are my own code for the tube colors in each mixture.

Go to the art supply store and buy a pad of 9" x 12" oil painting paper-the kind that's textured like canvas—or get some big, loose sheets of this canvas-textured paper and cut them up. You can also buy some large sheets of inexpensive illustration board. Cut them up, and give them a thin coat of acrylic gesso, which you buy in a can and thin with water to the consistency of light cream. The canvas-textured paper and the gesso-coated boards are equally receptive to oil paint.

Take the first sheet and place it before you like a sheet of typing paper, with the 9" dimension along the top and bottom and the 12" dimension along the sides. With a hard, sharp pencil, draw a kind of checkerboard on the sheet, dividing it up into sixteen boxes of the same size. Start out by making little marks about 21/4" apart along the top and bottom edges. Then make marks about 3" apart on either side. Connect up the marks with thin, cleanly drawn lines, and you've got a checkerboard of sixteen boxes, each 21/4" x 3".

Each of these boxes gives you just enough space for a daub of color with some space around it, plus some additional room at the bottom to make some notes. You'll use this checkerboard for all the tests in this chapter, so now make a couple of dozen more sheets.

In Chapter 4, I'll describe various methods of mixing color, but for the exercises in the present chapter, I'd like you to stick to one standard procedure. Do all your mixing with a palette knife on a white, tear-off paper palette. Each mixture should be completely blended so that the original colors merge and disappear completely into the new color you're creating. When the mixture is done, apply it to one of the squares on your checkerboard with the biggest flat bristle brush you've got. The color sample in the middle of the box on your checkerboard should be about 11/2" wide, surrounded by some white space. It will probably take several brushstrokes. Run all your strokes vertically, one overlapping the other so you're sure that there's plenty of paint on the surface. Don't skimp on paint.

Practically every mixture will require a small amount of white in order to bring out the full impact of the color. However, there are times when you don't need white in the mixture, so I'll tell you when to add white and when not to. Once you've painted the sample on the checkerboard, you will add white to the righthand half of the sample by picking up a brushload of pure white and blending it in. (This should also be a flat bristle brush, no more than 1/2"wide.) Thus, each sample on vour checkerboard will be divided in half: full strength on the left and a tint on the right. You're going to do this with every color sample on all your checkerboards, so you'll know how every mixture looks at its maximum color strength and when you reduce it to a tint.

A few important notes about cleanliness. Every time you pick up fresh color on your knife, be sure to wipe the blade absolutely clean with a cloth or a paper towel. Before you pick up fresh color on a brush, the brush should be absolutely clean too. Wipe off the old color on a rag or a paper towel; then rinse the brush in turpentine. You can get rid of most of the turpentine-though it doesn't matter if the brush remains slightly moist when you pick up fresh color-by running the bristles across a stack of newspapers a few times. I always keep a stack of old newspapers in the studio for this purpose. When the top page is soaked in turpentine or covered with muddy color, I peel off the sheet, and there's a fresh page beneath.

With all this color mixing, you're going to use up a lot of turpentine. For painting permanent pictures, the cheap turpentine in the paint store is chemically unsound, but there's no harm in using this for color experiments. Buy a gallon can and pour it out, one pint at a time, into a big, wide-mouthed jar from the kitchen. I find the quart-size mayonnaise or applesauce jars are particularly good. A pint of turpentine only fills them halfway up and allows you to slosh the brush around without splashing liquid color out of the jar. When the turpentine gets so filthy that it starts to muddy your colors, toss it out and start with a fresh pint.

I must admit that it bothers me to chuck out all that turpentine, and there is a way of recovering some of it. If you make a habit of collecting kitchen jars, as I do, pour the muddy turpentine into one of them, cap it, and let the turpentine stand undisturbed in the jar for a few

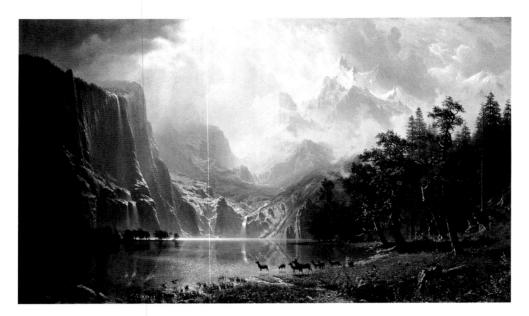

The Sierra Nevada in California by Albert Bierstadt. 1868, oil on canvas, $72'' \times$ 120'' (183 × 305 cm), National Museum of American Art, bequest of Helen Huntington Hull. The color strategy of this enormous, panoramic landscape is quite simple. Bierstadt relies on values and color temperature to guide your eye through the painting. Starting with the dark trees and cliffs of the foreground, he lightens the landscape by stages, gradually carrying you back to the focal point—the distant falls. The center of interest is bathed in warm light that pours down from the sky above the falls. And the falls are framed by the darker tones of the foreground cliffs, trees, and water. The closeup shows how the artist has linked the foreground, middleground, and distance by carrying the golden light into the trees, and by opening gaps between the trunks so that we can see the warm tones of the remote landscape. Notice how Bierstadt paints the pale, distant rocks and cliffs in flat, simple color areas.

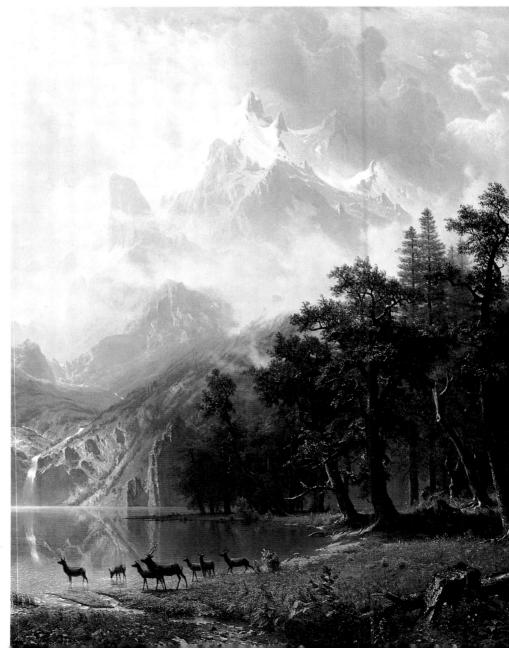

Housatonic Valley by Alexander Helwig Wyant, ca. 1880–1890, oil on canvas, $24^{1/8}$ " × $36^{1/8}$ " (61 × 91 cm), National Museum of American Art, gift of William T. Evans. In a landscape that consists almost entirely of cool color, a single note of warm color is enough to carry the eye to the center of interest. Suggesting a slight break in the overcast sky, Wyant allows a flash of sunlight to come through and fall on the dark, cool color of the meadow. To tie this warm color into the rest of the landscape, he adds a few warm touches at the horizon, between the dark trees, and among the foreground grass. The closeup reveals that the artist has done a lot of loose, spontaneous color mixing right on the canvas.

days. Most of the color will settle to the bottom, leaving the turpentine only faintly tinged with color. If you remove the cap gently and handle the jar very carefully—so the color isn't stirred up-you can pour about two thirds of the nottoo-dirty turpentine into a clean jar and toss out the old one, which retains the muck that's settled to the bottom. I realize this means wasting some good jars, but you do save turpentine, which you can reuse.

Before you start applying color samples to the checkerboard, perhaps you'd better work out some kind of system for recording the colors and the mixtures in your various boxes. The shape of each box allows a bit of white space around each color sample with some extra white space at the bottom for writing the names of the colors. Actually, there won't be room to write in the full names of all the colors unless you've got very tiny handwriting, but you can work out some abbreviations. Mine are just the first initials; UB for ultramarine blue, TB for thalo blue, CRL for cadmium red light, AC for alizarin crimson, CYL for cadmium yellow light, YO for yellow ochre, V for viridian, CO for cadmium orange, BU for burnt umber, BS for burnt sienna, IB for ivory black, and FW for flake white. It gets a bit more complicated when you're working with colors like cobalt blue and cerulean blue, both of which have the same initials; I solved this by calling them COB and CEB.

Below each color on the checkerboard, I pencil in the initials of the colors, starting with the dominant color in the mixture. UB+ YO+ FW means that the mixture is mostly ultramarine blue, modified with smaller quantities of vellow ochre and flake white. Label each of your color samples in this way or any other way that makes sense to you. But work out a consistent labeling system in advance so you don't get confused later on.

Now that you've got your recording procedure clearly in mind (I hope), you're ready to start your first series of color tests.

Broadening the Range of Blues

Blue is a primary color, of course, so you can't mix it by combining other colors. But this doesn't mean that you're stuck with the handful of blues provided by the manufacturers. By adding small quantities of other colors, you can expand a couple of tube blues to an extraordinary range of blue tones, as rich and varied as any other color family.

Let's begin with the assumption that you're staying with the starter palette which includes just two blues-ultramarine and thalo. This gives you one fairly subdued, warm blue and one cool, brilliant blue. With these two blues plus the other ten colors on the palette, you're now going to run a systematic series of tests to discover how many blues you can create.

- (1) The first thing you want to find out is what your two blues will do to one another. Since one is warm and restrained while the other is cool and aggressive, there must be several compromise tones between them. What happens when you add a touch of thalo blue to a larger quantity of ultramarine? Try this with your palette knife, mixing the two blues on your tear-off paper palette. Then add a touch of white to bring out the color; both these blues are transparent and murky when they come straight from the tube. When the mixture is finished, paint a patch of color in the center of the first square on your checkerboard. Now study what you've got. If you added too much thalo, it overwhelms the ultramarine-which has much more limited tinting strength-and the cool tone of the thalo takes over. Either way, you'll learn something worth remembering.
- (2) If you added just a little thalo blue the first time around, now go back and make a second mixture, adding more. On the other hand, if you added too much thalo the first time, be sure to add less to the second mixture. Again, add some white, though not too much. Clean your brush and apply a daub of the second mixture in the second box on your checkerboard. Compare the two mixtures.
- (3) Pick up a smaller brush and dip it into pure white. Blend this white into the right-hand half of the first color sample on your checkerboard. Clean the brush, pick up some more white, and do the same thing to the second color sample.

Now each sample is divided in half: full strength and a tint.

- (4) Reverse the process. This time, add a touch of ultramarine to a larger quantity of thalo, still remembering to add a small amount of white to bring out the color. Brush this sample onto your checkerboard, and blend pure white into the right hand half of the sample. Try it again with even more ultramarine. Now study your four samples, and you'll begin to see that there are various intermediate tones between your basic blues, all of them cooler than ultramarine but warmer than thalo. It may take a practiced eye to see the differences, but they're there.
- (5) Everyone knows that you're supposed to produce green if you add yellow to blue. But this takes a fair amount of yellow. A much smaller amount of yellow only modifies the blue without turning it green. For example, add a small amount of yellow ochre to each of vour basic blue: ultramarine and thalo. (Don't forget to add some white to bring out the color.) Here's where the limited tinting strength and subdued intensity of yellow ochre pay off; the vellow won't overwhelm either blue. The affect on ultramarine is to make it much softer, grayer, dustier, and more atmospheric. Thalo moves a step closer to green-perhaps more like cerulean blue-and it exchanges its electric quality for a certain softness that's closer to what you want in a remote sky tone. Record both these mixtures on your checkerboard, and be sure to blend some white into the right-hand half of the sample.
- (6) Doing the same thing with cadmium yellow light is trickier since this is a bright yellow with high tinting strength. Powerful thalo blue withstands the cadmium more easily than the weaker ultramarine. In both cases, however, add very tiny amounts of yellow plus some white, and see what you get. The ultramarine mixture is more subdued, as usual. As you blend thalo blue and cadmium yellow light, you'll learn one of the basic lessons of color mixing: it's easier to handle two hues of roughly equal tinting strength than it is to handle a weak color in combination with a strong one. The weak one is often the loser.

- (7) Modify each of the blues with a touch of each basic brown-burnt umber and burnt sienna-plus some white. Both browns push the blues a step closer to gray, though each of your mixtures will be subtly different. The lesson here is that earth browns gray down a color much more effectively than black, adding a certain warmth which brings a new dimension to the mixture. These blue-brown combinations are especially valuable to the seascape painter, who needs the widest possible range of grayish blues. Blue-brown combinations are ideal for those brooding, leaden skies in paintings of stormy weather; for the shadowy undersides of clouds; and for reflections on wet rocks.
- (8) Next come the reds. If you don't add too much, cadmium red light and alizarin crimson (plus some white) will warm both blues without turning them purple. Here's where you begin to experience the fascinating unpredictability of colors. A touch of dazzling cadmium red light actually grays down ultramarine blue, pushing it more toward gray than toward violet-the "usual" product of blue and red. Thalo blue, on the other hand, turns deeper and richer when you add a hint of cadmium red light. Alizarin crimson, which has roughly the same tinting strength as ultramarine blue, warms the blue and won't gray it down quite so much. For some reason, it's thalo blue that seems to lose some intensity when modified with alizarin crimson. These are the surprises that you'll want to record on your checkerboard and put to work for you in a painting some day.
- (9) You have just one green on your starter palette, and viridian is a good modifier because it's not terribly strong. Viridian cools and brightens both blues; this becomes particularly apparent when you add a fair amount of white, producing delightful sky colors.
- (10) If you remember your color wheel, you recall that orange is the complement of blue. Theoretically, cadmium orange-the one orange on your starter palette—should gray down both blues. Bearing in mind that cadmium orange has greater tinting strength than ultramarine blue, add a very small quantity of orange

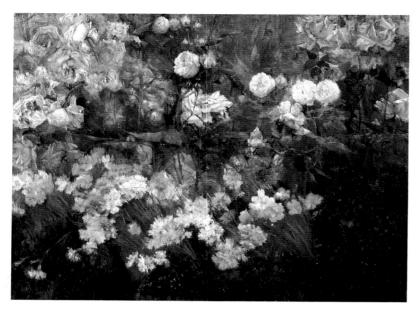

Garden in May by Maria Oakey Dewing, 1895, oil on canvas, $23^{5}/8'' \times 32^{1/2}'' (60 \times 82 \text{ cm})$, National Museum of American Art, gift of John Gellatly. Against the dark background of green leaves and stems, the flowers stand out as distinctly lighter notes. The white flowers are cooler than the warmer blossoms in the upper right and left corners. However, the brighter mixtures appear in just a few pink flowers at the center of interest. Seen from a distance, the painting seems to be filled with detail. But the closeup reveals that most of the brushwork is actually quite loose. The artist wants to tie the blossoms to the cool background tone. So she paints all the blossoms with some rough edges, and then blends a bit of background color into the petals.

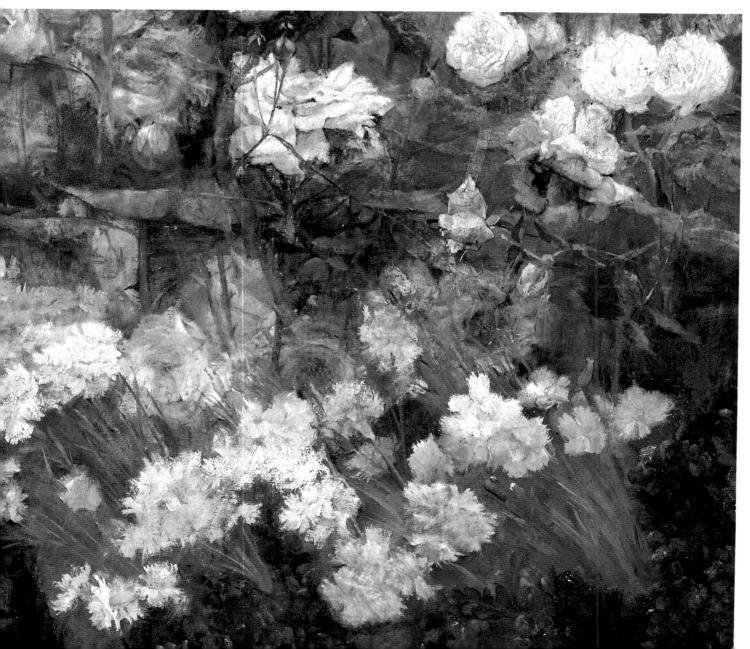

Melons and Morning Glories by Raphaelle Peale, 1813, oil on canvas, $20^{3/4}'' \times 25^{3/4}''$ (53 × 65 cm), National Museum of American Art, gift of Paul Mellon. The red of the watermelon seems even more intense because there's some green nearby in the leaves and the melon rind. The whiteness of the melon is also accentuated by the surrounding darks of the background and rind at the right. Thus, we have a contrast of values and complements. The artist softens the harshness of these contrasts by introducing a secondary color: the orange melon in the foreground. The extraordinary luminosity of the color—most apparent in the closeup—is produced by the character of the paint itself. The artist has worked with thin layers of translucent and transparent color, brushed smoothly over the canvas. The light literally passes through the paint and bounces back at us from the painting surface—like light through colored glass.

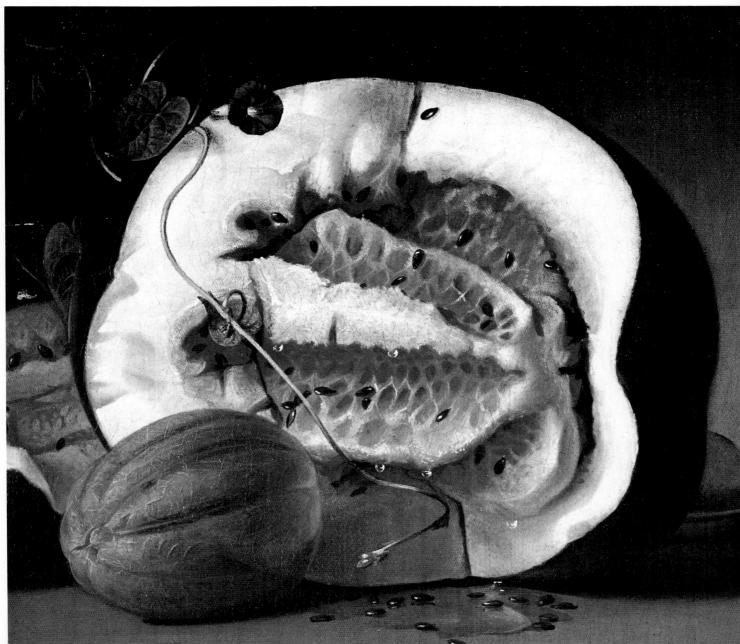

(plus some white) to the blue. As you expected, the blue does lose a degree of intensity; it becomes more "neutral" as the textbooks say. But try the same thing with thalo blue, and the mixture will surprise you by becoming cooler and richer without losing too much intensity provided that you haven't overdone the orange.

- (11) Although I've said that adding black is the least interesting way to gray down any color, you'd better try it just to see what happens. Add black and a little white and you'll see that both your basic blues turn hard and steely. I suppose there may be times when you'll want this forbidding color; sea and sky can sometimes look just as grim as a blend of blue and black.
- (12) Once you get beyond the colors on your starter palette, there are other hues that will produce interesting modifications in your two basic blues. Experiment with muted greens like green earth and chromium oxide green, but watch out for the powerful tinting strength of the latter. Muted earth tones like raw umber and raw sienna also produce interesting variations. So do the red-brown earths like Venetian red, light red, and Indian red, all of which are very powerful and must be added in small doses.

What's particularly interesting is the variation in colors you get by adding different amounts of white. In a sense, white is the brightest of all colors because it represents pure light. When you blend white into the righthand half of your color sample on the checkerboard, you may be astonished at the sudden increase in brilliance. Blues become bluer. This is particularly true when you add white to the more transparent colors. But like most "rules," it doesn't always work. You'll see what I mean when you work with the reds.

Broadening the Range of Reds

Now you're going to conduct a similar series of tests with the reds. Your two basic reds are alizarin crimson and cadmium red light. Both of them are bright, though alizarin is transparent

- and nothing special when it comes to tinting strength, while cadmium is opaque and powerful in mixtures. They react very differently when you add modifying colors. And the effects of white are particularly interesting.
- (1) Although both these reds are bright, you can produce an even brighter hue by mixing them together-without white. This is probably the most stunning red you can create and something you'll want to save for special occasions, like the ribbon in your model's hair. But when you add white to the right half of the color sample on the checkerboard, a surprising thing happens. In your blue tests, you found that white made most mixtures even brighter. But white cuts down the intensity of most red mixtures, and this is exactly what happens here. The resulting pink also seems cooler.
- (2) Just as you did in your blue tests, add a bit of yellow ochre (but no white) to each of your reds. Then do the same with cadmium yellow light. As you found with the blues, yellow ochre softens both reds and makes them seem more atmospheric, perhaps earthier. This is why yellow ochre is such a wonderful landscape color, both subduing and warming other colors without ever dominating them. In contrast, cadmium yellow light pushes both reds just a bit closer toward orange. Alizarin crimson, especially, will grow brighter.
- (3) You've got to exercise extreme care in adding blue to either one of your reds. Oddly enough, ultramarine blue (with or without white) pushes cadmium red light in the direction of an earthy red-brown, rather than producing violet. But both blues (plus some white) make alizarin crimson distinctly cooler and closer to violet. Thalo blue has an unexpected effect on cadmium red light, which becomes grayer and less intense. Here's one of the odd things about the cadmiums: although they're tremendously bright in themselves, they don't always produce vivid mixtures with other bright colors. The cadmiums sometimes turn murky when you least expect it.
- (4) Adding browns-like burnt umber and burnt sienna-is a good way of softening yet enriching both reds. For cooling a red, burnt um-

ber is easier to handle than any of the blues. Burnt sienna is a fairly hot brown which makes both reds seem sunnier vet earthier. Cadmium red light won't need any white in these mixtures, but the transparent alizarins always do.

- (5) The color wheel should remind you that the best way to gray down a color is to add its complementary. A green like viridian deepens and subdues both your reds without blackening them, as ivory black is inclined to do. Be sure to add some white to the alizarin-viridian mixture because both are transparent.
- (6) Among the optional colors, there are several that have particularly appealing effects on red. Naples yellow, one of my favorite optional colors, has an extraordinary way of brightening and softening all the reds without turning them orange. Hansa yellow is also an ideal brightener which won't overwhelm a red and turn it orange. The more powerful red earths—like Venetian red, light red, and Indian red-should be added in controlled quantities. It's also worthwhile to repeat some of the tests I've described above using quinacridone red and crimson instead of your two basic reds; some of the results will be similar and some will surprise you.

When you add white to these mixtures on your checkerboard, observe carefully how the hue changes. It doesn't just get lighter, but it undergoes some unexpected alterations in temperature and intensity. Many of the pinks are distinctly cooler than the full-strength reds from which they're derived. And in almost every case, there's a definite loss in brightness, quite different from the effect of white on most of the blue mixtures.

Broadening the Range of Yellows

Of all the colors on your palette, yellow is the hardest to modify without transforming it into some other hue. In conducting these tests with your two basic yellows, be sure to add the other colors in the smallest possible quantities or the yellow will suddenly disappear into a sea of brown or green or just plain mud. Add a little white to all the yellow ochre mixtures; cadmium yellow won't need it. Of course you will add white to the right-hand half of every sample on your checkerboard.

- (1) As in the blue and red tests, it's important to begin by seeing what happens when you combine the two basic yellows: cadmium yellow light and yellow ochre. Depending on how much you add of each, you get a series of compromise hues, each of them sunnier and brighter than the subdued yellow ochre, but always a bit darker and cooler than the brilliant cadmium vellow light.
- (2) In learning how to modify the two basic yellows-or how not to-it's probably best to start with miniscule quantities of the two basic browns, the cooler burnt umber and the warmer burnt sienna. As you might expect, both browns will darken cadmium yellow light, but burnt sienna warms the mixture while burnt umber cools it. Burnt umber (raw umber, too) produces a distinctly cooler, mustard tone. Since yellow ochre starts out on the tan side, both browns push it further in that direction and it's debatable whether these mixtures can be called yellow at all; they're in some noman's land between yellow and brown. You're already beginning to discover how difficult it is to mix anything with yellow without a distinct loss in warmth and brilliance. However, these mustard and yellow-brown tones are vellows of a sort, and they do have their uses.
- (3) You'll have similar problems when you try modifying yellow with the basic reds-cadmium red light and alizarin crimson-but it's worth trying. It's no surprise to discover that cadmium red light pushes cadmium yellow light a step closer to yellow-orange, still warm and brilliant. Alizarin crimsom has somewhat the same effect, but the mixture is slightly cooler and more subdued. Oddly enough, yellow ochre gets slightly pinker under the influence of either red; this is particularly apparent when you add a good deal of white. This is an important lesson about yellow ochre. Because it quickly loses its identity in mixtures, yellow ochre is almost impossible to modify, but it makes an ideal modifier for other colors.
- (4) Adding cool colors to the basic yellows is even more difficult. Thalo blue has so much

The Falls of the Schuylkill by Walter Stuempfig, oil on canvas, $18\frac{1}{2}$ " × $22\frac{3}{8}$ " (47 × 57 cm), National Museum of American Art, bequest of Henry Ward Ranger through the National Academy of Design. The artist intertwines analogous, warm colors throughout the landscape: rust, orange, and yellow. He even works a hint of orange into the cool sky mixture. Thus, the painting is unified by the presence of red and yellow in virtually every mixture. For example, as you study the closeup, you can see that orange tones shine through the ground in front of the big house. Stuempfig's brushwork is casual and scrubby. He rarely paints a smooth, solid layer of color, but applies his paint so loosely that every stroke permits some underlying color to come through. This effect, sometimes called broken color, is a splendid way to integrate the color scheme of a picture.

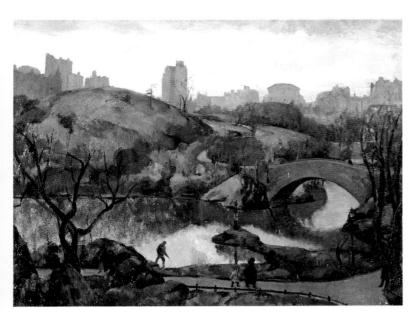

Scene in Central Park by Leon Kroll, 1922, oil on canvas, $27^{1/4}$ " \times 36" (69 \times 92 cm), National Museum of American Art, gift of Orrin Wickersham June. Kroll also unifies this urban landscape by weaving the same colors throughout the composition. For instance, the warm hues of the hill reappear in the bridge, the rocks, the foreground path, and soil—and in the reflection in the water, of course. More muted versions of these mixtures appear in the masses of trees at the horizon. In the same way, the artist picks up the cool mixtures in the hill and repeats them almost everywhere. This could become monotonous, but the sky provides a sudden change of pace—and this pale, bright color is echoed in the water. The shadows on the clouds are echoed in the buildings at the horizon. Like the painting on page 62, this landscape is also unified by broken color. The closeup shows how Kroll's scrubby brushwork lets one color penetrate another.

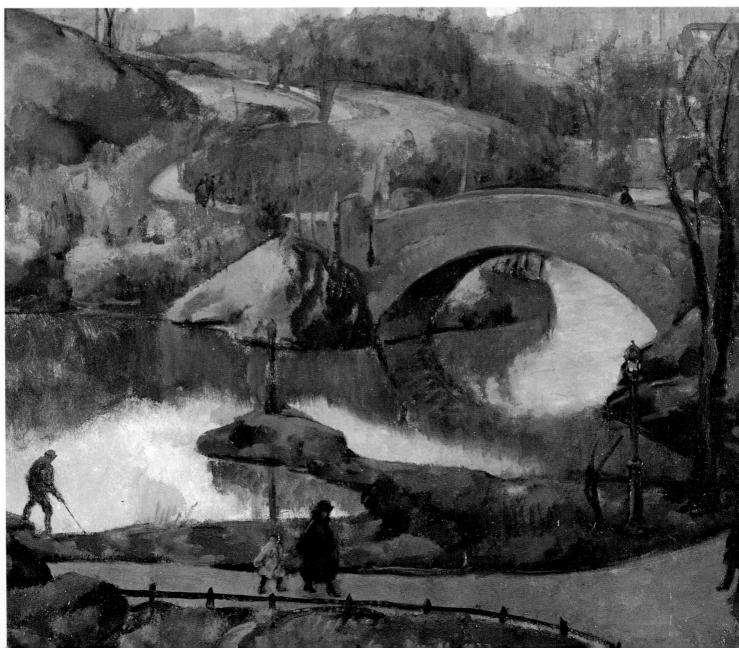

tinting strength that I wouldn't try it at all. The less powerful ultramarine blue and viridian cool and darken cadmium yellow lightyielding a greenish mustard tone-if you add them in microscopic quantities. Blues and greens push yellow ochre in the direction of olive, if there is such a thing as an olive yellow. In mixtures with yellow, black acts something like blue.

- (5) It's interesting to try some of the less powerful optional colors as modifiers for yellow. Among these would be weaker blues like cobalt and cerulean, soft earth tones like raw umber and raw sienna, and the transparent quinacridone red and crimson.
- (6) Because yellows are the most difficult of all tube colors to modify without significant changes in temperature and intensity, the optional yellows are particularly important to have on hand. Strontium, hansa, and Naples yellow all have unique qualities that can't be duplicated in mixtures. They also do interesting things to the two basic yellows. Hansa yellow light, with a fair amount of white, can make the brilliant cadmium yellow light even brighter, and it makes yellow ochre much sunnier. Naples yellow softens and brightens at the same time, even without the aid of white; it's like adding a combination of yellow and white. Strontium yellow cools cadmium yellow light without any loss in brightness, but it warms yellow ochre. The two basic yellows, amplified by these three optional yellows, produce an astonishing range of yellow tones without the aid of any other modifying colors.

Going over the color samples on your checkerboard, you've probably been struck by the fact that the lighter half-where you've added white to every sample-almost always seems much brighter and warmer than the darker half. The more white you add, the more intense the yellow becomes.

By now, you've experienced an important three-part rule about white: most blue mixtures need white to reveal their full color; red mixtures are cooled and subdued by white; and in turn, yellows are intensified by the addition of white.

Oranges, Pinks, and Off-Reds

The most fascinating and unpredictable of all the secondary and tertiary mixtures is in the territory of oranges, pinks, and reds which aren't quite red. You'll discover that red and yellow don't always make orange and that red and blue don't always make violet. Nor are mixtures of red and white the only way to make pink. In the process of trying out some of my suggestions, you're almost certain to discover delightful, accidental mixtures which you may never be able to repeat unless you record them on your checkerboard.

- (1) When I recommended tube colors in the preceding chapter, I mentioned only cadmium orange because I urged you to mix your own oranges. The obvious place to begin is by mixing cadmium red light and cadmium yellow light to obtain cadmium orange-this is the reason I list this as an optional tube of color. Don't add any white to the mixture, just to the sample on the checkerboard.
- (2) When you mix the other basic yellows and reds, the surprises really begin. Alizarin crimson and yellow ochre don't produce orange, but a kind of muted copper which turns pink when you add white. Yellow ochre and cadmium red light produce a slightly subdued, rosy tone which is also closer to pink than it is to orange. Cadmium yellow light and alizarin crimson do produce orange, but the mixture isn't nearly as brilliant as you might expect; it's slightly sombre.
- (3) For my money, the most beautiful oranges are produced by the optional reds and yellows. Cadmium red light and the luminous, transparent hansa yellows produce particularly stunning oranges. So do the hansa yellows and alizarin crimson. You can get particularly beautiful, muted, earthy oranges with combinations like hansa yellow and burnt sienna. hansa yellow and Venetian red, and other blends of yellow and the earthy red-browns.
- (4) Certain other optional colors are particularly useful for these offbeat mixtures. You may be amazed to discover that Naples yellow doesn't produce orange in combination with

the various reds, but instead develops a fascinating range of pinks and roses. Red-brown earths like Venetian red, light red, and Indian red will produce deep oranges with cadmium vellow light but move toward violet or cold pink when mixed with things like hansa vellow, yellow ochre, and other reds.

(5) At this point, the sky's the limit. Experiment to your heart's content. Try every yellow, every red, and every brown in every conceivable combination to see what you get. In particular, note what happens when you add a significant quantity of white. Bright oranges are likely to lose some of their potency, just as reds do. Coppery mixtures containing the redbrown earths have a curious way of turning pink or even violet. Combining reds like alizarin crimson and Venetian red, or light red and quinacridone crimson, yields unexpectedly rich, earthy tones, with a hint of violet when you add white. I'll stop here, but you keep going.

The point of these tests is to develop a sense of self-reliance in color mixing. You don't need a vast array of secondaries and tertiaries in tubes. On the contrary, you'll experience a thrilling sense of your own creativity by discovering the offbeat colors you can mix with your starter palette plus six or eight optional yellows, reds, and red-browns.

Creating Greens

If you've spent any time painting landscapes, you know that all the tube greens you can buy in the art supply store are hopelessly inadequate to interpret the luxurious range of greens in nature. You have to learn to mix your own greens when you paint landscapes. I think you'll be encouraged to see how many greens you can create without ever buying a tube of green.

(1) Your basic palette contains not only two blues, but a third color which can function as a kind of blue: ivory black. Begin by mixing each of these three "blues" with cadmium yellow light, the brighter of the two yellows. No white, this time. Thalo and cadmium produce the

- richest, brightest green. Ultramarine and cadmium yield something like the green of many young trees in spring: bright but much softer and more delicate. Black produces a rich olive.
- (2) Now blend your three "blues" with the softer vellow ochre, but without white. Thalo produces a deep, powerful evergreen like the pines outside the window of my studio. Ultramarine gives you a grayish olive like the shadowy tone of trees in deep woods. Ivory black turns yellow ochre into a smoky browngreen-another color which is familiar if you've spent time deep in the woods on a wet, gray day.
- (3) Your next step is to try some threesomes. Add a touch of ivory black to each of the blueyellow mixtures. For example, thalo blue and cadmium yellow light plus black gives you that wonderful blackish green you need for evergreens deep in the woods or silhouetted against the sky.
- (4) Now instead of adding black to each of your blue-yellow mixtures, add each of your warm colors: burnt umber, burnt sienna, cadmium red light, alizarin crimson, and cadmium orange. There are all kinds of warm, brownish greens in the landscape around you.
- (5) So far, I haven't even mentioned the one green on your basic palette: viridian. First try this with the two basic yellows. Viridian and cadmium yellow light give you a lovely, bright green, while viridian and yellow ochre give you a warmer olive than either of the blues. Working with very small quantities of the two basic reds and two basic browns, see what happens when you warm viridian and move it in the direction of brownish green. White is important in all these mixtures since viridian is transparent.
- (6) Many landscape painters claim that you can't experience the full excitement of mixing your own greens unless you've got Prussian blue on your palette. I'm inclined to agree. Prussian blue and cadmium yellow light produce a magnificent, vivid green which seems richer to me than the thalo-cadmium combination. With yellow ochre, Prussian blue yields a

Elizabeth Winthrop Chapman by John Singer Sargent, 1893, oil on canvas, $49^{3/8}$ " × $40^{1/2}$ " (125) × 101 cm), National Museum of American Art, gift of Chanler A. Chapman. In this portrait, the beauty of the sitter is what matters most, and all other pictorial elements are secondary. The painting is designed to focus attention on her striking head and arms. Thus, Sargent surrounds the head with a dark neutral that dramatizes the glowing color of the sitter's face. He also uses the dark tone of the dress to frame her neck, shoulders, and arms. For a change of pace, the artist places some rich, but subdued color at the left. The painting is a triumph of values: half-close your eyes and you'll see that the skin tones are the lightest and brightest notes on the canvas. The artist's color strategy is even more apparent in the closeup. Out of a sea of darkness, the sitter's skin tones come forward with powerful impact. The somber background heightens the effect of the few warm touches on the eyesockets, ear, nose, lips, and cheek.

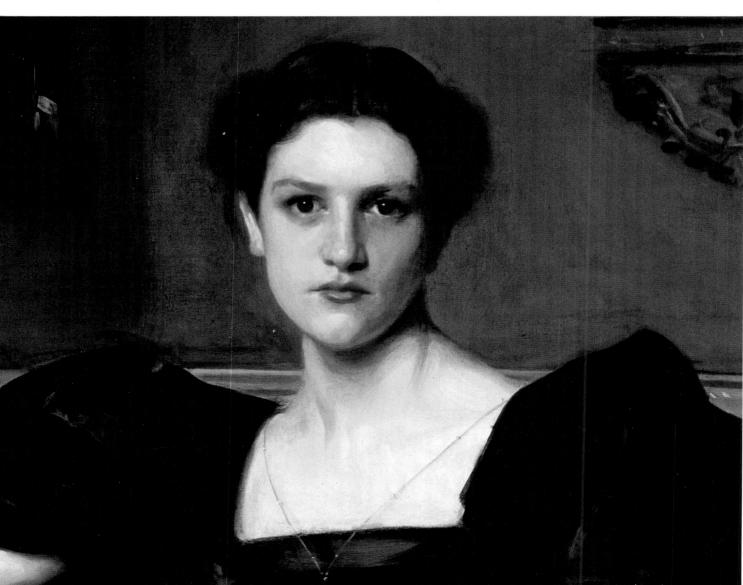

Man with the Cat (Henry Sturgis Drinker) by Cecilia Beaux, 1898, oil on canvas, $48'' \times 34^{5/8}''$ (122 × 88 cm), National Museum of American Art, bequest of Henry Ward Ranger through the National Academy of Design. In contrast with the Sargent portrait on the opposite page, this male sitter's head and hands are surrounded by rich color. Yet his warm skin tones—and the cat-stand out because the background mixtures are essentially cool. The artist draws attention to the face by darkening the background near the head, thus accentuating the light that falls on his forehead and cheek. The daylight also brightens the upper part of the jacket, near the head, while the lower part of his figure is in shadow. To integrate the figure with its surroundings, Beaux brushes a hint of warm skin color into the shadowy background near the head, and into the floor at the right. In the closeup, you can see how colorful that "white" jacket turns out to be-reflecting the cool background colors and containing hints of flesh tone. The artist also blends some cool background color into the darks of the skin, the hair, and the moustache.

magnificent, bluish green like the spruces in front of my house. Prussian blue even does something extraordinary with burnt sienna, producing a blackish tone that's deeper than any green I can think of. And when you add white to these mixtures, new subtleties emerge from the more sombre combinations. Prussian blue, burnt sienna, and white give you a distant, smoky gray-green like a wooded headland in fog. Prussian blue, yellow ochre, and white look something like the delicate new growth on my favorite evergreen. Does this sound like a pitch for Prussian blue? It is.

- (7) Two of the optional yellows—hansa yellow light and Naples yellow-will greatly enrich your range of greens. With thalo and ultramarine, hansa yellow produces even brighter greens than cadmium yellow light. Naples yellow, on the other hand, produces the delicate, remote greens you want in the distant landscape. With ivory black, Naples yellow produces an indescribable, warm gray-green.
- (8) Three more optional blues-cobalt, cerulean, and manganese-enrich your possibilities to the point where you may become drunk with power. Each of them produces a distinctly different green with each of your yellows. Cobalt yields especially soft, airy greens. Cerulean creates airy greens, too, but a little brighter than cobalt. And the wonderfully clear, bright manganese gives you greens that have a remarkable combination of brightness and delicacy.

Although I've suggested that you try six different blues in this test, I don't think you'll want them all, even for the most ambitious kind of landscape painting. But it's important to test them all to see which blues do the job you want. For example, you may want to drop thalo and add Prussian. Cobalt and ultramarine yield somewhat similar results, but you may prefer the greater delicacy of cobalt for reasons of your own. Cerulean and manganese are both such wonderful sky colors for landscape painting that you'll want to add one of them to your palette; so it makes sense to find out what kind of greens they can produce.

Pay particular attention to the effect of white

on all these mixtures when you blend white into the right-hand half of the sample on the checkerboard. Some green mixtures brighten suddenly when you add white, while others turn bluer or grayer. For future reference, it's vital to record all these mixtures on your checkerboard with proper labels.

Creating Violets

There are so few violet objects in nature that it's tempting to skip violet altogether. However, purely for the experience in creating color mixtures, it's important to see what you can do with the colors on your palette. The results won't be electrifying, but they're instructive. Generally, violet mixtures need some white to bring out the color.

- (1) Theoretically, red and blue make violet, but cadmium red light-like all the cadmiums-has a will of its own. This brilliant color combines with the equally brilliant thalo blue to produce a curiously subdued violet, which verges on gray if you add enough blue. Another subdued violet results when you mix cadmium red light and ultramarine blue. Actually, it may be a relief to discover that not all violets have to be boudoir colors; a subdued violet may actually be more useful than a brighter tone that threatens to throw the whole picture out of kilter.
- (2) Although alizarin crimson isn't nearly as bright as cadmium red light, the crimson has the great advantage of transparency. It also starts out with a slightly violet tone. So alizarin crimson produces somewhat richer violets in combination with thalo and ultramarine, plus white. But once again, neither of these violets is as bright as the color you're likely to buy in a tube.
- (3) For a violet that combines the brightness of cadmium red light and the transparency of alizarin crimson, mix these colors together and then add thalo blue, plus white.
- (4) To mix really bright violets, you've got to turn to some of the optional colors. Alizarin crimson combines beautifully with manganese blue because they're both transparent; with

white, they produce an especially attractive violet. Alizarin crimson and cobalt blue are another good combination, rich but not quite as bright; the mixture needs white for the full brightness to show up. Also try substituting quinacridone crimson for alizarin crimson in some of these mixtures.

(5) I must admit that most vivid violets do come from tubes. If you want to have one or two tubes of violet on hand-cobalt violet light or manganese violet, let's say-it's important to learn how to modify and tame them if necessarv. Add a touch of subdued blue, like ultramarine, to cool a violet. A touch of yellow, the complement of violet, takes some of the edge off an aggressive tube color while a hint of brown makes violet more mellow. If you actually want to raise the temperature, add alizarin crimson.

When you add white to the samples on the checkerboard, the cold violets turn bluer and the hot violets turn pinker. When a violet threatens to get out of hand and disrupt the color organization of the picture, it's usually because the violet is too red. Cool it down by adding blue or soften it by adding brown.

Diversifying the Browns

Like greens, brown tones are enormously diversified in the world of nature. This is true not only in landscape painting but also in the enormous range of skin and hair tones. Fortunately, almost every color on your palette can be added to brown. If yellow is the hardest color to modify without destroying it, brown is probably the easiest.

- (1) By now the procedure should be familiar. Start by combining the two basic browns: burnt umber and burnt sienna. Between the two are a variety of compromise tones, each warmer and lighter than burnt umber, each cooler and darker than burnt sienna. Be sure to add a little white to bring out the full flavor of the color.
- (2) Each of the reds (plus a little white) enriches brown in its own way. Burnt umber often needs the additional warmth the reds pro-

- vide. Burnt sienna and alizarin crimson are especially compatible because they're both transparent. Reddish browns like these mixtures are particularly useful in autumn landscapes, of course.
- (3) Equally useful in autumn are the golden browns you get by adding yellow and some white. Be careful not to add too much cadmium vellow light, or it will dominate both the basic browns. Yellow ochre can be added more freely; it softens and lightens both browns, rather than warming them up.
- (4) Blues and greens darken both basic browns. Ultramarine with burnt sienna or burnt umber yields a variety of velvety browns, each becoming deeper and colder as you add more blue. Thalo is harder to handle because it's so much more powerful than both browns; it cools them down very quickly and produces warm or cool grays. Viridian creates very soft, smoky browns in combination with burnt sienna and burnt umber. All these mixtures need some white to bring up the color.
- (5) Threesomes greatly expand the number of possibilities. Experiment with combinations like ivory black, burnt sienna, and yellow ochre; either of your blues, either of your browns, and yellow ochre; either of your reds, viridian, and ivory black. Be sure to add some white.
- (6) Among the optional colors which enlarge the range of browns are the earthy red-browns like Venetian red, light red, and Indian red; Naples yellow; and the softer blues, cerulean and cobalt. Try any of the red-browns with black or blue, then add Naples yellow or yellow ochre. The softer blues will yield more delicate browns, of course, but don't try cobalt or cerulean in combination with one of the earthy redbrowns: these blues are far too powerful. Remember that it's best to combine colors of roughly equal tinting strength.

If you spend enough time mixing browns, you'll see why so many painters feel that they can do an entire picture in shades of brown. There are so many red-browns, yellow-browns, green-browns, orange-browns, violet-browns,

Summer Wind by Alexander Brook, ca. 1933, oil on canvas, $40^{1/8}$ " × 26" (102 × 66 cm). National Museum of American Art, gift of Mrs. Otto L. Spaeth. The artist follows a color strategy that should be familiar by now. He combines contrasts of value and color temperature to dramatize the model's skin color. Thus, the middle value of the sky accentuates the lighter tone of the model's body. And the cool sky mixture heightens the warmth of her skin. Two additional notes of contrast attract attention to her head: her dark hair and the touch of red on her lips. Brook knows that it's important to avoid the feeling that the figure is a kind of paper cutout standing in front of an imaginary background. The closeup reveals how he integrates the figure with the total atmosphere of the outdoors. With scrubby strokes of broken color, Brook blends the sky tone into the shadows and halftones on the skin. He then reverses the process, blending almost imperceptible touches of warm skin tone into the upper sky. (These warm mixtures are more obvious at the horizon.) The cool touches in her hair make us feel that we can see the sky through her curls.

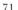

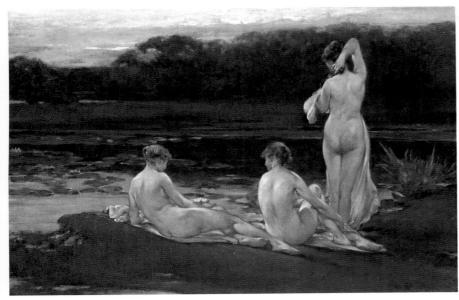

Water Lilies by Walter Shirlaw, before 1889, oil on canvas, $20^{1/2''} \times 30^{3/4''}$ (52 \times 78 cm), National Museum of American Art, gift of William T. Evans. Shirlaw follows a similar strategy in this study of three nudes at the edge of a stream-but with some interesting differences. The figures are silhouetted against the cool darks of the trees and their reflections, which dramatize the paler, warmer tones of their skin. Like the water, the skin tones also seem to reflect the cool color of the trees, particularly in the halftones and shadows. In the same way, the golden sky color is reflected not only in the water, but in the lighted areas of the bodies. Thus, the artist actually treats the models' skin as a reflecting surface that picks up the dominant hues in the landscape. This effect is most apparent in the closeup, where nearly all the skin tones reflect the cool surroundings, except for the flash of warm light on the back and thigh of the seated figure, who seems to be spotlit by a ray of sun from the sky.

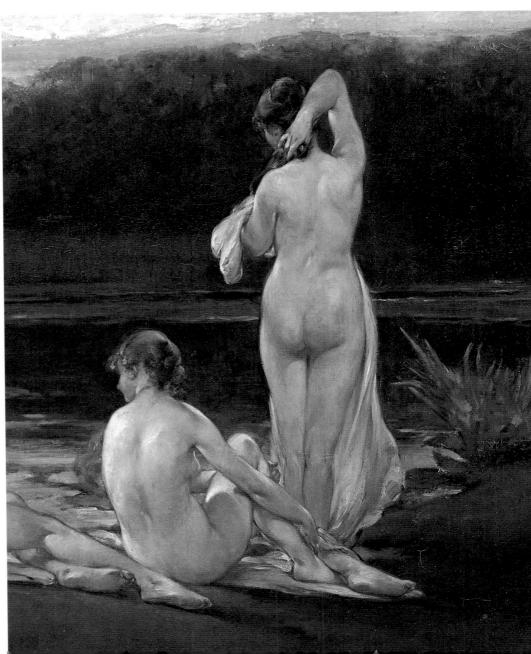

gray-browns, and black-browns that you begin to wonder whether there is such a thing as brown at all.

Alternatives to Black

Much earlier, I said that black was the least useful, least interesting dark note you could put into a picture. You can mix so many deep, rich darks that black seems almost useless, except as a component in mixtures.

Practically any combination of two deep, dark colors-one warm, one cool-will produce an interesting dark note. The most obvious are blue and brown combinations like thalo blue and burnt umber, ultramarine blue and burnt umber, Prussian blue and burnt sienna, any of the deep blues with the earth red-browns. The balance of blue and brown determines whether these darks will be on the warm or cool side.

Other interesting combinations of warm and cool darks include things like thalo blue and cadmium red light, which yields a bluish black or reddish black, depending upon the balance of the colors; viridian and either of the reds; viridian and burnt umber; and ultramarine blue with cadmium red light. The point about all these mixtures is that they're blackish but not black. Every one of them carries a hint of some other color, whether blue, brown, violet, red, or green. At first glance, they look black in the picture, and the viewer may never stop to think that they aren't really black. But these colorful darks add vitality whether the viewer is conscious of it or not.

Another interesting way to create offbeat darks is to save up what I call mud. Periodically, every oil painter scrapes off all the dirty, useless, excess color from his palette. So do I, but I don't chuck it out. I save up these horrible, muddy mixtures in tightly capped, little baby food jars, labeled green mud (usually left over from landscape painting), brown mud (often left over from portrait or figure painting), or blue mud or gray mud (often left over from seascape painting). It's surprising how useful these various shades of mud can be when I want a particularly deep, dark tone. Prussian blue and some brown mud gives me a particularly potent blackish tone. Venetian red can do weird and fascinating things to green mud. The idea is to add a powerful warm color to cool mud and a powerful cool color to warm mud. Some of the darks you get this way are amazingly beautiful.

Black is a Color

Having warned against using black all by itself, I'm strongly in favor of using black as a rich, versatile color in mixtures. I'm not talking about adding a touch of black as a means of subduing a bright color—the quickest way to produce the mud I mentioned a moment agobut I am talking about using black as you'd use any other color, as a component in a variety of lively blends.

Black is at its best in mixtures with yellow to produce a range of very appealing greens: lovely olive tones with cadmium yellow light and hansa yellow; strange brown-greens and gray-greens with yellow ochre and Naples yellow; bright, deep greens with thalo blue and cadmium yellow light or hansa yellow light; and even more diversified greens when mixed with pairs of yellows like yellow ochre and hansa yellow light.

Acting something like a member of the blue family, black creates an interesting violet with alizarin crimson alone or with a combination of crimson and cadmium red light; rich browns in combination with red-brown earths like Venetian red, light red, and Indian red; subtle browns in combination with burnt umber or burnt sienna; even a strange violet-brown with Venetian red and Naples yellow.

These are only some of the possibilites. Once you start thinking of black as a color-rather than as a gloomy modifier that turns other colors to mud-there's lots of room for experimentation.

Another creative way to use black is to treat it like a primary color, a color which you must learn to modify without destroying its identity. Try to create colorful blacks by adding controlled amounts of other dark colors like red, blue, brown, and green. The idea is to produce a black which retains its identity but carries a distinct flavor of some other color. Just as there are bluish greens and reddish browns, there are

blue-blacks, red-blacks, green-blacks, and many other vivid darks that use black as the basic component. Forget the textbooks that tell you that black represents the "absence of color." Artists who love to draw will tell you that black is the richest of all colors

White is a Color Too

Looking back on all the tests you've tried so far, you must be aware that white does a lot more than simply lighten other colors. It has the same kind of bold, unpredictable personality as any other brilliant color. It takes a lot of experience to learn the idiosyncrasies of white, a hue which warms one color and cools another, intensifies certain hues and then cuts down intensity when you least expect it.

But white is more than a modifier; it's also the color of many objects of nature. Perhaps it's more accurate to say that it's the local color of many objects in nature, altered by prevailing light and atmosphere, shadows, and reflections of nearby colors.

White is never really dead white. It's more likely to be white with a hint of some other color: the bluish white of snow in shadow: the yellowish white of snow in sunshine; the pinkish white of clouds as the sun begins to set; the greenish white of the foamy ribbons running down the face of a breaking wave.

In mixing such colors, the whole trick is to learn just how much color you can add to white without creating some other hue. Experiment with adding infinitestimal quantities of each color on your palette. You'll soon see that some colors—the ones with great tinting strength—instantly dominate the white, while the weaker colors are a lot easier to handle. (In fact, this is an ideal way to learn the relative tinting strength of your colors.) You'll find that it's easy to produce a warm white by adding a hint of yellow ochre, but it takes a lot of experience to learn how little thalo blue or cadmium red light you can add.

As a rule, it's best to stick to the weakest colors-or to mixtures of weak colors-when modify white. Of course, a lot depends upon the surrounding colors, too. A bluish white may look too blue on the white surface of your tear-off paper palette, but it might look a lot whiter next to a deep, warm brown in your painting. More about this later on.

Discovering the Grays

One of the greatest compliments that one professional painter can pay another is: "He's a master of grays." Perhaps the ultimate test of your creativity in color mixing is how many ways you can think of to mix grays. For gray isn't a drab mixture of black and white paint, but the generic term for an enormous family of warm and cool colors which you can mix with practically every color on your palette. It's conceivable that you could paint an entire picture in various warm and cool grays, or perhaps in browns and grays as Velasquez did.

- (1) Practically every interesting gray is a blend of a warm color, a cool color, and white. The combinations that almost always works is blue. brown, and white. So start out by mixing each of the blues on your starter palette with each of the browns. Try different proportions of blue and brown, and you'll see that just these four colors-plus white-yield an unexpected range of brown-grays, blue-grays, and even greengrays. Thalo blue produces the most interesting range of blue-grays and green-grays because of its exceptional tinting power. Ultramarine, because it's warmer and softer, is especially good for producing those soft, velvety grays.
- (2) If you've done all the preceding tests, you know that ivory black also functions something like blue when you mix it with warm colors. You can develop an interesting range of grays with ivory black and the two basic browns. See how you can warm or cool the mixture by adusting the balance of black and brown. The amount of white also makes a difference.
- (3) Although I've told you to steer away from black and white mixtures, ivory black also produces interesting grays when blended with yellow. Ivory black and yellow ochre are a combination you tried earlier to produce a very subtle olive green. Now try different proportions of black, yellow ochre, and white to see the variety of warm and cool grays you can produce.

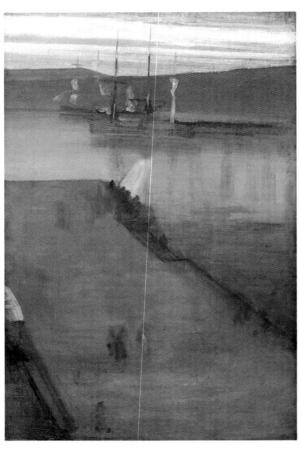

Valparaiso Harbor by James Abbott McNeill Whistler, oil on canvas, $30^{1/4}$ " \times 20" (77 \times 51 cm), National Museum of American Art, gift of John Gellatly. This sparse and satisfying design proves that only two colors are enough to make a masterpiece. Whistler constructs his picture with just one warm and one cool color, which alternate and interpenetrate. The picture contains only four major shapes: the cool sky and water, and the warm pier and coast. But examine the closeup to see how he ties these shapes together. The thin, horizontal strips of clouds—especially the cloud layer at the horizon—contain a slight hint of warmth where the artist blends in a touch of land color. When you study them closely, the ships are hardly there at all! Whistler first paints them with warm strokes, and then brushes cool color right over them. He paints their reflections in the same way. The result is a ghostly image, combining warm and cool color, at the focal point of the painting. In fact, the entire canvas conveys the feeling that warm and cool color have been lightly brushed over one another. Whistler works with long, loose strokes of liquid color, so thin that the underlying color shines through whenever he brushes new color over old. And he often skips so lightly over the canvas that the woven texture breaks through the brushstroke.

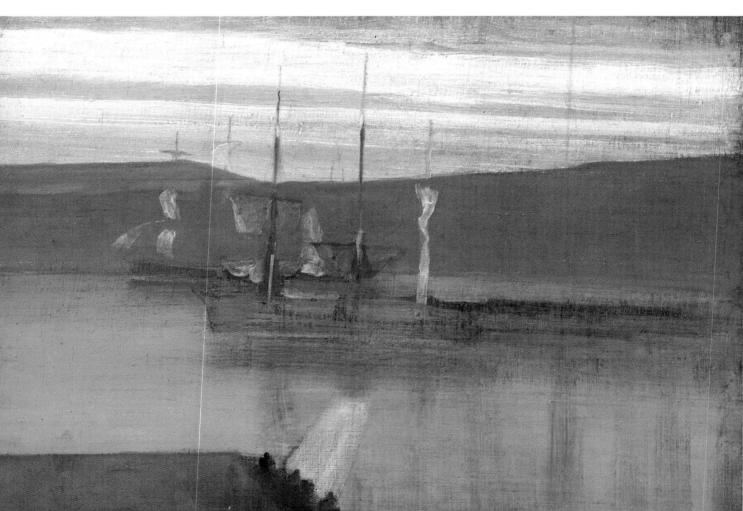

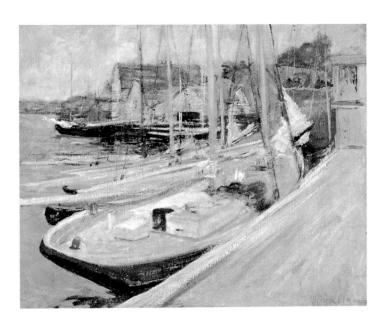

Fishing Boats at Gloucester by John Henry Twachtman, 1901, oil on canvas, $25^{1/8}$ " × 30 $^{1/4}$ " (64 × 77 cm), National Museum of Art, gift of William T. Evans. Here's a similar subject by another master of muted color. Twachtman's harbor scene is painted almost entirely in tans, browns, and grays, with a few touches of redbrown on the ship in the foreground and some greenish touches in the middleground. The sea and sky are just barely cooler than the ships, pier, and seaside architecture. Yet the colors are never monotonous, but full of subtle variety, as you can see in the closeup. The rooftop reflects the cool tone of the sky, which the artist brushes here and there over the underlying warm mixture. In the same way, a hint of warmth shows through in the sky. The tiny green window is echoed by suggestions of green in the dark reflections of the boats. And the darks have surprising power in their pale surroundings.

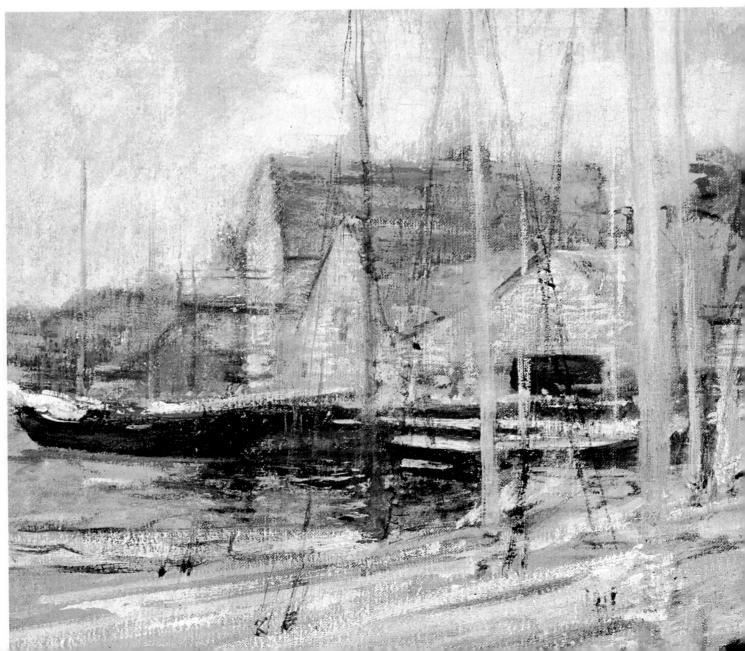

- (5) Now you can begin to work with some threesomes, plus white. Experiment with adding different degrees of yellow ochre to the blue-brown combinations I suggested earlier. Thalo blue, cadmium red light, and yellow ochre also offer a number of interesting possibilities. So do ivory black, burnt sienna or burnt umber, and viridian.
- (6) When you move into the territory of the optional colors, the range of grays becomes even greater. Naples yellow is a marvelous color for making grays: try it in combination with ivory black and white; then broaden the possible range of that combination by adding cadmium red light or one of the browns. Prussian blue develops its own unique range of grays in combination with any of the browns and with the red-brown earths like Venetian red, Indian red, or light red. These red-brown earths also make interesting grays with the other blues and with greens like viridian or the much stronger chromium oxide. The weaker optional blues like cobalt, cerulean, and manganese produce particularly delicate grays when blended with the less powerful browns, like burnt sienna, raw sienna, burnt umber, and raw umber.

All the foregoing exercises are mere suggestions, mere points of departure. In testing out these and other combinations of warm and cool colors—always adding white—you'll find that the range of possible grays is almost infinite. Everything depends upon the balance of warm and cool colors in the mixture. Just a little too much cool color and your gray turns green or perhaps even blue, but this may not be a disas-

ter as you may add another cool color to your vocabulary of mixtures. Just a bit too much warm color and you may find yourself with brown or violet or deep pink, and that might be a discovery too. In short, practically every combination of warm and cool color yields a variety of tones—depending upon the proportions of the colors in the mixture—and one of these is likely to be an interesting gray.

Flesh Tones

The hardest colors to get right (most painters would agree) are the colors of flesh and hair. Beginning painters often ask their teachers for some standardized mixture that can be called "flesh color," some magic formula that will take the guess work out of this most difficult of all color mixing problems. But the truth is that no such thing as "flesh color" exists.

If you look at the people you pass on the street, you'll soon see that they come in a wide range of colors that reflect not only racial background, but the state of their health and even the climate. So-called white people aren't white at all; neither are black people black. Even the whitest skin is likely to be a kind of ivory tone tinged with pink, while the blackest skin usually contains several shades of brown. Between these two extremes are delicate beiges, golden tans, olive-browns, ruddy pinks, and scores of other tones too subtle to describe.

So, when I speak of mixing flesh tones, I'm really talking about a range of colors. Frederic Taubes, in his classic Oil Painting for the Beginner, suggests three groups of colors that will deal effectively with the basic flesh colors you're likely to encounter in most models.

(1) For the palest tone, he suggests a blend of white and yellow ochre, which yields anything from an ivory, off-white to a pale, golden tan, depending upon the proportion of the two colors in the mixture. This can then be warmed and darkened with Venetian red to give a ruddier tone for the warmest areas in flesh. For a darker, cooler tone, you can substitute burnt umber for Venetian red. And for the darkest tone—a rich, deep brown—he suggests combining yellow ochre, burnt umber, Venetian red,

and a touch of ultramarine blue. Properly handled, this range of colors should give you everything from pale blond skin to a deep brown.

- (2) Another possibility begins once more with yellow ochre and white for the palest tones. Taubes then suggests adding burnt sienna for darker, ruddier tones. For the deepest browns, he suggests yellow ochre, burnt sienna, and a touch of ultramarine blue.
- (3) For a cooler range of flesh tones, Taubes suggests yellow ochre and white for the palest hues; yellow ochre, burnt umber, and white for the middle tone; and yellow ochre, burnt umber, and ultramarine blue for a deep, comparatively cool brown.

The significant thing about these three color ranges is that they always rely on earth colors: an earth yellow, two red-brown earths, and a deep, earthy brown. The only blue is a restrained one, limited in tinting strength so it's easy to handle and won't overwhelm the warm colors. Except for the powerful Venetian red, all the earth colors are limited in tinting strength and are easy to control in mixtures for that reason. Furthermore, the earth colors have a natural, subdued warmth which seems inherently right for flesh.

Certainly, this doesn't eliminate the possibility of bringing in a small quantity of cadmium yellow light or the more restrained Naples yellow for a slightly more golden tone when you need it. And you can just as easily bring in a hint of cadmium red light or alizarin crimson for those ruddy flesh tones, suffused with pink. And very black skin-not too common in the United States or Europe but frequently seen in parts of Africa-often has a beautiful blue undertone, which demands something as powerful as Prussian blue. I'd suggest that you try Taubes' color selection as a basic palette for portrait and figure painting, adding other colors when you need them.

In Complete Guide to Portrait Painting, Furman J. Finck suggests a very different approach to painting flesh tones. For an overall light flesh tone, he suggests mixing alizarin crimson, yellow ochre, and white, For grays and other darker areas, he recommends a blend of alizarin crimson, viridian, and white. For pronounced darks, he mentions two combinations: burnt sienna and viridian: cobalt blue and burnt sienna. And for dark, luminous shadows, he suggests alizarin crimson, viridian, cadmium red light, and white. As you can see, all these combinations-except for the overall light flesh tone—are essentially a warm color, a cool color, and white. By adjusting the proportions of the mixture, you can make subtle changes in color temperature, intensity, and value. Either the warm color or the cool color can dominate, depending upon what you need.

Finck also makes two suggestions for the occasional notes of really warm color sometimes found in skin: alizarin crimson and cadmium red light for bright pinks; and cadmium red light, cadmium yellow light, and white for the brightest flesh tones.

Finck's recommended colors are likely to produce more brilliant flesh tones than an earth color palette, but all these bright colors especially cadmium-can get out of control. Be sure to add these brilliant hues in small quantities and use plenty of white, or your flesh tones will be too beefy.

In Complete Guide to Oil Painting, Ernest Fiene suggests a basic mixture of cadmium yellow light, cadmium red light, yellow ochre, and white, cooled with cerulean blue or viridian. For a ruddier skin tone, he recommends that you substitute Venetian red or burnt sienna for cadmium red light. And finally, he suggests still another combination: raw sienna, cerulean blue, and alizarin crimson. Essentially, all these are combinations of yellow, red, and blue, the three primaries that normally yield brown. By varying the proportions of the colors-and adding white, of course-you can produce a range of skin tones that tend toward yellow, pink, or brown, depending upon the complexion of the model.

In short, every professional painter has his own ideas about flesh color. You're got to experiment and find out what's best for you.

Hair Tones

Painting hair is just as tricky, of course. For blond hair, yellow ochre or Naples yellow is

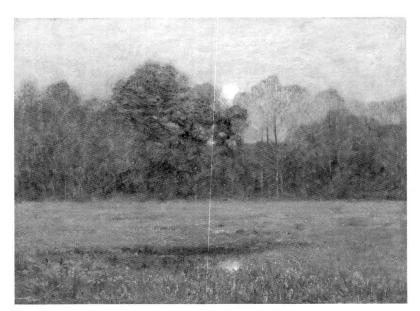

Midsummer Moonrise by Dwight William Tryon, 1892, oil on wood panel, $19^{\bar{n}} \times 25^{5/8}$ " (49) × 65 cm), National Museum of American Art, gift of IBM Corporation. On pages 50, 51, and 62, you saw warm analogous color schemes. Now here's a cool analogous color scheme, consisting of blues and greens. These colors provide a wonderful setting for the single warm note in the painting: the pale, yellow moon. But is it really the only warm note? The moon seems to reappear in a reflection in the grass. And there are also tiny warm touches that seem to suggest wildflowers in the meadow. But study the closeup and you'll discover that the cool mixtures of the trees contain tiny flecks of warm color throughout the foliage. In fact, it's likely that Tryon painted the cool foliage very loosely over a warm undertone, working with thin color and skipping lightly over the canvas to let the underlying color shine through.

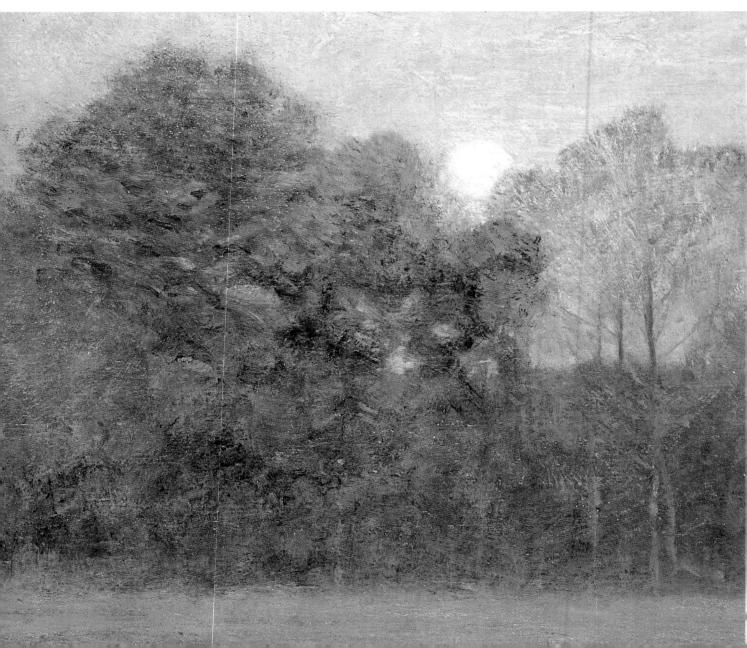

Brooding Silence by John Fabian Carlson, oil on canvas, $37^{1/8}$ " × 52" (94 × 132 cm), National Museum of American Art, bequest of Henry Ward Ranger through the National Academy of Design. Here's another cool analogous color scheme that consists mainly of blues, violets, and blue-grays. But the artist creates a feeling of magical variety as he places small flecks of warm color among the foliage. He also lets just enough sunlight through the overcast sky to illuminate the snow, which reflects the sky color—as water normally does. Carlson works with solid strokes of juicy color, which are obvious in the closeup. He also paints wet-in-wet. That is, he brushes one wet color right over another, playing warm over cool and cool over warm, letting the vigorous action of the brush blend the colors slightly as it strikes the canvas. The result is a scintillating mosaic of bold strokes that fill every square inch with unexpected color combinations.

fairly easy to handle, and these can be darkened with burnt or raw umber, plus an occasional touch of ultramarine or cobalt blue for a cooling influence. Cadmium yellow is much too bright for blonde hair.

For so-called red hair-which isn't red at all—the red-brown earth colors (burnt sienna, Venetian red, and so forth) can be modified with vellow ochre, burnt umber, and ultramarine blue. This is essentially the same combination that you can use for flesh, though darker. You might also try substituting Naples yellow for yellow ochre.

For brown hair, try various blends of warm and cool colors. The deepest, coolest browns are mixtures of ultramarine blue and burnt umber or burnt sienna. You can warm these up by adding vellow ochre or Venetian red. It's also interesting to substitute viridian for blue.

Don't use ivory black for black hair. Ultramarine blue and burnt umber give you a more colorful black, with a hint of warmth if you allow the umber to shine through. Prussian blue and burnt sienna or cadmium red lightwith the blue dominating it this time-make a luminous blue-black which goes well with the cool brown skin of a dark sitter. In painting black hair, it's important to decide whether you want a warm black or a cool one. This decision determines whether you allow the blue component or the brown component of the mixture to dominate.

Hair color should harmonize with skin color. The best way to insure this is to use similar color combinations in both areas if you can. This is the value of using earth colors as the basis for skin and hair tones: the earth colors work equally well in both.

Color Mixing and Color Control

When you conducted the tests in the last chapter, you followed one standardized method of color mixing to make sure that each combination came out in a completely predictable way. You used a palette knife to compound all your mixtures on the white surface of a tear-off paper palette. The idea was to make every mixture absolutely smooth and uniform.

But this is only one of many ways to mix colors. In this chapter, I'm going to explore various other ways. I'll also talk about ways of altering colors to make them lighter or darker, brighter or more subdued, warmer or cooler. And I'm going to spend some time examining how colors affect one another when they're not mixed but placed side by side.

Nine Principles of Color Mixing

While you were making the various mixtures recommended in Chapter 3, you began to discover certain "rules" for combining colors. Now, before going any further, I'm going to give you a series of rules-of-thumb that most painters would agree upon.

- (1) Try to plan each color mixture and decide exactly what colors you're going to mix before you touch your brush or your knife to your palette. Don't just pick up "a little of this and a little of that" on your brush and scrub them all together, hoping that the mixture will turn out more or less right. Make a clear-cut decision that you want a certain green, let's say, that combines a specific blue with a specific yellow, plus a certain amount of white. If you've done the exercises in Chapter 3 religiously, such decisions should be a lot easier to make.
- (2) Planning your combinations—rather than picking up colors at random on impulse-is particularly important because it preserves the brilliance and clarity of your colors by limiting the number of colors in the mixture. You should always try to arrive at the mixture you want with as few colors as possible. Ideally, you should never need more than two or three colors, plus white. When you discover that you need a fourth color, it's probably because you want to correct a miscalculation you've made in a mixture of three colors. Another reason for

Moonlight by Albert Pinkham Ryder, 1880-1885, oil on wood panel, $15^{7/8}$ " × $17^{3/4}$ " (40 × 45) cm), National Museum of American Art, gift of William T. Evans. The colors of this powerful marine painting are supremely simple: bluegreen and gold for the sky and the moonlit area of the sea; and luminous, blackish darks for the boat, the shadowy areas of the sea, and the two clouds. Ryder emphasizes contrasts of value, placing his strongest lights and darkest darks near one another. Thus, the dark shape of the boat is surrounded, above and below, by the reflected moonlight on the sea. And the moon is placed between the two dark clouds. These contrasts make the moon seem even more brilliant and the boat even darker and more mysterious. As your eye moves toward the corners of the picture, the sky and sea darken, and the contrast decreases. Study the brushwork in the closeup. Ryder builds up thick, rough color to intensify the light in the moon and the sea.

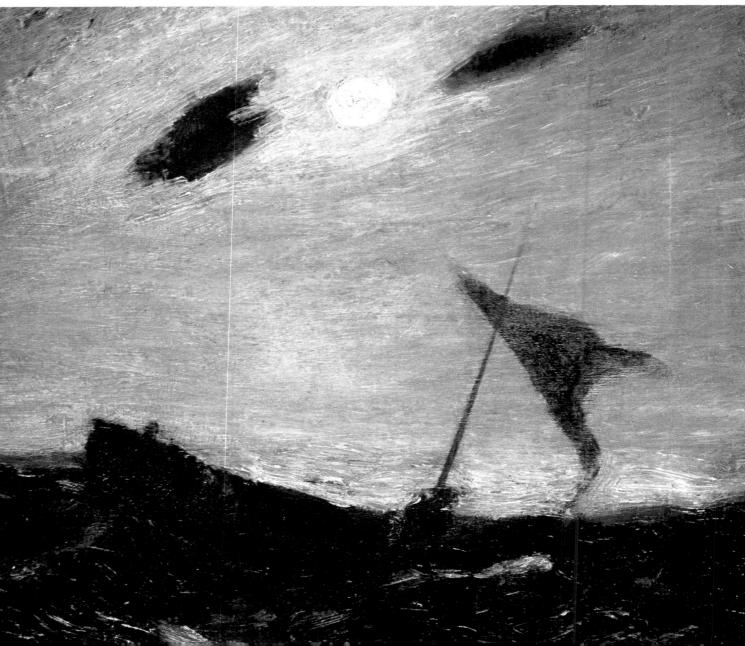

Entrance to the Harbor by Henry Ward Ranger, 1890, oil on canvas, $18^{1/4}$ " × $25^{5/8}$ " (46×65 cm), National Museum of American Art, gift of William T. Evans. Like the Ryder on the opposite page, Ranger's seascape is based on a very simple color scheme. The overcast sky is reflected in the sea, which means that nearly the entire canvas is covered by subdued, but varied, grays, all quite pale. At the focal point, Ranger places his strongest darks and a few bright, warm tones-which are echoed in the softer tones of the shoreline and distant boats. Thus, the painting is a study in contrasts of value and color temperature: the darks and warm tones of the central boats against the pale, cool tones of the sea and sky. The closeup shows the rough brushwork that creates so much variety in every square inch of sea and sky color. The boats are painted so roughly that the gray background tones break through the darker strokes.

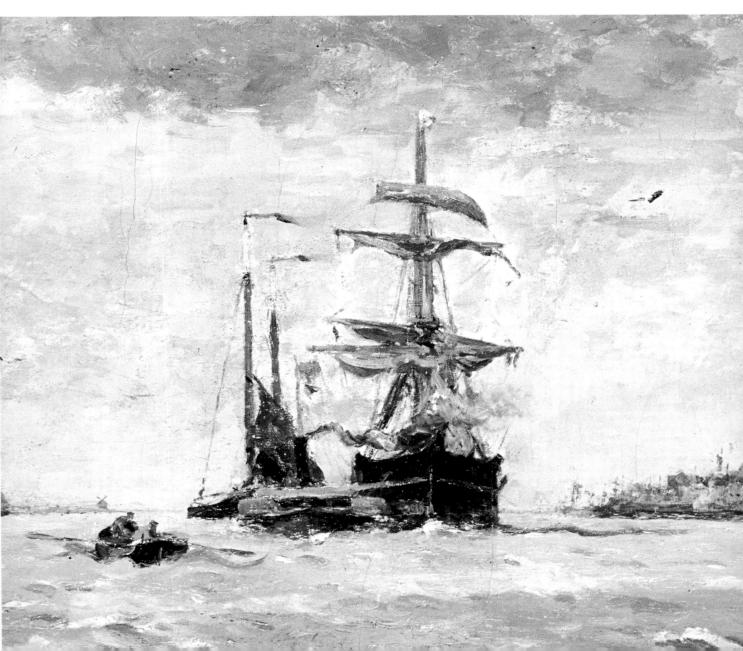

- sticking to two or three colors, of course, is that the more colors you add the harder it is to remember the components of the mixture, so that it's almost impossible to duplicate if you need more paint.
- (3) Don't mix your colors too thoroughly. For some obscure optical reason, mixtures decline in brilliance as you push them around on the palette (or on the canvas) with your brush or your knife. Watch the mixture carefully as you blend it. As soon as you've got the color you want, stop! Even if the colors aren't blended to an absolutely smooth consistency, don't stir them around any longer. Remember that the color will be blended a bit more in the process of brushing it onto the canvas. And you may blend it again once it's on the canvas when you smooth it out or grade it into an adjacent color. Even if the final color mixture isn't absolutely smooth on the canvas, the viewer's eye will see it as a fairly uniform mixture. Only you are likely to notice that the mixture is a bit irregular, but this actually adds to its vitality.
- (4) Keep your knives and brushes as clean as possible. Before picking up color, wipe your knife blade absolutely clean with a cloth or a paper towel. Wipe your brushes frequently and rinse them in turpentine regularly, taking care to wipe away the turpentine on a stack of newspapers, a cloth, or a paper towel. Nothing ruins a mixture so quickly as a knife or brush that carries some unwanted color.
- (5) If you prefer to mix your colors on the palette—though you'll see in a moment that you can also mix them on the painting surface—I'm absolutely convinced that a palette knife yields clearer, brighter mixtures than a brush. With a swipe of a cloth or a paper towel, you can wipe the blade absolutely clean and dry so that the mixture never contains even the faintest hint of some unnecessary color. Once you get going on a painting, your brushes are never absolutely clean. No matter how much you wipe or rinse them, they always contain a tinge of wet color imbedded in the bristles, and this color inevitably makes its way into any mixture you stir up with that brush.
- (6) However, not everybody likes the feel of a

- palette knife, and you have every right to perform your mixing operations with a brush if you want to. If so, be sure to wipe the bristles as clean as possible with a cloth or a paper towel before starting any new mixture. Rinse the brush in turpentine and wipe away the muddy fluid on that stack of newspapers, cloth, or paper towel. To avoid soiling the fresh color you've squeezed out around the edges of your palette, wipe the brush carefully before picking up a dab of fresh tube color to add to the mixture. It's especially important to wipe your brush before you pick up white because white soils so easily.
- (7) Another way to keep your mixtures (both on the palette and on the canvas) as clean as possible is to assign a specific job to each brush. If you have enough brushes, you can assign one to each color family: you can have a dark blue brush and a light blue brush, a dark green brush and a light green brush, a dark red brush and a light red brush, and so on. Even if you have several shades of dark green in a landscape, you always use the same dark green brush for them, never making the mistake of using that brush to muddy a red mixture or even a lighter green. If your supply of brushes is limited, you can get by with as few as four brushes: one for dark, warm colors; one for light, warm colors; one for dark, cool colors; and one for light, cool colors. I realize, of course, that you may need both large and small brushes for painting various passages, and these should be assigned specific color jobs as well.
- (8) Colors of roughly equal tinting strength are easiest to handle in mixtures. Combining a very powerful color with a very weak color isn't inherently bad; it's just tricky. If you can get the color mixture you want by combining two or three hues of roughly equal tinting strength, do it. On the other hand, if you absolutely must combine two or three colors of widely different tinting strength, proceed with care. Start with the weaker colors and add the stronger colors in very small quantities, building up gradually to the mixture you want unless lots of practice has made you absolutely sure of the right proportions.

(9) Most color mixtures need a certain amount of white to bring out the full richness of the hue. This is particularly true of transparent colors, which often look blackish and dull until that touch of white is added, and then they suddenly blossom forth in their full beauty. On the other hand, be careful about adding white to colors which are brilliant and opaque as they come from the tube.

There's nothing sacred about any of these rules and I realize that rules are apt to go out the window in the excitement of painting. Some of these recommendations—like the ones about brushes-may seem burdensome for a while. You may think: "So what if my color mixtures aren't absolutely pure!" That's your decision. But if you discipline yourself to follow these rules consciously for a while, they'll soon become second nature, and you'll do them automatically. Then they'll no longer feel like a burden, but they'll happen by themselveswithout your even thinking about them. Good work habits will show up in the brilliance and clarity of your color.

Mixing on the Palette

The most common place to mix colors is on the palette, as you know. Unless you develop good work habits, the palette soon becomes a gummy, muddy mess. Here are a few suggestions for making the job easier.

Make sure you've got a big enough palette. Most paint boxes contain a 12" x 16" wooden palette and that seems to be the smallest reasonable size. Although 12" x 16" is adequate for outdoor painting, I recommend an even bigger palette for work in the studio: 16" x 20" or thereabouts. You'll need lots of elbow room for all those mixtures.

It's important to give some thought to the color and material of the palette. I know that the traditional wooden palette is a beautiful brownish tone, which becomes darker and even more beautiful with age and use. But I think it's terribly hard to judge the exact hue of a mixture on any surface which isn't white. For maximum control of color, I strongly recommend a white palette. In the studio, you can use a sheet of thick glass painted white underneath or set on a white illustration board. Most beautiful of all is a slab of white marble, polished smooth, which you can get from a stonemason. (It's also fun to shop for an old, marbletopped table in antique stores.) White tear-off paper palettes are most convenient of all, since you don't clean them but simply throw away the top sheet when it gets too filthy to use. You can buy a 12" x 16" tear-off paper palette for outdoor painting-it fits into your paintboxbut I'd place two or three of them side by side on a table or counter for studio use.

Work out some rational arrangement of colors on your palette, as I said earlier. Group the cool colors and the warm colors separately, I have a rectangular palette, and I run the blues and greens along the left-hand edge, the yellows and reds and browns along the top. I like to keep a big mound of white in the upper lefthand corner where the row of cool colors and the row of warm colors meet. The value of this arrangement is that it keeps the whole center of the palette clear for mixing. And the white is far from the center, so this essential color is kept pure. As I need them, I squeeze out fresh tube colors along the edges of the palette, never directly into the mixing area.

The logic behind my palette arrangement and this is true of every painter I know—is that the mixing area is kept separate from what I'd call the "storage area" where the fresh paints are squeezed out. Never do any mixing in the storage area. If you want to mix orange, for example, don't pick up some red on your knife or brush and blend it into the mound of yellow sitting on the edge of the palette. Instead, pick up some red and transfer it to the center of the palette; then wipe the knife or brush, pick up the vellow, and transfer this to the same spot in the center of the palette. Do your mixing there. Thus, the fresh colors stored along the edges of the palette remain fresh.

Clean your palette frequently. If you're working with a paper palette, this is easy because all you've got to do is tear it off. But if you're working on wood or glass or marble, wipe the mixing area clean when it becomes covered with mixtures you no longer need. It's horribly frustrating to have the mixing area covered with paint and find yourself searching

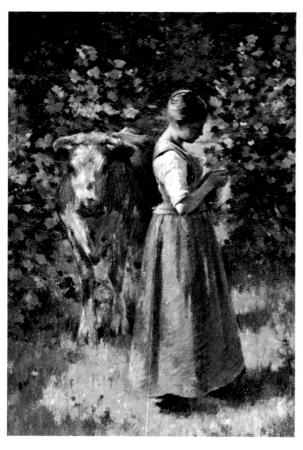

La Vachere by Theodore Robinson, ca. 1888, oil on canvas, $30^{1/4}$ " × $20^{1/8}$ " (77 × 51 cm), National Museum of American Art, gift of William T. Evans. The warm colors of the girl and her cow are surrounded by the cooler hues of the foliage and grass. The greens of the background and the red-browns of the figures are roughly complementary. And the strongest value contrasts are at the center of interest, where bright light falls on the girl's neck and upper arm, and on the cow's head, with each sunlit shape framed by shadow. There's also bright sunlight on the grass, but there are fewer strong darks here, so there's less contrast to distract attention from the upper part of the painting. Robinson has organized the picture around three different kinds of color interaction: contrasts of temperature, complements, and values. With so many different kinds of contrast going on, it's important to tie all the colors together—as you see in the closeup. Robinson works with ragged strokes that are broken up by the texture of the canvas. This irregular brushwork allows him to brush cool background colors into the warm mixtures of the girl and cow. In the same way, he adds touches of warm color to the background foliage. Examine the girl's head and the surrounding area. There are cool touches in the shadow on her face—as well as on her hand—and warm touches in the leaves near the head.

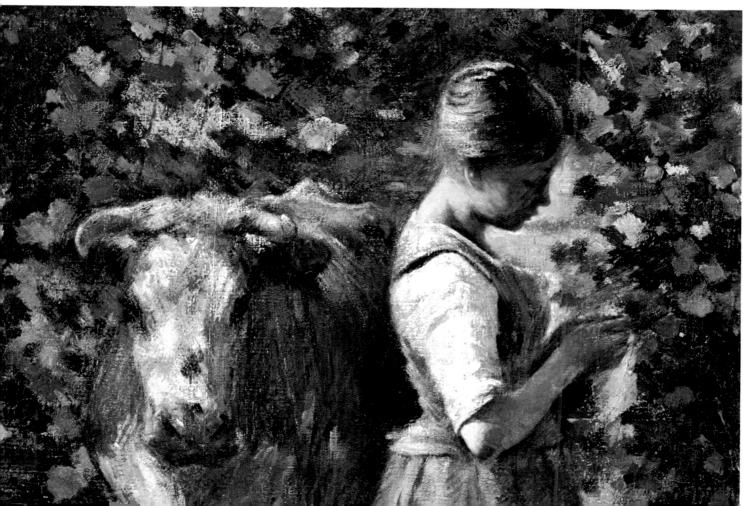

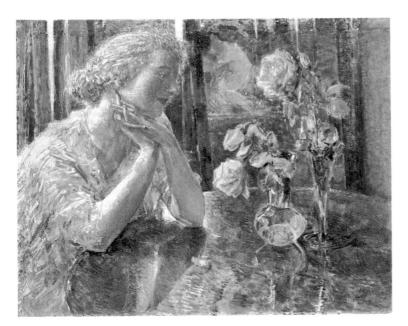

Marechal Neil Roses by Childe Hassam, 1919, oil on canvas, $26^{1/2}$ " × $32^{5/8}$ " (67 × 83 cm), National Museum of American Art, gift of John Gellatly. Here's an even more complex example of interpenetrating color to unify a figure and her surroundings. Working with small, ragged strokes of thin color—further broken up by the canvas texture—Hassam weaves the golden hue of the flowers throughout the painting. This dominant hue reappears in the woman's skin, hair, and dress, of course, as well as in the vase, the table, and the warm, sunlit wall in the upper left-hand corner. He does the same with the reddish browns of the table, which reappear in the warm shadows of the woman's face, hair, and hands; the halftones in her dress; and throughout the background. The green of the leaves is echoed in more subdued mixtures, not only in the table, but in the wall and the dress. The closeup reveals the interplay of these major colors and still other hues.

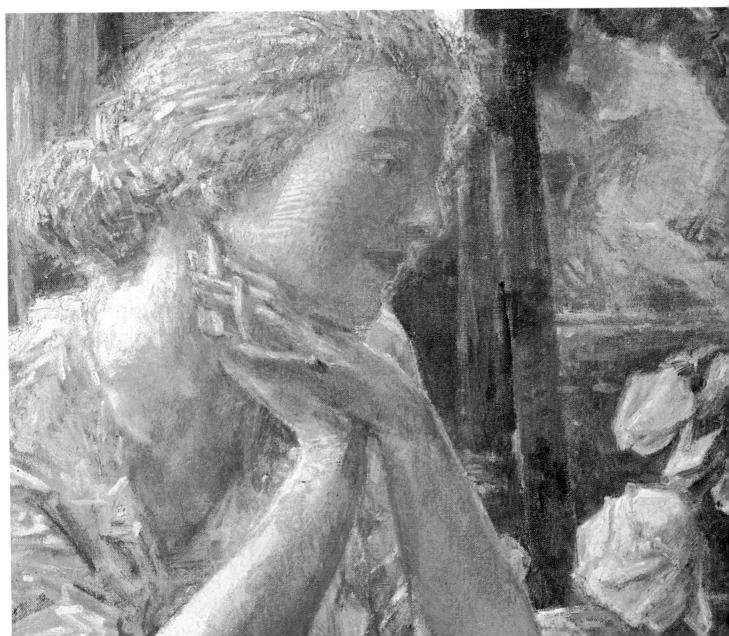

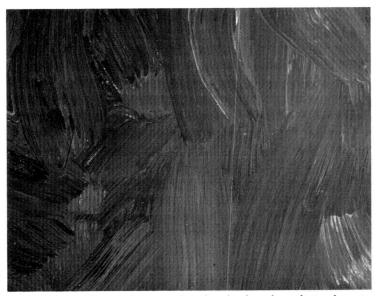

These colors were loosely mixed on the palette, then applied with a bristle brush before the mixture was thoroughly fused. Strands of various colors are apparent in each stroke. But they'll blend in the viewer's eye and look more vibrant than thoroughly mixed colors.

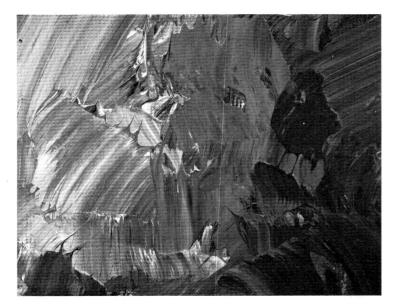

Roughly mixed with the palette knife and then applied with a short-bladed painting knife, this loose mixture has an exciting texture and great vitality. From normal viewing distance, the colors integrate and gradate from light to dark.

breathlessly for an empty spot to start a new mixture. This takes all the fun out of color mixing. And you also run the risk of an old mixture creeping into a new one and spoiling it.

Loose Versus Thorough Mixing

A moment ago, I cautioned you against mixing the colors too thoroughly and beating the life out of them. In combining two or three colors, the less you blend them, the more vibrant the mixture looks. In planning a mixture, it's important to decide just how thoroughly you want to blend it. In any one painting, you can have thorough mixtures, slightly loose mixtures, and very loose mixtures, depending upon the color effect you want in each passage. To compare loose and thorough color mixtures, try some brief experiments.

- (1) Squeeze out three powerful primaries on your palette: cadmium red light, cadmium yellow light, and thalo blue. Now mix a vivid orange by combining the red and the yellow, blending the colors thoroughly with the knife so that the orange is absolutely uniform. Knife this mixture onto one of the squares on your checkerboard color test sheet (Chapter 3) and leave a couple of empty squares beside it for comparative mixtures. Then make an equally thorough mixture of blue and yellow to produce a vivid green—again blend it thoroughly for a uniform hue—and knife this onto another square, leaving two empty squares for two more comparative mixtures.
- (2) Now mix the same red and yellow very briefly with the knife, leaving lots of streaks of red and yellow showing, so the mixture isn't uniform. Knife this ragged mixture onto the square next to the uniform orange. Clean the knife and make the same kind of loose mixture of blue and yellow, producing an irregular green with streaks of blue and yellow still showing. Knife this onto the square next to the uniform green mixture.
- (3) Using a brush this time, roughly mix the red and yellow and stop short of blending them thoroughly. Brush this onto the empty square next to the previous orange mixture. Take a clean brush and perform the same rough mix-

ing process with the blue and yellow; then daub this irregular green next to the previous green mixture.

Now you have two rows of mixtures. Ranked side by side are a thoroughly mixed orange, an orange loosely mixed with a knife, and an orange loosely mixed with the brush. Also ranked side by side are a thoroughly mixed green, a green loosely mixed with the knife, and a green loosely mixed with the brush. Look at them close up so you can see the irregularities; then stand away from the mixtures so that the irregularities blend in the eye. It's not hard to see that the loose mixtures are more vivid and dynamic than the uniform mixtures.

This doesn't mean that loose mixtures are always preferable. A painting composed entirely of loose mixtures might look unbearably busy. But this experiment demonstrates that you have a great many choices about the character of each mixture in your painting. For a delicate, remote sky, you may want an absolutely smooth mixture, while the ragged, brilliant foliage of a tree in autumn may look best with a very loose mixture of hot colors. The rocky wall beyond the tree may require a notso-loose mixture, rougher than the sky but smoother than the foliage. There are various degrees of looseness, and you should try them all.

Mixing on the Painting Surface

You could go through your entire life doing all your color mixtures on the palette and producing excellent pictures. But if you haven't tried mixing your colors directly on the surface of the canvas or panel, you've missed something. There's nothing quite like the vitality and spontaneity of a color mixture that takes place right on the painting itself.

The simplest method is called wet-into-wet. You cover a portion of the canvas with wet color and paint directly into this with a second color. The two colors can come straight from the tube, or each of them can be a mixture that's first prepared on the palette.

For example, you can produce a lovely sky effect by coating the sky area with a thin layer

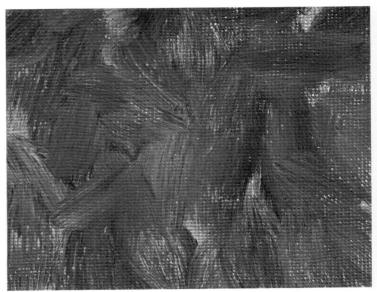

The canvas was first coated with a light color and then a darker color was roughly applied over the wet undercoat. No attempt was made to blend the two colors, but a partial fusion took place as the second coat was brushed over-and into-the first. Wet-into-wet mixtures, done right on the painting surface, look most vital when each color retains some of its identity and the undercoat is allowed to shine through.

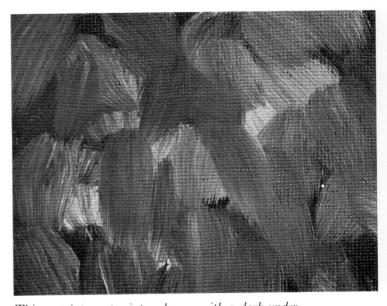

This wet-into-wet mixture began with a dark undertone, and a lighter color was then brushed into the wet surface. The lighter strokes were partially darkened by the wet undertone-which breaks through here and there—creating a lively, irregular blend.

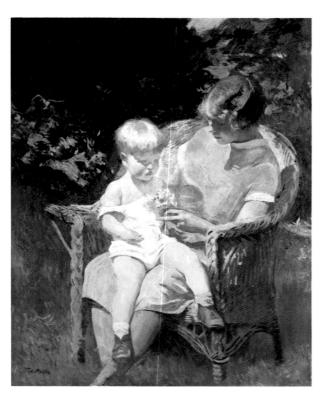

Margery and Little Edmund by Edmund Tarbell, oil on canvas, $50\frac{1}{4}" \times 40\frac{1}{4}" (128 \times 102)$ cm), National Museum of American Art, bequest of Henry Ward Ranger through the National Academy of Design. Most portrait painters stay with quite simple color schemes, like this complementary contrast of the skin tones and the woman's dress. A shadowy and more subdued version of the this same complementary contrast appears in the warm and cool darks that surround the heads. Tarbell links the figures to the background by repeating the color of the dress in the breaks in the foliage. The wicker chair is also painted in quiet versions of the dress and skin colors. As a change of pace, the artist introduces the warm, sunny grass, but places much of the ground in shadow so it won't detract from the sunlit figures. Note how the woman's hair color is echoed in the foliage in the upper right and in the grass on the left. The lights and shadows on the heads are particularly fascinating—as you see in the closeup. Notice how Tarbell blends cool tones—like those of the sky and dress—into the warm tones of the faces. The woman's hair is framed by touches of this same mixture.

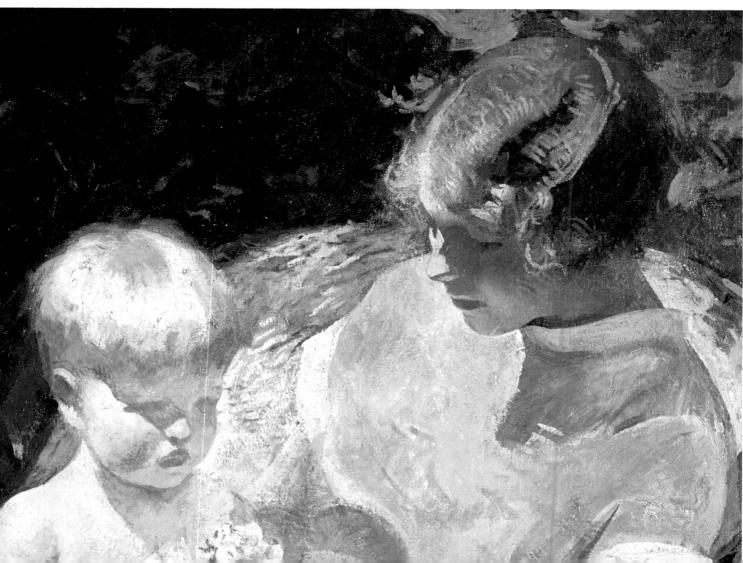

The Caress by Mary Cassatt, 1902, oil on canvas, $32^{7/8}$ " \times $27^{3/8}$ " (83 \times 69 cm), National Museum of American Art, gift of William T. Evans. Mary Cassatt's triple portrait follows a similar strategy. The pale, warm hue of the baby's skin is framed by the dark, cool color of the woman's dress. Thus, the center of interest is established by contrasts of value and color temperature: light against dark and warm against cool. There's also a change of pace in the lower left, where the pink skirt introduces a complementary contrast to the green blouse. But Cassatt chooses a subdued pink that won't divert attention from the center of interest above. Observe how the artist repeats her colors—like a recurring musical theme—throughout the canvas. The children's hair color, for example, reappears in the skirt, on the chair, on the girl's sleeve, and (more subdued) at the top of the woman's blouse. The loose brushwork—in the closeup—emphasizes the soft play of natural light on the skin. Cassatt also knows that women and children's skin color looks most delicate when shadows are played down and modeling is kept to a minimum.

of vellow ochre, lightened with white to a delicate golden tan, and then painting into the wet undertone with a mixture of blue and white. The result is a sky with a kind of warm, inner glow that's hard to get any other way. The golden undertone is particularly effective if the blue is brushed into it very casually, allowing some of the yellow ochre to shine through here and there. At the horizon, you can even fade the blue and allow the golden glow to remain untouched at the lower edge of the sky. Throughout the sky, the yellow ochre warms the blue without turning it green. As you paint in the second color, decide just how much blending you want to do. Wet-into-wet mixtures look best when they're not too thoroughly blended.

You can try this with more dramatic subjects, like that autumn tree once again. Try painting golds and oranges into wet, brown undertones. Or reverse the sequence and paint the yellow and the brown into wet oranges and reds. Blend some portions partially and leave others rough. Above all, don't iron out the passage, but allow the colors to work into one another like the strands in a roughly woven fabric.

The old masters often worked on a colored painting surface which had a beautiful way of shining through the next layer of color and integrating the entire picture. Beginning with a white canvas or panel, they applied a washy, transparent layer of color called an imprimatura. Or they coated the canvas with a solid, opaque tone, which we call an toned ground. If you paint rather thinly on an imprimatura or on a toned ground, the underlying color shines through the brushstrokes and creates an optical mixture: that is, the underlying and overlying colors aren't physically mixed (since the undertone is dry), but they mix in the eye of the viewer. Even if you paint fairly heavily over a toned ground or an imprimatura, the underlying color will come through if your brushstrokes are sketchy enough.

The best way to apply an imprimatura is to dilute the tube color with very thin copal painting medium and brush the fluid paint onto the canvas like watercolor. Don't worry if the imprimatura is a bit streaky; this will en-

liven the brushstrokes that go over the streaks. The best colors for an imprimatura are bright and clear, but not blatant. Warm earth colors like yellow ochre and burnt sienna always work well, but the cadmiums need to be toned down so they won't overpower the colors that go over them. Viridian, bright but not dazzling, is good for the same reason. Actually, you can divide your pictorial design into several broad areas and give each one an imprimatura that will "mix" well with the colors you plan to apply next.

A toned ground is usually solid, opaque paint. Most painters prefer subtle browns, grays, and ochres, but you can try any colors you like—as long as you lighten them and soften them with plenty of white. The effect of the toned ground is to unify all the colors that go over it. A muted golden brown, for instance, lends a general warmth to the entire picture, even though the viewer has no idea what the underlying color is.

Working on a toned ground or an imprimatura is a very simple method of optical mixing. Glazing and scumbling are richer, more complex ways of doing the same thing, and they generate far more exciting results. A glaze is a layer of transparent color applied over a dry coat of some other color, usually one that's lighter and more opaque. The effect is something like putting a sheet of colored glass over a paler sheet of colored cardboard. A scumble, on the other hand, is a semiopaque layer of light color applied over a dry layer of darker color, usually opaque. The effect of a scumble is something like a colored mist which partly obscures the underlying color.

Whether you glaze or scumble, the over-painting (as it's called) appears to mix with the underpainting, and the two combine in the eyes of the viewer to create a third color. Any color—even the most opaque—can be turned into a glaze by adding enough painting medium. And even the most transparent color can be turned into a scumble by adding white, plus enough painting medium to make the color fluid. Try some experiments like glazing blue over yellow to see what kind of green you get, red over yellow to see what kind of orange you get, or even green over red to see the strange,

indescribable tone that you can produce by optically mixing complementaries. Now reverse the process by scumbling yellow (with some white) over red or blue, red over green, or any other combination that intrigues you. The possibilities are endless.

It's hard to visualize the effects of these four kinds of optical mixing until you try them. Perhaps the best way to explain optical mixing is to say that the paint itself seems to have an extra dimension. Colors are within and behind one another; they seem to move toward you from deep inside the picture. This is especially true of glazing and scumbling techniques. Perhaps this is why the paintings of the old masters have a powerful sense of the third dimension.

Optical mixtures look radically different from physical mixtures blended on the palette. A glaze of red over yellow doesn't merely give you a very different orange from a physical mixture of red and yellow; the optical mixture also radiates an extraordinary inner light that no physical mixture can match. To see what I mean, just try physical and optical mixtures of the same two colors. First mix cadmium red light and cadmium yellow light to produce a vivid, opaque orange. Then glaze some cadmium red light over a dry layer of cadmium yellow light. Compare them and you'll never forget the difference.

The lesson really hits home if you take the time to paint the same tomato-preferably one that's not completely ripe and still a trifle green-first with physical mixtures, then with optical mixtures. First try painting the tomato with physical mixtures of yellow, red, and green blended on the palette. Then try underpainting the tomato in yellow and completing it with glazes and scumbles of red, green, and some more yellow. The optical mixtures emit an inner glow that you can't get with the physical mixtures. And the optical mixtures make the tomato seem more three-dimensional.

Some Experiments in Mixing on the Painting Surface

To give you some concrete idea of the diverse color possibilities of mixing on the painting surface, I've given you a few examples. But per-

A glaze is a dark, transparent color applied over a lighter color, usually opaque. The underpainting and overpainting combine optically (though not physically) to create a new color, which is quite different from a physical mixture of the two colors on the palette. Note how the light brushstrokes of the underpainting sometimes break through the darker overpainting.

A scumble is a light, semiopaque color applied over a darker color, which may be either opaque or transparent. Like glazing, this is a method of optical mixing: the underpainting and the overpainting create a new color which is different from a mixture of the same two colors combined on the palette. The bare underpainting appears in the upper left. The scumble is heaviest and most opaque at the right.

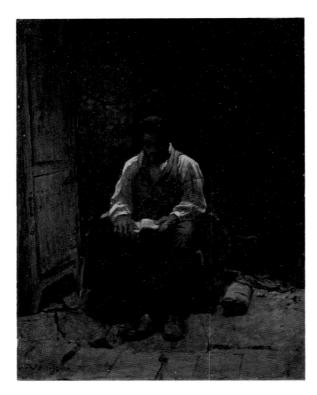

The Lord Is My Shepherd by Eastman Johnson, ca. 1863, oil on wood panel, $16^{5/8}$ " × $13^{1/8}$ " (42) × 33 cm), National Museum of American Art, transfer from National Museum of History and Technology. A powerful contrast of values dramatizes the meditating figure, who emerges from the shadows as his collar, shoulders, arms, and book are caught in the golden light. This light is not only the palest value in the dark picture, but also the only really intense hue producing a contrast of brightness as well as value. (The other bright touches are the reds of the smoldering embers at the lower right, and what appears to be a pocket handkerchief near his knee.) The rest of the figure melts away into the darkness. The warm tone of the man's face seems to blend into the background tone, lending a remarkable tenderness and poetry to this small painting. The same warm mixture, just a bit lighter, appears in the floor. But here the artist introduces a hint of cooler color for relief and he carries this mixture up into the green trousers. In the closeup, you can see that Johnson has remembered an old master technique in applying his colors. He's painted the shadowy darks with transparent color and reserved more solid touches of opaque color for the strong lights—the brightly lit edges of the figure. Transparent glazes tend to recede, while more opaque colors tend to move forward, which is exactly what happens here. Johnson relies on this "rule" for the dramatic impact of his color.

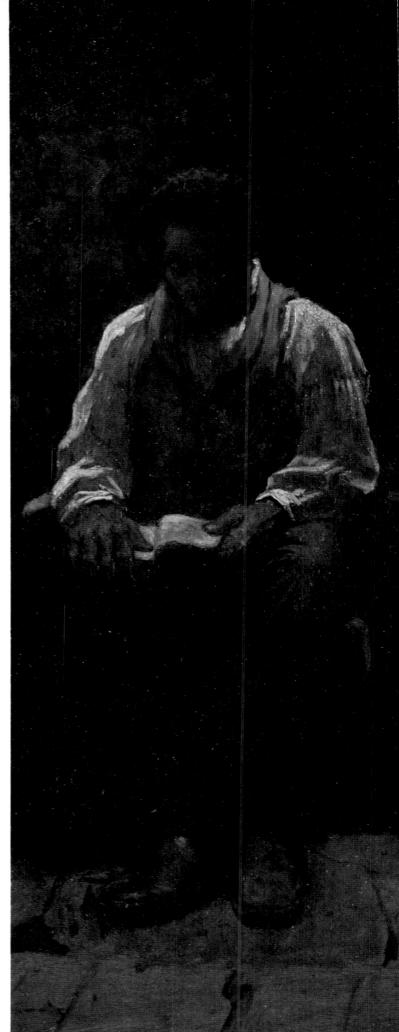

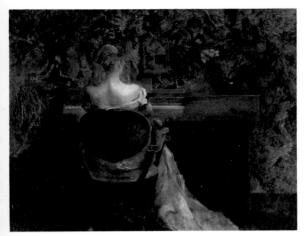

The Spinet by Thomas Wilmer Dewing, ca. 1902, oil on wood panel, $15\frac{1}{2}$ " \times 20" (40 \times 51 cm), National Museum of American Art, gift of John Gellatly. In this view of an elegant female figure in a fashionable interior, Dewing follows a color strategy that's surprisingly similar to Johnson's image of a slave on the opposite page. Once again, you see a picture dominated by warm, shadowy color, suddenly interrupted by a few patches of light that draw attention to a figure that emerges from the semi-darkness. The pale, golden light catches the woman's neck, shoulder, sleeve, and skirt-and the keyboard of the spinet. For relief, cooler touches appear in the background and in the dress. Dewing's method of handling color—as shown in the closeup—is quite different from Johnson's, however. The woman's back is built up with tiny touches that gradually fuse into soft, luminous gradations. It's especially interesting to see how Dewing works cool color into the shadow along the spine, and then places specks of this same mixture throughout the halftones on the back and neck. The hair and the warm background melt into one another—and both are painted with irregular scrubs of transparent color. Like the Johnson picture on the opposite page, The Spinet is executed mainly with transparent glazes that create a feeling of shadowy space that moves away from the viewer. But those few touches of opaque color make the figure move toward you and away from the background.

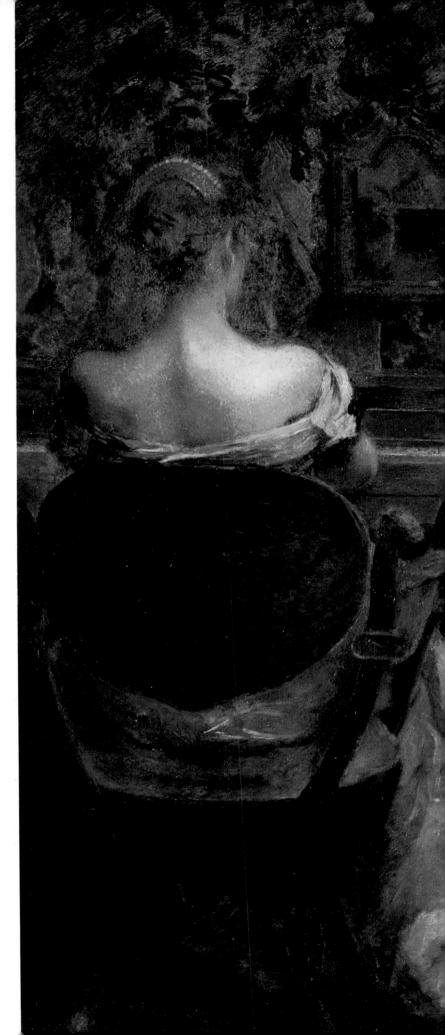

- haps it might be helpful if I actually suggest some painting projects that will reveal why so many artists work wet-into-wet, paint on an imprimatura or on a toned ground, and fall in love with glazing and scumbling once they've tried them. You may not want to try all these projects just yet, but keep them in mind for the next time you're in an experimental mood.
- (1) The safest way to test out wet-into-wet color mixing-at the very beginning-is to plan a picture in which the mixtures are mainly in related colors, rather than contrasting colors. For example, think about doing a seascape with a stormy sky. You can begin the sky with a wet undertone of blue, and then paint into this with deeper grays for the storm clouds. The sea itself can be a muted, green undertone, which you paint into with blues and more grays. You can approach a sunny summer landscape, full of lush greens and yellows, in the same way. The wet undertone for the foliage can be yellow-or perhaps several shades of yellow and yellow-brown—which you can then attack with brushloads of greens, which obviously contain yellow. The cool tones of the distant mountains can be painted blue-into-gray or vice versa.
- (2) Now for some more dramatic experiments in painting wet-into-wet. Plan some pictures in which the colors beneath and the colors on top contrast with one another, or even conflict strongly. Contrasts of warm and cool tones are particularly exciting because so many surprising, unpredictable mixtures turn up. Try underpainting a sky in muted red or orange; then work back into it with rich blues. If you don't stir the colors together too thoroughly, the warm and cool tones will interweave rather than blend, like the vibrant strands in a tapestry; at other points, do blend the two layers of color somewhat more to see what offbeat tones develop. Going back to that sunny, green landscape, try underpainting the entire picture in reds and oranges and violets; then go back in with vivid greens and yellows. Here, the secret to remember is that the top layer should never completely obscure the layer beneath. Allow the color beneath to break through the strokes of the top layer so that you get a fascinating effect of color vibration. You

- can control color intensity by the amount of blending you do: generally, the more you blend, the more subdued the colors become. When you work with contrasting colors, be prepared for lots of surprises, and don't be discouraged if the painting doesn't turn out exactly as you expect it. The unexpected is part of the
- (3) The traditional way of using a toned ground is to pick a color that will function as a middle tone between the lights and darks. Let's say you're painting a portrait head. It's effective to tone the canvas a shade of tan that's darker than the lightest passages of the skin but not as dark as the shadow planes on the side of the nose, forehead, cheek, and jaw. Many old masters blocked in the lights and shadows, leaving the middle tone of the ground slightly exposed. This gives the painter a shortcut to the three basic values of the picture-light, halftone, and shadow-and the toned ground also provides the unifying, overall warmth that's usually seen in paintings of people.
- (4) You can also experiment with a toned ground that reinforces and unifies the entire color scheme of a landscape, a seascape, or a still life. The sunny greens of that same summer landscape might benefit by being painted over a sunny yellow canvas. A gray undertone might benefit the mood of that stormy seascape. A still life of fruits and flowers and growing things might be enhanced by a canvas toned with soft green.
- (5) Having tried these experiments with a toned ground, repeat them with an imprimatura. But you'll notice a significant difference. Since the imprimatura is washy and transparent, the color is more luminous because it has the inner light of a glaze. Actually, your studio light moves through the transparent color of the imprimatura and bounces back off the white canvas beneath. Because an imprimatura is inherently more luminous than a toned ground, you should be encouraged to experiment with brighter colors. Forget about the colored painting surface serving as a middle tone in a portrait and try a light but vivid redbrown (like burnt sienna) as the imprimatura

for a portrait. As you paint flesh tones over this hot color, you'll see how they're warmed and integrated. Try the same thing with a green imprimatura which will cool the flesh tones painted over it. Remember to keep your overpainting thin and rather sketchy.

- (6) Plan some pictures in which each of the major color areas gets its own imprimatura. For comparison, you may want to repeat some of the combinations you tried in the wet-into-wet experiments. Paint the cool tones of the sky over a yellow or orange or red imprimatura. Paint the greens of trees and foliage over an imprimatura of yellow or red or red-brown. You can see that I prefer a contrasting imprimatura, which is far more exciting than something "safer."
- (7) The best way to learn about glazing and scumbling is to paint some still lifes in which each object gets its own carefully selected underpainting. Let's say you're painting a bowl of oranges and lemons. The oranges might look best with an underpainting of yellow, glazed with transparent reds and oranges. The lemons, on the other hand, might work well with a underpainting, scumbled reds with yellow and white. The exciting thing is to invent various combinations. There's no one way to paint any given subject. An eggplant might begin with a purple underpainting and conclude with blackish glazes; or you could start out with a black underpainting and scumble shades of purple over it. Earlier in this chapter, I suggested painting a not-too-ripe tomato that contains red, green, and yellow. The underpainting doesn't have to be yellow, glazed with red and green. It could just as easily be a light green underpainting, glazed with bright red and scumbled with yellow. This is an opportunity to be inventive. However, keep your underpainting a flat color and save modeling for the overpainting.
- (8) Landscapes present new opportunities for inventing combinations of underpaintings, glazes, and scumbles. An obvious way to paint autumn foliage is to glaze oranges, reds, and red-browns over a yellow underpainting. But why not try underpainting some trees in deep

- reds and browns, then scumbling over them with yellow and orange? One of the "rules" of the old masters was to paint light areas in opaque color and shadows in transparent color. You can try this with the planes of a graybrown rock formation. Underpaint the entire shape of the rock with a grayish middle tone; then glaze the shadow sides with murky greens and browns, and scumble the lightstruck planes with a lighter, warmer gray.
- (9) The greatest challenge is portrait and figure painting, of course. The old masters rarely underpainted faces and figures in vivid colors but began with what's called a grisaille. They modeled the light and shadow planes of faces and figures in simple tones of grays or light browns, just to get the forms right. Then luminous flesh tones were glazed over the grisaille underpainting, when it was thoroughly dry. Try this on a portrait or a nude, and you'll see that this method makes your job a lot easier. First you concentrate on accurate drawing, proportion, likeness, light and shade-without having to worry about color-and then you can let yourself and go with color without worrying about wrecking the forms you've worked so hard to render accurately.
- (10) You can underpaint hair and clothing in more vivid colors because these forms usually aren't as hard to draw as faces and hands. The sheen of hair lends itself particularly well to underpainting and overpainting techniques. How many approaches can you think of to render the richness of blonde or red hair? Either one of them can be underpainted in soft yellow and then glazed with browns, red-browns, and oranges. But you could also underpaint them with browns-for the shadows-and then scumble over them with lighter, warmer tones. If your model has the temerity to wear a red dress (and you have the guts to try painting it), there are also several alternatives. You can try the old-master method of painting the folds meticulously in cool grays in order to get the shapes right, then glaze over the dried underpainting with fiery, transparent red. (You can cool down the garish red by underpainting it in green.) Or you can really take you life in your hands and intensify the red by underpainting it

Smugglers' Notch, Stowe, Vermont by Chauncey Foster Ryder, oil on canvas, $45^{1/8}$ " \times $60^{1/4}$ " (115) × 153 cm), National Museum of American Art, bequest of Henry Ward Ranger through the National Academy of Design. The basic color scheme is a contrast of muted complementaries: violet and yellow. The dark woods and the ground beneath them are filled with soft violet mixtures, interspersed with touches of brown, orange, green, blue, and quiet yellows. Yellow dominates the central section of the picture, but Ryder varies the colors of the sky, slope, and sunlit ground by blending in delicate touches of the same mixtures that appear in the woods. The rich pattern of broken color becomes more evident in the closeup. The trees are painted with rough strokes, each retaining its distinct color. Much paler versions of these mixtures, both warm and cool, are carried up the slope and into the sky—with gaps between the strokes to let the soft yellow shine through.

Forsythia and Pear in Bloom by Fairfield Porter, 1968, oil on canvas, $36\frac{1}{8}$ " \times 29" (92 \times 74 cm), National Museum of American Art, gift of the Woodward Foundation. Yellow is the unifying element in the analogous colors of the foreground grass and much of the surrounding foliage—with complementary touches of soft violet mixtures that are so inconspicuous that you hardly notice them. Notice how he ties the color scheme together by spotting touches of yellow throughout. All these colors provide a setting for the white blossoms of the flowering tree, which stands out precisely because its color is so quiet. Unlike the rough, varied brushwork of the Ryder painting opposite, the Porter landscape is painted with broad, flat strokes of fluid color that are particularly apparent in the closeup. The artist knows that color has great impact when it's applied very simply, and so he visualizes the painting as a kind of poster, composed of flat, colored shapes. His brushwork is casual and relaxed, never calling attention to itself, but letting the color sing out. The painting looks so simple that it's easy to overlook the artist's careful planning of colors and shapes.

in yellow. Think back to your still life experiments with oranges and lemons and eggplants and tomatoes. These lessons work just as well with your portrait sitter's dress or the chair she's sitting in.

If you've never tried underpainting, glazing, and scumbling before, you'll find a particularly good treatment of the subject in Frederic Taubes' classic *Oil Painting for the Beginner*. Many of my suggestions are drawn from this excellent book, which adapts classical painting methods to fit the needs of the modern reader.

Lightening Colors

Learning to lighten and darken color is a mixing problem that *should* be easy, but isn't. Theoretically, all you have to do is add some white to make your color lighter and add more black to make it darker. But if you've performed the color exercises in the preceding chapter, you know that it's not that simple. White and black aren't mere lightening and darkening agents; they're colors in their own right, and they can change the essential character of any tube color or mixture.

Let's begin by looking at the problem of lightening a color. I've said that most colors on the palette benefit by the addition of some white. If you want to lighten a color and white gives you the tint that you're looking for, then white is the color to add. But what if you discover that white transforms your color into something you don't want, like the violet tint you get by adding white to alizarin crimson or the pink you get by adding white to Venetian red?

Once you develop an experienced eye, you'll come to the conclusion that lightening a color often means adding white *plus* some color to compensate for the change that white makes. If adding white to alizarin crimson means a significant loss in warmth, then you've got to compensate by adding a touch of cadmium red light to bring the warmth back. If you don't like the pink you get by mixing white with Venetian red, you can compensate by adding some yellow. If you feel that thalo blue turns too cold when you add white, you can warm it up again with some burnt umber.

It's also worthwhile to scan your palette for some other color which might just do a better job than white. One of the best lighteners is yellow ochre (with some white, perhaps) which lightens warm colors without damaging their warmth. You may even find this a good lightener for some of the cooler colors on your palette. There are times when Naples yellow will perform the same function very beautifully.

Darkening Colors

If you add the right compensating color, white can be used to lighten most colors effectively. But darkening a color becomes more of a problem because black usually is inherently wrong for this purpose. Practically every color on the palette loses its identity when you add black. So you've got to find some other solution, and this calls for creativity on your part.

Theoretically, you can darken any color by finding a slightly darker color somewhere on your palette, but you come back to the same problem you have with white; you're not just adding a darkener, you're adding a color. Whatever you add, there's going to be some change in temperature and intensity, as well as in value. The trick is to find the darkener that's most compatible with your original tube color or mixture. The best way to darken a hot red without cooling it too much is to find a deep, warm brown that's reasonably close to the color temperature of the red. Burnt umber and burnt sienna will both work, but burnt umber is cooler and will make a more obvious change in temperature. To darken a pale color like yellow, the best choice might be something like a slightly darker yellow, which is least likely to sully the purity of the original hue; even as light a color as yellow ochre can serve as an effective darkener for cadmium yellow light. You can darken green by adding either a warm or a cool color; at the cool end, ultramarine blue might be the right darkener; at the warm end, the answer might be a comparatively cool brown like raw umber.

There are no rules for choosing the right darkener, but I can give you a few guidelines that summarize what to look for.

(1) When you're trying to select the right dark-

ener, scan all the available colors on your palette to determine which are darker in value than the original color.

- (2) When you've isolated these, determine which are warmer and which are cooler than the original color. Decide whether you prefer a darkener that will warm or cool the color you've already got.
- (3) You've also got to determine whether the darkener is more or less intense than your original color. Will the darkener increase or decrease the intensity of the mixture? Will the darkener's intensity overwhelm the original color or will the original color hold its own?
- (4) Nor should you forget about the old problem of tinting strength. Is the darkener significantly stronger or weaker than the color you want to change? If it's stronger, you've got to be sure that you don't add too much.

With all these factors in mind, make your final choice and hope you're right. It's important to be realistic about the fact that any darkener is a compromise. Learning to live with such compromises is part of the challenge.

Intensifying and Graying Colors

In theory, a color is at its maximum intensity when it comes straight from the tube. A good color manufacturer has done his best to insure that his tube colors are as pure and bright as the pigment allows. But the fact remains that it is possible to increase the intensity of some tube colors by rather simple means.

You've already discovered that certain colors become more intense if you add a small quantity of white. The most obvious example is yellow: most yellows get brighter and brighter as you add more white, up to the point where the white takes over and bleaches out the yellow. The same is true of most blues, as you discovered when you conducted your color tests: practically every blue needs some white to radiate maximum "blueness." On the other hand, there are some colors-particularly certain reds that lose intensity when you add white.

Therefore, white increases the intensity of some colors but decreases the intensity of others. This principle applies to virtually every color on your palette. Practically every color adds intensity to some colors and grays down others. You must get to know what each color will do to the other colors on your palette as well as to mixtures.

Let's look at cadmium red light, probably your most vivid color. Adding a touch of this to alizarin crimson instantly produces a much more vivid crimson. But add even a hint of cadmium red light to ultramarine blue, and you'll produce a much grayer blue. If you want to brighten ultramarine blue, a better solution is to add a touch of some clear, bright green like viridian or thalo. But add either one of these greens to cadmium red light, and you get a more subdued red.

This should all sound familiar if you remember the color wheel I asked you to memorize in Chapter 1. The main value of the color wheel, I said, is to help you remember complementaries-directly across from one another on the wheel-because these are the colors that subdue one another most effectively. Since you won't find exact complementaries on your palette, you've got to interpret the concept of complementaries rather loosely. When you're looking for what the color theorists call a neutralizersomething that grays down another color-find something that's in the same general color range as the complementary. Thus, if you want to gray down a blue, cadmium orange isn't the only possibility; a red-brown like burnt sienna or Venetian red will do the job as well.

The color wheel also provides a workable guide for intensifying color. If the best way to find a neutralizer is to look at the far end of the wheel, it stands to reason that the best brighteners are those nearest your original color. If you've got an orange mixture that needs more snap, the answer is most likely to be a red or a vellow, both colors nearby on the wheel.

By now, you should know enough about color mixing to ask: "But when you add yellow to orange, you're not just changing the intensity; aren't you also changing other things too?" You're absolutely right. You're also making subtle changes in hue, value, and color temperature. You're making the orange brighter by making it a trifle yellower, a trifle lighter,

Mr. and Mrs. Phillip Wase by George Bellows, 1924, oil on canvas, $51^{1/4}$ " × 63" (130 × 160 cm), National Museum of American Art, gift of Paul Mellon. In a portrait, the focus is normally on faces and perhaps on hands—as in this double portrait. Thus, the artist chooses his colors to direct our attention to the sitters' skin tones. Here, Bellows paints almost the entire picture in grays and blue-grays that frame the warm tones of the heads and hands. Lest this become monotonous, he adds a few touches of color to the picture frame, Venetian blinds, parrot, the book, and the floral shape near her knee. The power of this simple color scheme is obvious in the closeup, where you see that Bellows has brightened the reflected light on the shadow side of the head and hands—and actually reddened the hand that lies in the sitter's lap. A few cool touches link the face to the background.

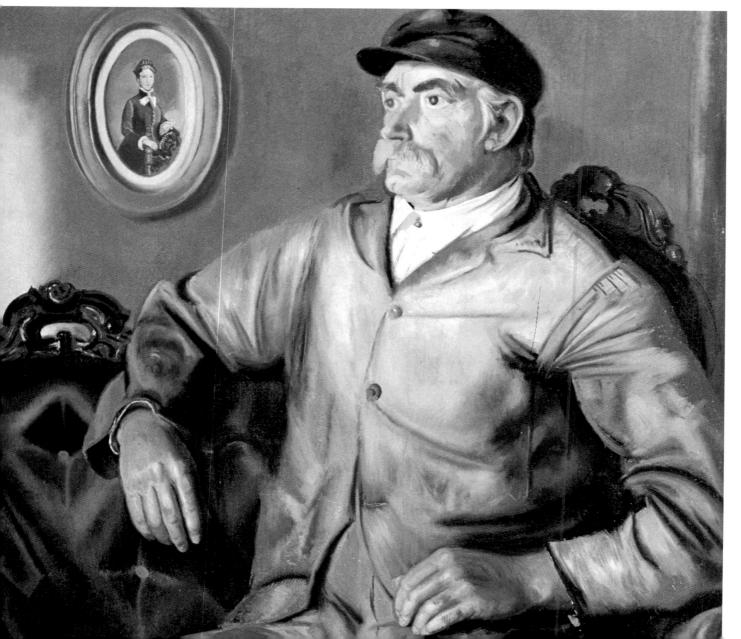

Artists of WPA by Moses Soyer, 1935, oil on canvas, $36^{1/8}$ " \times $42^{1/8}$ " (92 \times 107 cm), National Museum of American Art, gift of Mr. and Mrs. Moses Soyer. In this complex composition of figures in an interior (surrounded by large paintings), color is an essential unifying element. The artist's strategy is to paint most of the picture in neutrals—warm and cool browns and grays-using them not only for the floor and walls, but also for the furniture and the big canvases that fill the studio. Soyer thus confines his brighter colors to the figures and one big canvas, which he places carefully against the neutral background. Like all good colorists, the artist applies his paint very simply, as you can see in the closeup. The color areas are quite flat, with a minimum of blending. This is equally true of larger shapes, such as the floor, and smaller areas, such as the checkered pattern of the blouse. Notice how the modeling of the woman's face also consists of distinct patches of color.

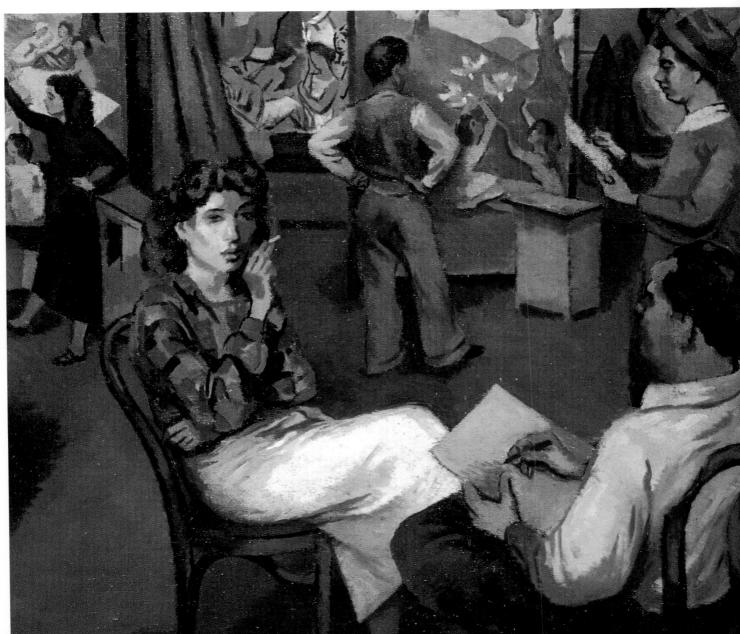

perhaps a trifle warmer. You can't just change intensity without changing other things too. Although I may talk about hue, value, intensity, and temperature as if they're separate phenomena, they all happen together. You can't adjust one without adjusting all the others.

Warming and Cooling Colors

Warming a color doesn't neecessarily mean that you reach for the hottest color on your palette. You can warm up a cold blue like thalo by adding a drop of alizarin crimson (thus pushing the blue a step closer to purple), but this isn't the only way to do the job. A muted earth yellow like raw sienna or yellow ochre may do the same job more unobtrusively. Nor is a warm color the only answer. Perhaps all you need to add is another cool color that's slightly warmer than thalo blue—ultramarine or chromium oxide green, for example.

The same lesson holds true if you're trying to cool down a warm color. To reduce the powerful heat of cadmium red light, it's not necessary to reach for a powerful antagonist like thalo blue or viridian green. A more moderate solution is to find another warm color which isn't as hot as the cadmium. A red-brown earth like burnt umber, burnt sienna, or Venetian red might do the job much more effectively than a cool color, without threatening to demolish that gorgeous red altogether. An even more prudent course would be to reach for one of those marvelously gentle yellows: yellow ochre or Naples yellow.

Caution is the watchword in warming and cooling colors. It's not necessary to jump across to the opposite side of the color wheel in most cases. If you want to warm or cool a color without destroying its integrity, the answer is often a related color which is just slightly warmer or cooler.

The most obvious example of this principle is yellow. Cadmium yellow light is so warm that lots of other warm colors will cool it! Burnt umber is a warm color, but it's so much cooler than cadmium yellow light that even a touch of this warm brown produces a radical drop in temperature. Yellow ochre has the same effect.

To raise the temperature of cadmium yellow light, the answer is also close to home. Hansa yellow light will do it. And so will a touch of white.

Let's see if I can summarize what I've just said in the form of three "rules." If you want to warm up a cool color, first see if you can do the job with a slightly warmer cool color before turning to the warm side of the palette. If you want to cool down a warm color, first see if you can do the job with a slightly cooler warm color before turning to the cool side of the palette. And don't forget that white cools some colors and warms others.

Color Against Color

So far, I've been talking about changing colors by adding other colors. But this isn't the only way. A color is also transformed by its surroundings.

Eliot O'Hara cites a particularly memorable example of this in Watercolor with O'Hara. "I once watched a fellow artist do a portrait of a young Negro girl, which I thought was very good in every respect except color. To me, the face appeared to have a sickly green pallor. Months later, when I saw the same picture in a watercolor show, the green cast was gone and the face looked warm and healthy, yet the only thing actually changed was the background. Instead of the pale pink boudoir of the original scene, the artist had substituted green palmetto fronds with sunlight streaming through them. The complementary pink background had emphasized the green tones in the skin, but the green and gold background toned down the green and brought out the warmer skin tones."

The painter had "saved" her portrait by remembering that a patch of green makes adjacent colors look redder. She'd introduced a note of warmth into the model's skin *not* by repainting the skin, but by creating a cool background that made the skin *look* warmer.

This color phenomenon is so important that it needs careful explanation. In Chapter 1 when I talked about complementary colors, I touched briefly on the fact that complements, placed side by side, intensify one another. Thus, if you place red and green side by side,

the red looks redder and the green looks greener. If you place blue and orange side by side, the blue looks bluer and the orange looks oranger. And so on. What actually happens is that a color seems to add a hint of its complementary to any nearby color. Green makes any nearby color look redder and orange makes any nearby color look bluer.

In a painting, no color exists in isolation. It's always next to another color. Every color is influenced not only by what you add to it but also by what you place beside it. Every color can be lightened or darkened, heightened or neutralized, warmed or cooled by its surroundings. Here are some color problems and some possible solutions, based on what the theorists call the phenomenon of "color contrast."

- (1) The distant mountains in your landscape are actually a warm blue, which you've matched accurately, but they look gray in contrast with the brighter blue of the adjacent sky. If you remember that the complement of that bright sky blue is a bright orange, you'll realize that the blue sky is actually adding orange to the color of the mountain. The orange is neutralizing the warm blue of the mountains and turning it gray. The answer is to get that sky blue away from the mountains and introduce a warmer color. Why not introduce some sunstruck, low-lying clouds along the horizon, so the warmth of the clouds will make these mountains look bluer? Or simply warm up the blue sky itself with a hint of yellow as it approaches the horizon. Whichever solution you choose, some warm color nearby will accentuate the cool tone of the mountains.
- (2) Your portrait sitter's skin has a decidedly pink tone, which looks positively beefy because she's wearing a green dress. The green dress is automatically adding even more red to a reddish complexion. You can get the sitter to change her dress, of course, or you can gradually move the green of the dress towards blue, which will add a hint of orange to the skin. If she absolutely insists that this is her favorite dress and it must be painted accurately, maybe you can convince her to add a blue scarf at the neck. And if her hair is brown or red, you can

exaggerate its warmth just a bit in order to cool her skin by contrast.

- (3) You're painting a landscape in mid-summer, and you've composed the picture so that one large tree is your center of interest, but everything is so green that your big tree fails to hold the viewer's attention. You can't make that central tree any greener-it's already green enough-but you can introduce some warmer tones behind it to accentuate the green. Imagine that some of the nearby trees are beginning to turn reddish-brown just a bit earlier this year. You needn't paint them solid red or brown; just a few branches will do. But this warm note will accentuate the bright green of the tree that's supposed to dominate.
- (4) You're painting a white farmhouse with a green landscape and a couple of red barns off in the distance. In contrast with the green foliage, the two red barns pop out and dominate the picture. You could repaint the barns, but you could also work on their surrounding colors and on the colors that surround the white farmhouse that's supposed to be the focal point of the picture. If you exaggerate the black-green shadows of the trees that surround the white farmhouse, its walls will look a lot whiter and brighter. And if you tone down the green of the trees that surround the two distant red barns, introducing some browns into the foliage to minimize the green-red contrast, the barns will look less red.

As you see, this kind of color control depends entirely on contrast. If you want to make something lighter, darken the color next to it. If you want to make something darker, lighten the color next to it. To brighten a color, subdue the colors nearby. To subdue a color, brighten the colors nearby. To warm a color area, add cool surroundings. To cool a color area, add warm surroundings. You may have an unerring eye for matching the colors of nature, but you can't paint a successful picture until you learn to control these color contrasts.

Correcting Colors

Everyone makes serious errors in his paintings from time to time both in color mixing and in

Betty Wertheimer by John Singer Sargent, 1908, oil on canvas, $50^{3/4}$ " \times 39³/8" (128 \times 100 cm), National Museum of American Art, gift of John Gellatly. When a portrait sitter chooses a costume as dazzling as this one, the painter must plan his colors so that the dress doesn't steal the picture and distract attention from the head. Sargent's solution is to heighten the contrasts around the head in two ways. First, he emphasizes the coolness and delicacy of the sitter's skin—by framing her face with a hair color that's the darkest note in the picture. Second, he places the head against a cool sky tone and then carries the red of the dress into her hair to create a striking contrast with the sky. Thus, despite the competition of the dress, the boldest contrasts of value and color temperature appear around the face. And Sargent repeats these contrasts—as you can observe in the closeup—in the face itself, where the hair color is repeated in the eyes, and the red again appears on the lips and ear. Both the skin and the dress are painted in quite flat tones. Sargent executes the fabric with large, simple strokes and lets them stand, with very little blending. You might expect more blending in the skin, but this too is painted in fairly flat color. The artist limits his blending to the edges of the forms, where light and shadow meet. Notice such important subtleties as the cool notes in the skin, the warm reflected lights in the shadows on the head and neck, and the hot reflection in the edge of the arm that picks up color from the brilliant fabric.

Portrait of Paul P. Juley by Sidney E. Dickinson, 1950, oil on canvas, $46'' \times 40^{1/8}''$ (117 × 102 cm), National Museum of American Art, gift of Paula Juley Baker. Here's another portrait in which the sitter—a distinguished photographer—is shown in a colorful garment that happens to be essential to the picture because it's his working outfit. And the painter deals with the competing colors in a way that recalls Sargent's solution to a similar problem shown on page 106. Dickinson puts his strongest color and value contrasts around the head. He uses the cool color of the smock to frame the warm color of the shirt and the sitter's head. He also frames the face with the bright colors of the hair and the shirt. Then he places the lighted head against the dark background, creating the boldest value contrast in the painting. Thus the hair, face, and shirt become the warm focal point of the pictorial design. Then, to prevent the head and shirt from becoming an isolated island of warm color, the artist repeats the skin tones on the hands, camera, and even on the bench in the lower left. The rich contrasts of value and color temperature are executed with surprisingly flat color, as you discover in the closeup. Dickinson works with big strokes of thick, juicy paint, laid over one another and placed side-by-side—with minimal blending to avoid killing the vitality of the pure color. The lights and shadows in the face, for example, are flat color areas with just a bit of blending where they meet. The details of the forehead, nose, and mouth are rough, unblended strokes—so that even these details are colorful.

his color schemes. I've given you various guidelines for adjusting tube colors and mixtures, plus some suggestions about altering the balance of the picture by controlling color contrast. But here are some additional suggestions for correcting obvious errors in a wet or dry picture.

If a color seems obviously wrong and the picture is still wet, the odds are usually against your saving the passage by blending in fresh color. If you think you can save it by adding strokes of fresh color wet-into-wet, try it; but be sure that you add the new color with quick, decisive strokes and a minimum of blending. Too much blending is likely to mean mud. If the wet-into-wet attack won't work, scrape out the entire passage with a knife and start over.

When you scrape out the offending passage, don't leave hard edges around the shape you've removed. The scraped passage shouldn't look like you've cut it out with a scissors. Try to wield the knife so that you leave a slightly soft, ragged edge. The soft edge makes it easier to integrate the fresh color with the surrounding colors, avoiding the feeling that the new passage has been stuck on like a piece of colored paper.

If the painting is too dry and the unsatisfactory color is hard as a rock, you've got to repaint it so that the fresh color integrates with the overall texture of the picture. The secret is the old-master technique called "oiling out." Apply a very thin coat of painting mediumwith a brush, a cloth, or even with your fingerto the offending passage and a bit beyond. Then when you apply fresh color, you'll be painting on a wet surface and the strokes will seem to merge with the rest of the picture. You can then wipe away any excess painting medium that's left around the edges of the fresh paint.

It may be unnecessary to repaint the entire passage, of course. Perhaps all you want is an additional hint of warmth or coolness or maybe a suggestion of some other color. The solution may not be a solid layer of fresh paint but a glaze or a thin scumble that mixes optically with the color beneath. If a green needs to be just a bit bluer, try a light glaze of blue over the original color. If an orange needs slightly more

yellow, try a delicate scumble of yellow, which should integrate nicely with the orange if you've "oiled out" the passage beforehand.

And don't forget that you can change a color by adjusting its surroundings, rather than repainting the color itself. That added glaze or scumble or wet-into-wet effect may actually work best alongside the color you want to change.

Mediums and Varnishes

The subject of color control would be incomplete without some brief discussion of the influence of mediums and varnishes.

As it comes from the tube, oil paint is stiff, not fluid. This consistency may be right for impasto painting (thick paint applied with knives or big brushes). But most painters add some sort of liquid medium to make tube colors more

Plain turpentine makes tube color more fluid for a brief time, until the turpentine evaporates. But this solvent does absolutely nothing for your colors. In fact, many painters claim that tube colors thinned with turpentine actually lose intensity when the turpentine is gone.

Nor is the popular 50-50 blend of turpentine and linseed oil much of an improvement. As compounded by the manufacturer, tube color contains about as much linseed oil as it needs, and too much linseed oil can actually threaten the permanence of a painting.

Centuries ago, the old masters found that the ideal medium to preserve color luminosity consisted of a solvent like turpentine or mineral spirit, a heat-processed oil like stand oil or sunthickened oil, and a resin like damar or copal. The turpentine or mineral spirit provides the solvent to thin the paint, then evaporates when it's no longer needed. The heat-processed oil another form of linseed oil-improves the brushing quality of the paint and toughens the dried paint against future wear and tear. And the resin is actually a kind of varnish which brightens and preserves the color from within. Copal and damar painting mediums are made by several leading manufacturers and are sold in any well-stocked art supply store.

Just as the right painting medium enhances color luminosity from within, the right varnish enhances the color when the painting is dry. Colors always look brightest when they're wet and have a tendency to "come down" as the painting dries. As soon as the picture is dry to the touch, you can spray or brush on a light coat of retouching varnish, which restores freshness to your colors temporarily. Because retouching varnish is mostly solvent and just a bit of resin-usually damar-it forms a very thin coat, hardly enough to protect your colors over the years. It's just enough to freshen the colors so you can enjoy the painting while it's drying out to accept a heavier coat of varnish.

Two or three months after it's dry to the touch, a thin painting is sufficiently dry all the way through to receive a coat of "final" picture varnish. A thicker painting might take six months and a really thick painting can take as much as a year to dry thoroughly. By the time you're ready to apply picture varnish, the effects of retouching varnish have usually worn off. Damar and copal picture varnish both contain a much higher concentration of resin than the thinner retouching varnish. A good varnishing job will preserve the brightness of your colors for decades, although even the best-preserved picture needs cleaning and revarnishing eventually.

Sundown by George Inness, 1894, oil on canvas $45'' \times 70''$ (114 \times 178 cm), National Museum of American Art, gift of William T. Evans. Here the painter gives us a sunset that's dominated by cool color. The strategy, of course, is to paint the foreground and much of the sky in cool mixtures to set off the lovely, warm notes of the setting sun and its waning light that falls on the cattle, the figure, the houses, and the trees. It's worth noting that nearly all these warm touches appear near or on the horizon, where the cool areas of the sky and meadow come together The warm tones of the horizon are also echoed higher in the sky, but they're so delicate that they don't compete with the richer colors below. Inness emphasizes the soft, diffused light with soft-edged brushwork, as you see in the closeup. All edges and transitions are soft and blurred. Thus, the warm hues seem to melt into the cool surroundings. Notice how the grass is literally filled with warmth.

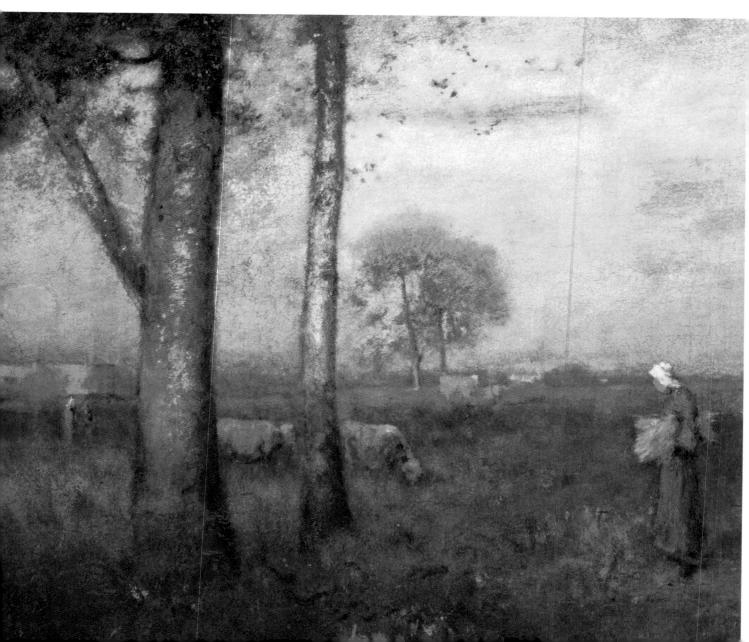

End of Winter by John Henry Twachtman, after 1889, oil on canvas, $22'' \times 30^{1/8}''$ (56 × 76 cm), National Museum of American Art, gift of William T. Evans. At first glance, this may seem like a cool picture—as we expect of a winter landscape—but Twachtman, like Inness, does the unexpected. As we study the landscape closely, we see the warm tones of spring creeping through the cool neutrals. This pale, misty picture turns out to be filled with warm color after all. The contrasts are also stronger than we think, particularly around the stream, where the artist places his strongest darks and lights to establish the center of interest. Twachtman's characteristic brushwork-scrubby and softfocus-is revealed in the closeup. Warm and cool colors are scrubbed together in a magical blur that somehow congeals into an atmospheric landscape. The color is applied thinly, leaving gaps where warm tones shine through cool areas and cool tones appear within warmer mixtures.

Applying Color with Brush and Knife

The way you apply color-and the way that color looks on the painting surface-is profoundly influenced by the tools you use and by the nature of the painting surface itself. There are many ways of applying color with these tools, as you'll see if you spend any time walking through museums, examining the "handwriting" of the great artists of the past. Whole books could be written on this subject (like Coulton Waugh's excellent How to Paint with a Knife), and this chapter simply suggests some directions to explore.

Brushes

The traditional brushes for oil painting are the relatively stiff bristle brushes (made of hog hair) and the softer sables and oxhairs. Each type of brush leaves a very different kind of mark in the wet paint, and this has decisive effects on the quality of your color.

The most widely used bristle brushes are called flats and brights. The flats have a long, resilient, rectangular body of bristles that come to a squarish end. The brights are rectangular and square-ended too, but the body of bristles is considerably shorter and less resilient. There's also a kind of brush called a filbert which starts out flat and squarish where the bristles leave the metal ferrule (the metal tube that grips the hairs) and then tapers to a rounded tip. Filberts usually have a long body, like flats. Among painters who like a bristle brush with a rounded tip, the filbert has generally replaced the round bristle brush (with a cylindrical, rather than flat body of hairs) once favored by the old masters.

Sables and oxhairs are made of the soft hairs of various fur-bearing animals. These hairs are far more slender and flexible than the stiffer hog hairs used for bristle brushes. Sables and oxhairs come in flat shapes of various lengths, as well as in round, pointed shapes, more like watercolor brushes. Squirrel or badger hair is often used for especially soft brushes called blenders.

In order to understand the effect of these various brushes on wet paint, try to visualize the action of the brush itself. As the brush spreads the wet color, each bristle or hair leaves

behind a small groove, like a plow moving through the earth and leaving behind a furrow. The thicker and stiffer the bristle or hair, the deeper and wider that groove will be. The groove holds a tiny shadow, practically invisible unless you look very closely. The deeper the groove, the stronger the shadow will be, of course. Obviously, the brush that leaves the most decisive dent in the paint also leaves behind the most pronounced shadows. And the brush that leaves the slightest dent in the paint produces the least pronounced shadows. Either way, these shadows are inseparable from the color.

Now, let's see how this relates to the different kinds of brushes I've described.

- (1) The stiffest bristle brush—the one that digs most deeply into a layer of wet paint-is the bright. Because short bristles don't bend as easily as long ones, the bright can carry more paint than any other brush and can make bold, three-dimensional strokes. This is why brights are so useful to the painter who seeks rich textural effects. But the bright does leave behind deeper furrows than any other brush, and this means a pattern of jagged shadows that reduce the brilliance of your color. Although you gain in textural excitement, you must be prepared to lose some brilliance. You can't have it both
- (2) The bristles that are used to make flats are just as thick as those used to make brights, but the body of the brush is longer and therefore more resilient. This means that the flat doesn't bite into the wet paint quite as deeply and leaves behind shallower grooves in the wet surface. There are still shadows, but the paint is smoother and the color is a bit brighter. The texture of the painting isn't as bold, but your color gains in clarity, and you can get softer gradations when you want to blend one color into another.
- (3) Filberts and flats are equally resilientthough you can sometimes buy extra long filberts which are more resilient-and both roughen the painting surface far less then the brights. But the soft, slightly ragged tip of the filbert makes a slightly blurry stroke, which is part of the fascination of the brush. The bristles

can dig into the paint just as deeply as those of a flat, leaving behind grooves of about the same depth. But if you just skim the surface of the painting with the tip of the filbert, you get an even softer stroke and shallower grooves. So the filbert can make slightly smoother paint, with a gain in color clarity.

(4) It should be obvious, by now, that the soft hair brushes (sables, oxhairs, squirrels, and badgers) produce the smoothest paint with the shallowest furrows and the clearest color. The super-soft brushes called blenders leave practically no impression in the wet paint. So soft hair brushes yield the brightest color. However, soft hair brushes-particularly blenders-can be overused. They can be mistakenly employed to smooth out the color by repeated strokes that eventually iron all the life out of your paint and actually reduce intensity.

Make no mistake about it: this is not an argument for painting everything with soft hair brushes in order to minimize shadows within the paint and make everything smooth and bright. There are times when you want paint to be rough and irregular and other times when you want it smooth as silk. Most of the time you want your paint to be somewhere in between. In a single painting, there can be many different textures. Whatever your tastes in so-called paint quality, remember the basic rule: the rougher your texture, the less brilliant your color will look.

Painting Knives

The smoothest stroke of all is made by the painting knife. The straight edge of the knife blade obviously has no irregularities that might leave shadow-catching furrows in the stroke. So it stands to reason that a passage painted with the knife would be more brilliant than a passage painted with the brush.

In the chapters on color mixing, I spoke of the palette knife as the best mixing tool, but I said nothing of the painting knife. Let me explain the difference.

The most common palette knife has a blade about 4" long, terminating in a slightly rounded tip. Some painters prefer a straight

Dover Plain, Dutchess County, New York by Asher B. Durand, 1848, oil on canvas, $42^{1/2}$ " × $60^{1/2}$ " (108 × 154 cm), National Museum of American Art, partial gift from Thomas M. Evans and museum purchase. In this panoramic landscape, the artist uses color to create a sense of deep space stretching miles to the horizon. True to the "laws" of aerial perspective, the landscape is divided into distinct planes, each with its own value and color temperature. The foreground is darkest and warmest-even though the colors are predominantly coolwhile the flatland in the middle distance is paler and cooler, and the distant mountains are paler and cooler still. To draw our attention to the center of interest, the artist uses the familiar device of placing warm figures against the cooler background. In the closeup, notice how Durand warms the foreground foliage with tiny touches of sunlight, and then cools the distant mountain with small touches of blue-gray shadow.

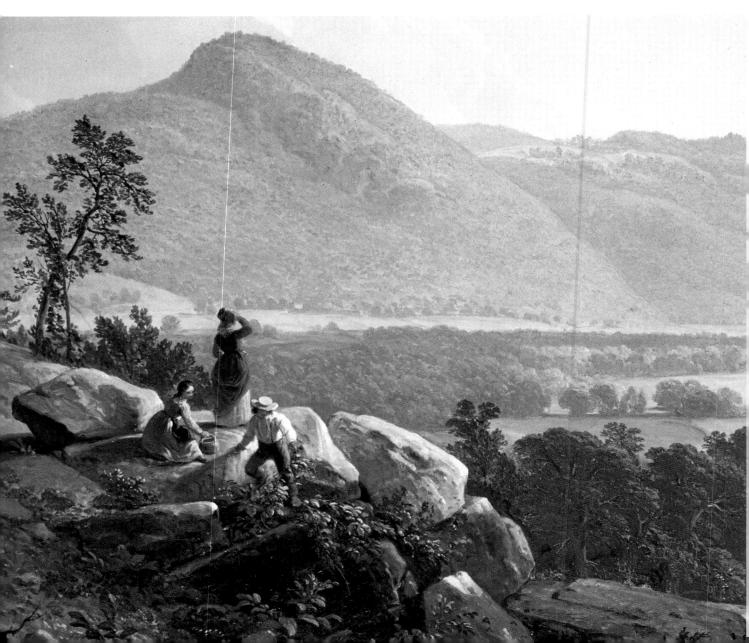

Upland Pasture by Julian Alden Weir, ca. 1905, oil on canvas, $39^{7/8}$ " × $50^{1/4}$ " (101 × 128 cm), National Museum of American Art, gift of William T. Evans. The sunlit meadow is brightened by the cool sky above and the cool shadow in the foreground. It's interesting to note that the shadow mixture is roughly what you'd get by mixing the sky and sunlight colors—a subtle way of unifying the color mixtures in the painting. Weir also links the land and sky by using similar colors in the rocks and the clouds. The closeup reveals still other devices for tying the colors together. For example, working with tiny touches of the brush—rougher and thicker than those in the Durand painting, opposite—Weir carries the sunny meadow mixtures down into the rocks and foliage. The colors of the foreground shadows reappear (in small touches) in the shadowy blur beneath the tree. The artist then warms the tree with specks of hot color.

Painting knives come in a great many shapes, depending upon the kind of strokes you want to make. A short, diamond-shaped blade, about 2" long, is serviceable for most purposes. The blade is usually thinner and springier than a palette knife, so that the painting knife responds more like a brush.

The smooth, shadowless stroke isn't the only reason that a painting knife produces the clearest, brightest color. The knife also allows you to pile up a very thick, solid layer of color so that the sheer density of the pigment produces the greatest possible richness. If you look back at your experiments with loose color mixtures, you'll find that a patch of paint partially mixed with a brush doesn't look quite so vivid as the same patch mixed with a knife.

Painting Surfaces

The two most common surfaces for oil painting are canvas and panels. Each has its own special influence on your color.

Canvas, of course, is a fabric woven of linen or cotton fibers. Even the smoothest canvas has a distinct texture, and some painters prefer canvas almost as rough as burlap. The warp and woof of the fabric naturally cast small shadows, and the entire surface is actually crisscrossed by tiny shadows which become more pronounced in rougher grades of canvas. Even the smoothest, whitest canvas always carries a hint of gray because of these built-in shadows.

In contrast to the woven texture of cotton or linen, a wood or hardboard (usually Masonite) panel is normally smooth. The white gesso coating on the panel is smooth, too, unless you apply the gesso roughly on purpose. So a bare panel generally looks more luminous than a bare canvas.

Theoretically then, the road to the purest color would be to paint with a knife on a panel.

But it doesn't work out that way. The smooth, rigid, textureless panel doesn't respond properly to the springy, sensitive blade of the knife, which actually feels best on the springy surface of a stretched canvas. The knife is hard to control on a panel, slithering across the smooth surface like someone who's learning how to skate. The flexible, toothy canvas grips and stabilizes the knife. I think this is why knifestrokes on a panel always look so lifeless and uncontrolled, while knifestrokes on canvas look decisive and vital.

Here are some guidelines to help you decide when to use canvas and when to use a panel.

- (1) If you're planning a painting with heavy, irregular textures—painted mainly with the knife or with bristle brushes—canvas is best. The roughness of the fabric unifies and softens rough knifestrokes and brushstrokes, helping to tie them all together. The weave of the fabric and the texture of the paint will both contain a fair amount of shadow, but this may actually help to control thick color that might become too vivid.
- (2) For complicated color effects involving drybrush and broken color (more about these in a moment), the texture of canvas is absolutely necessary. Canvas lends itself especially well to wiping, scratching, and scraping techniques. The weave of the fabric and the resiliency of the fibers also make it easier for you to create subtle blends and gradations.
- (3) Panels are most effective if you like to paint with smooth, fluid color, using resilient painting tools, such as sables, oxhairs, or your longest bristle brushes. The smooth surface will make your colors look most brilliant if the paint isn't applied thickly and roughly, but in a fluid consistency that preserves the smoothness of the panel. A panel is especially good for transparent painting because the inner light of glazes and scumbles is enhanced by the shadowless brilliance of the gesso.
- (4) A toned ground and an imprimatura both look good on canvas. But on a panel, I'd stay away from a toned ground and stick to an imprimatura, which preserves the smoothness and luminosity of the gesso.

(5) An elaborate buildup of color in many layers, with lots of underpaintings and overpaintings, is best executed on canvas. The texture of the weave will hold lots of paint, so you can keep piling it on. But the smooth surface of the panel looks overworked if you pile on too many layers of color; the color seems tortured and loses its freshness.

A final word about the color of the painting surface. Over the centuries, artists have come to agree that, no matter what color you plan to pile on top of it, the original painting surface ought to be as brilliant a white as you can get. Whether you buy canvas from an art supply store or prepare it yourself, be sure that your painting surface has a good, solid coat of white lead. A panel should carry a solid coat of the traditional glue gesso or the modern acrylic gesso. If you apply the gesso yourself, it's best to do it in several thin layers, so that the brushstrokes are invisible and leave no shadowy fur-

Just as a stained glass window needs sunlight behind it for the colors to shine forth in their full beauty, oil paints need whiteness behind them. Colors may look opaque, but the inner light of the painting surface is always there, even if you can't be sure you see it. Even if that white surface is covered by a toned ground or an imprimatura, the whiteness lends clarity. It's worth remembering that oil paint often becomes more transparent with age, so that the white ground becomes even more important as the years pass.

Thick and Thin, Rough and Smooth

A thick, roughly painted picture-or a thickly painted, heavily textured passage within a picture-should look free and spontaneous, but actually it needs careful planning. Those rugged, seemingly accidental strokes must be visualized beforehand, placed just where you want them, and then left alone. Just as color loses its vitality when it's too thoroughly mixed on the palette, color quickly loses its freshness when you keep pushing the paint mixture around on the painting surface. This is especially true when you work with thick paint. Knowing that an impasto brushstroke starts out with all of those tiny crevices of shadow, don't reduce the freshness of your color even more by stirring it around.

Van Gogh, who probably painted the thickest, brightest pictures in history, is Exhibit A. The elaborate network of brushstrokes in a Van Gogh is as carefully planned as a tapestry. The colors were painstakingly premixed on the palette to avoid any second thoughts once the paint was on the canvas. In his mind's eye, Van Gogh located the stroke (or series of strokes) on the painting surface; he decided not only the location of the stroke, but its direction, length, width, and thickness. With all of these decisions made in advance, Van Gogh then attacked the passage rapidly and decisively, placing each stroke where it belonged-and rarely touching it again. Despite all the jagged shadows on his craggy painting surfaces, Van Gogh's colors remain amazingly fresh. Like the great masters of Japanese brush-painting, Van Gogh knew that spontaneity must be planned.

Of all impasto painting techniques, knife painting requires the most planning and the most decisive attack. An impasto passage painted with the brush can be moved around a bit if necessary, though it's still best to leave it alone. But once a knifestroke is on the canvas, it's there to stay, unless you scrape it off and start over. The most you can do to a knifestroke is smooth it out with one or two additional strokes; but you'll soon discover that each time you go back to adjust that first stroke, the color dies a little. The unique brightness and clarity of knife painting depend upon a carefully planned attack. You've got to visualize each stroke before you touch the knife to the canvas. Remember that a knife is not a spoon-it's meant for spreading, not stirring.

Thin, smooth passages of paint take more pushing around than impasto passages. First of all, thin paint is physically easier to move around simply because there's less of it. Thin paint is also more transparent and therefore draws luminosity from the white canvas or panel beneath. This inner light helps to preserve the freshness of the color even if you subject the painting to prolonged brushing. You'll also recall that smooth color looks somewhat

Sun and Storm by Paul Dougherty, ca. 1907, oil on canvas, $35^{3/4}$ " \times 48" (91 \times 122 cm), National Museum of American Art, gift of William T. Evans. The artist has set himself the difficult challenge of capturing the strange color of a storm on a sunny day. At first, we think of the sea as a pale, cool tone, while the rocks seem distinctly warmer and darker. But then we look more closely and we see that the rocky forms are mainly in shadow—and those shadow mixtures are quite cool. Only the sunlit planes of the rock formations are really warm. The brushstrokes in the closeup are a fascinating patchwork of warm and cool color. In the shadows of the rocks, the artist brushes rough strokes of muted blue, green, and gray over a warm undertone that constantly breaks through. There's only a bit more warm color in the sunlit planes, which also contain many cool touches. The sea, however, isn't nearly as cool as we expect, but is full of delicate, warm color, suggesting sunshine.

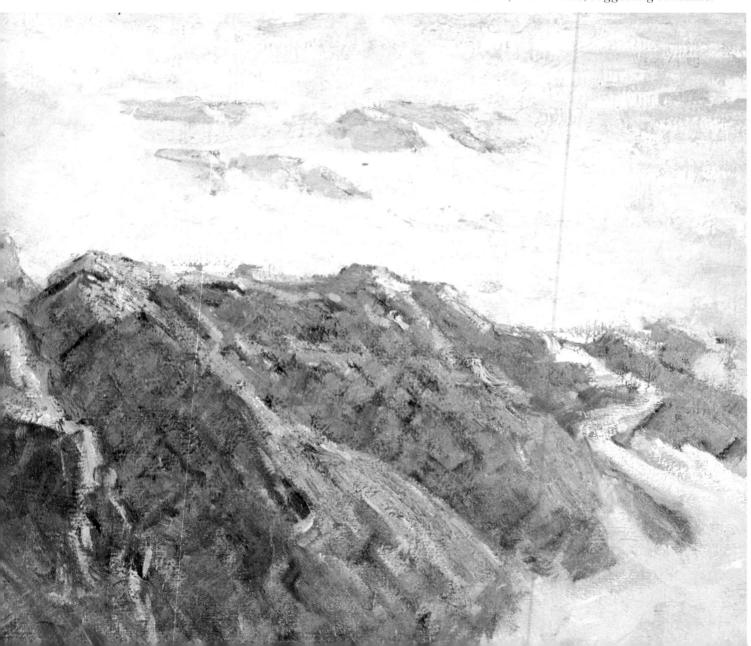

Southwesterly Gale, St. Ives by Frederick Judd Waugh, 1907, oil on canvas, 301/8" × $50^{1/8}$ " (76 × 127 cm), National Museum of American Art, gift of William T. Evans. The artist frames a sunlit wave—illuminated through a break in the storm clouds-between the dark sea in the foreground and in the distance. At this moment, the "laws" of aerial perspective just don't work. The foreground and the distance are both darker and cooler than the pale, warm middleground, which becomes the center of interest. The closeup shows how Waugh ties the colors together. The dark, distant headland mixtures reappear in the foreground waves. The sky tone is reflected in the foreground foam. And this same color-now the light color of the foreground foam-literally flows into the sunlit middleground, where it becomes pale shadow.

brighter because the strokes contain fewer shadows, so you have more "brushing time."

But don't abuse that "brushing time." Too much brushing deadens even the thinnest, most brilliant glaze on the most luminous underpainting. You may not have to plan every stroke, as you do in a heavily textured painting, but you should still keep your strokes to the minimum. Every teacher of painting knows the adage: "It takes two people to paint a picture—one to apply the paint and one to hit him on the head to make him stop."

Blending

If you've got to discipline yourself to keep your number of strokes to the absolute minimum, how can you achieve those beautiful, melting color gradations and smoky shadows that we admire in the great masters? Looking at the flesh tones in a figure painting by Rubens—with its incredibly soft transitions from light to halftone to shadow to reflected light—the viewer gets the feeling that the painter must have spent hours with a fistful of sables, brushing and brushing and brushing. It looks as if Rubens went over each stroke a dozen times with a soft hair blender. But he didn't!

The old masters knew that too much blending meant death to their colors, so they found ways of creating soft blends without too many strokes. If you look carefully at the masters of magical blending like Rubens, Rembrandt, and Velasquez, you'll make some surprising discoveries:

- (1) Most of the color areas in their paintings are fairly flat with a minimum of gradation. If you look at the lighted frontal plane and the shadowy side plane of a Velasquez head, both planes are essentially flat color with very little internal variation.
- (2) The blending occurs mainly at the spot where the two planes meet. If the artist must indulge in prolonged brushing to get the softness he wants, he focuses his attention on the smallest possible area: the edge of the form, where light blends into shadow or one color blends into another.

- (3) To counterbalance the thoroughly brushed, thoroughly blended edge where the two planes meet, the artist often surrounds the blended areas with much more casual brushwork. For example, if you look at a Rembrandt portrait, you'll see that most of the brushwork is rough, with the strokes standing out prominently around the few blended areas.
- (4) The blended areas are kept thin in order to retain as much luminosity as possible. The unblended areas are sometimes thin, sometimes thick, but they retain enough textural variety to offset the smoothness of the blended areas.
- (5) Even the blended areas are often rougher than you think. From a distance, the gradations may seem smooth and textureless, without a sign of brushstrokes. But when you get closer, you can often see the mark of the brush in the blended passages and can sometimes count the strokes. Even here, the masters remembered to keep the number of strokes to the absolute minimum in order to maintain the freshness of their colors.

The simplest way to test out these principles is to paint some globular shape, such as an apple or an orange. Put the fruit near a window or near a lamp, so that you get a clearly defined area of light on the subject, a clearly defined shadow area, and a halftone in between. Don't simply paint the apple a solid red or the orange a solid orange and then blend in some darker color on the shadow side. It's far better to mix one color for the lighted side and fill in that area. Then mix the right tone for the shadow side and fill in that area. Finally, with the minimum number of strokes you can get away with, blend the two color areas just where they meet. The narrow blended zone forms the halftone. The two main color areas are actually flat, and the strokes in these areas should be as casual as possible. Only that narrow edge between them is thoroughly brushed.

Don't blend the entire apple or orange, no matter how strong the temptation. From the proper viewing distance, the form will *look* smoothly blended if you blend just that one zone where light and shadow meet. When you're tempted to overdo the blending, remind

yourself of this fundamental color principle: flat color, casually brushed, looks brighter than graded color, thoroughly brushed.

Broken Color, Drybrush, and Pointillism

Having said that flat color looks brightest, I hasten to add that brightness isn't the only test. Variety is also important. Although they knew how to create bright color when they wanted to, the impressionists were also willing to sacrifice brilliance for the sake of variety. They developed what we now call broken color.

Broken color is just what the name implies. If you look closely at many impressionist paintings, you have the feeling that the surface is literally broken into thousands of flecks and blurs and dabs of color, like a melted mosaic. The sky isn't a uniform blue, but a patchwork of warm and cool tones that flicker and vibrate and merge in the viewer's eye. There are often unlikely colors within other colors: a blue sky turns out to contain touches of pink and violet where you least expect them; the blue-green sea contains flecks of orange and brown; the white snow contains yellow and purple. None of these passages is as bright as a flat patch of purple or orange might be, but the entire picture is filled with vibrating, constantly changing, constantly surprising color.

Broken color can be an end in itself, simply a fascinating method of optical color mixing which makes your picture look like a gorgeous tapestry. Or broken color can have a specific function like rendering the intricate texture of an old stucco wall or a weathered wooden fence. Here are some broken color techniques.

Wet-into-wet. The technique called wet-intowet is actually a broken color method. If you start out with a wet undertone of one color, then paint back into it with strokes of a second or even a third color, the effect is broken color if you allow all three colors to retain their identity. So long as you don't blend them all together but allow the separate strokes to stand out, the effect is very similar to that of the broken color of the impressionists.

Stroke-against-stroke. The impressionists usually placed strokes of color side by side, allowing

When you blend one color area into another, keep the two adjacent areas fairly flat and fuse them just where they meet. Don't try to create a continuous gradation over a large area; you'll brush the paint to death. Limit all that brushwork to the smallest possible area and avoid overworking the rest of the picture. Besides, flat color looks clearer and brighter than gradated color.

Another way to fuse colors—but avoid overworking them—is to vary your brushwork. Where two adjacent colors must be blended into each other, they'll need prolonged brushing; but restrict this thorough brushing to a small area where the two colors meet, and then purposely surround the smooth area with rougher brushwork.

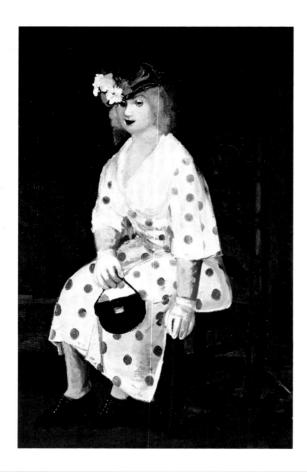

The Polka Dot Dress by George Luks, 1927, oil on canvas, $58^{1/8}$ " \times 37" (147 \times 94 cm), National Museum of American Art, gift of Mrs. Howard Weingrow. The dress and the face flow together to become a single pale value against the dark background—a cool, somber tone that emphasizes the brightness of the dress and heightens the warmth of the skin color. The chair and the background are roughly complementary, but their values are close enough to subdue the contrast and avert any competition with the figure. Luks uses the same two complements (red and green), plus bright touches of the remaining primaries, to animate the hat and call attention to the face, with its smear of lipstick and dark eyes that echo the hat. The shoes also repeat the dark tones of the hat. The artist links the figure to its setting by using the same warm color for the shadows on the arms and legs, on the floor, and in the broad tone scrubbed behind the head. The vivid colors of the hat are revealed in the closeup. Luks simply daubs on the brightest colors on his palette—the three primaries and white—to spotlight the head. He paints with broad strokes of juicy color, swinging the brush as freely as a man painting a barn door! There's a bit of blending in the skin, hair, and background, but it's done with a few rapid scrubs to preserve the vitality of the color.

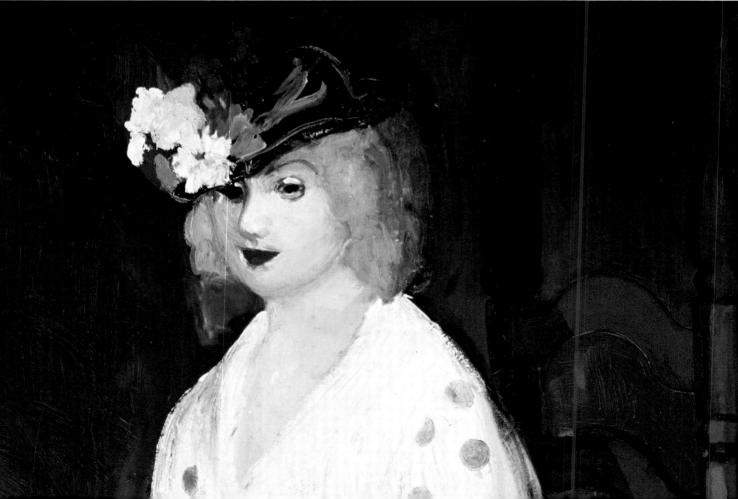

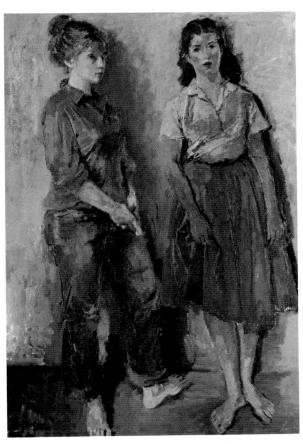

Two Girls by Raphael Soyer, 1961, oil on canvas, $47'' \times 32''$ (119 × 81 cm), National Museum of American Art, gift of S.C. Johnson & Son, Inc. The colors here are so quiet that it's easy to overlook the fact that this is a study in muted complementaries. The orangy skin tones of the girl in jeans are literally surrounded by the complementary colors of her blue clothing and the wall. The wall also complements the skin color of the other girl-but a second complementary contrast appears in her clothing: the pink blouse and greenish skirt are also complementaries in a gentle, inconspicuous way. The warm neutrals in the jeans and skirt are also worth examining. On the jeans, the shabby color above the knees is approximately the hue you'd produce by blending the colors of the skin and the faded denims. And the warm darks in the skirt are actually a mixture of muted red and green. The closeup shows how Soyer uses very simple means to unify his colors. A few casual strokes of the cool background tone are carried into the warm blouse. Conversely, the cool blouse is warmed by inconspicuous touches of warm flesh tone, which you can see on the sleeve, collar, and bust. The brushwork is deceptively soft because Soyer works with small brushes and ragged, scrubby strokes. But like all skilled colorists, he does minimal blending, letting the strokes "mix" in your eye.

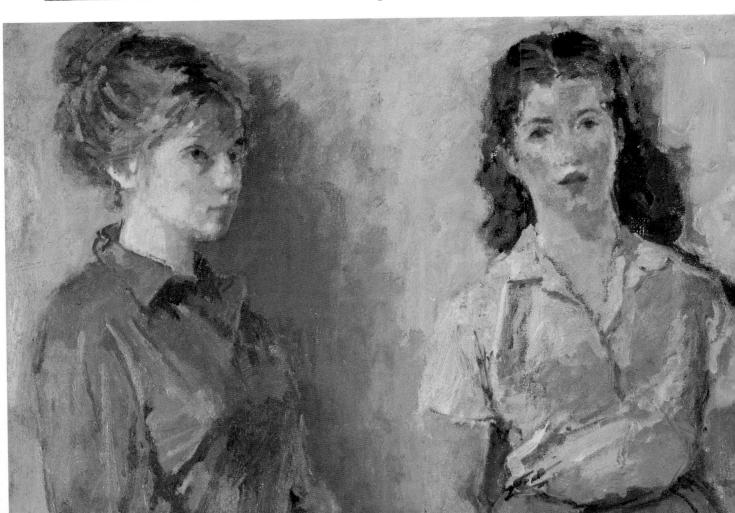

The transition between one color and another doesn't have to be smoothly brushed. You can bring the two colors together with quick, casual strokes that keep your color alive. The blend may look rough to you, but it will smooth itself out in the eye of the viewer.

The impressionists piled one wet stroke over and into another, creating partial mixtures on the painting surface purely by the action of the brush applying the paint. A certain amount of blending happened "accidentally," but the strokes were never ironed out and each touch of the brush was easy to see.

each stroke to overlap the next stroke slightly. This overlap created a partial blend where the two strokes met. Then, additional color adjustments were made by piling on more strokes over those beneath. As the strokes were piled next to and over one another, a rough impasto was often built up, developing the distinctive, ragged texture that's characteristic of Monet.

Pointillism. Painters like Seurat refined the stroke-against-stroke method into a much more precise technique called pointillism. The entire painting consists of small, round dots of color applied with the tip of the brush. These are not rough, casual strokes of thick paint, but relatively uniform touches of color, like the tiles in a mosaic. Color mixing takes place in the viewer's eye. Theoretically, if you interweave dots of blue and yellow, the viewer sees green—but a much more vibrant, flickering green than he'd see if blue and yellow were mixed on the palette and applied flat.

Loose mixtures. You've already discovered (in Chapter 4) that loosely mixed color is more vibrant than thoroughly mixed color. This is actually a method of creating broken color on the palette before you apply paint to the canvas. If you stir together two or three colors with a knife or brush but stop before the colors actually merge, you have a broken color mixture. When you pick this up with the brush and apply it to the painting surface, the stroke contains strands of each color in the mixture. The effect is something like a tweedy fabric; each fiber retains its color identity, yet it intertwines with all the others.

Drybrush. This is actually an underpainting and overpainting technique. You start out with one layer of fairly thick, irregular color with lots of distinct brushstrokes. When this is dry, you apply additional colors with a very light stroke, just skimming the rough underpainting. This skimming stroke deposits color on the peaks but skips over the valleys. Where the brush has skipped over the valleys, the underpainting shines through. Where the brush has touched the peaks, the underpainting and overpainting combine to create a new color.

The pointillists applied their colors in small, fairly neat dots made with the tip of the brush. Each dot had a distinct color and wasn't blended with the other dots. Seen from a distance, the dots were supposed to mix in the viewer's eye and form new colors. Such color has a wonderful flickering quality.

If you apply dots of color roughly and vigorously, over and into one another, you get a wet-into-wet mixture that seems to combine the best qualities of impressionist and pointillist color. The dots are softened, but they don't quite disappear.

Drybrush starts out with a rough underpainting, which you allow to dry. Then the second coat is applied with very light strokes, just skimming the ridges of the underpainting and depositing color on the high points only. This illustration shows dark drybrush over a textured middle tone, also applied with a brush.

This drybrush sample shows a dark underpainting lightly brushed with a pale overtone. Because the drybrush strokes touch only the high points of the rough underpainting, the underlying strokes are thrown into bold relief.

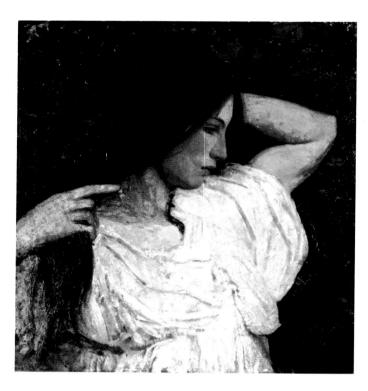

Girl Arranging Her Hair by Abbott Handerson Thayer, 1918–1919, oil on canvas, $25^{5}/8'' \times$ $24^{1/4}$ " (64 × 62 cm), National Museum of American Art, gift of John Gellatly. The young girl's face is the single note of rich, warm color in this subdued canvas. The hot color of her cheek and lips, surrounded by the warm blush of her skin. is framed by darkness above-where the hair merges with the somber background—and by her white gown below. Even her other skin tones—her neck, chest, arm, and hand—are cooler and more subdued than her face. The artist places a wedge of darkness next to her profile to create a strong value contrast. The closeup may surprise you with its rough brushwork, particularly in a subject where you might expect a great deal of soft blending. In the face, the artist lets the canvas roughen his brushwork to give the paint a lively, spontaneous texture. And the rest of the figure remains ragged and sketchy, full of unpredictable broken color. The white gown isn't white at all, but contains pale hints of other colors, picking up the background tone at the raised shoulder and the skin tone at the neckline.

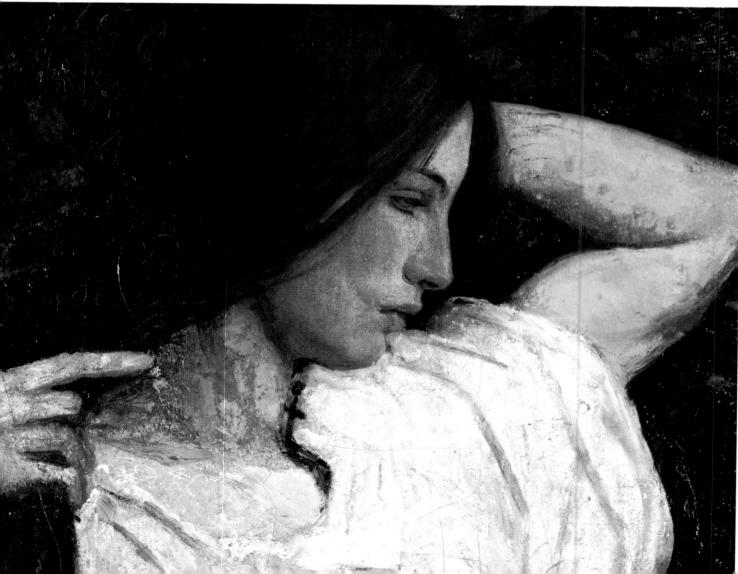

Self-Portrait in Gray Shirt by Edwin Dickinson, 1943, oil on canvas, $24'' \times 19''$ (61 × 48 cm), National Museum of American Art, gift of S. C. Johnson & Son, Inc. Here's a more extreme example of the color strategy you've seen in the Thayer portrait on the opposite page. Nearly the entire portrait is painted in monochrome, with the merest hint of warmth in the skin and a patch of richer color on one cheek. Practically the entire canvas is covered with misty middletones, plus a few strong value contrasts that call attention to the head. But look at the closeup for a memorable lesson in color temperature: Dickinson works in rough-edged patches of color, within which there are delicate shifts of temperature—from warm to cool and back again. The head is composed of so many different warm and cool grays that it seems as varied (in its own way) as a head painted in a much fuller color range. And notice that single blur in the background at the left of the head; the color temperature seems to change with each slight shift of your eye. The painting teaches us that grays can be as colorful as anything else on the palette.

A dark, transparent glaze was brushed over a lighter underpainting, which had been applied with a knife and allowed to dry. While wet, the glaze was lightly scraped with a knife to expose the high points of the rough underpainting.

A light semiopaque scumble was brushed over a dark underpainting, which had been executed with a knife and permitted to dry. The wet scumble was lightly scraped with a knife to reveal and accentuate the ridges of the dark tone beneath.

This is what might be called "drybrushing" with a knife. A rough underpainting was applied with the knife and allowed to dry. Then a very small amount of dark color was picked up on the underside of the knife blade, which was moved lightly across the canvas darkening the high points of the underpainting and the high points of the canvas texture.

Here's another example of knife "drybrush." A dark underpainting was applied with the knife and permitted to dry. A small amount of light color was picked up on the underside of the blade and skimmed across the rough texture of the dried undercoat.

Underpainting, overpainting, and wiping. Here's a technique which is just the reverse of drybrush. Once again, you start with a roughly brushed, heavily textured underpainting, which you allow to dry. When it's dry, you brush on a liquid glaze or scumble that covers the peaks and also settles into the valleys. While this overpainting is still wet, you slightly wipe away the wet paint and lift the color that covers the peaks, leaving the valleys untouched. Now the underpainting shines through on the peaks where you wiped the overpainting away, but the underpainting and overpainting combine to form a new color in the valleys.

Scraping and scratching. There's still another way to use that rough, heavily textured underpainting. Making sure that the underpainting is bone dry, try techniques such as (a) drybrushing with a knife, (b) glazing and scumbling with the brush and then scraping away wet paint with the knife, and (c) glazing and scumbling with the brush and then scratching away selected areas with the tip of the knife.

Each of these techniques is exciting in itself,

but you should also think of practical applications. Wherever possible, the technique should match the subject. The stroke-againststroke method of the impressionists is particularly good for painting the rapidly changing light on clouds, trees, and water, which were the subjects that fascinated the impressionists most of all. The pointillist technique is good for these subjects, too, but this highly controlled pattern of dots also lends itself particularly well to more geometric subjects, such as figures, buildings, and still life. Textured underpaintings-drybrushed, wiped, and scratchedare ideal for closeups of heavily textured subjects, such as rocks and treetrunks.

One warning about broken color effects: don't get so carried away that the technique dominates the picture. Monet and Pissarro didn't invent broken color; they discovered colors within colors in nature. They saw broken colors where other people simply hadn't seen them before. If you force broken colors where they don't belong, your color will look artificial and contrived. Look for broken color effects in nature and learn how to interpret them.

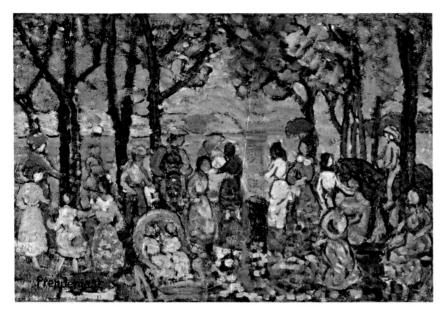

Summer, New England by Maurice Prendergast, 1912, oil on canvas, $19^{1/4}$ " \times $27^{1/2}$ " (49 \times 70 cm), National Museum of American Art, gift of Mrs. Charles Prendergast. The artist has covered the entire canvas with big rough dabs of paint that actually follow a simple logic. The sky, water, and grass are all cool colors, against which the artist places the figures and trees-all of which are either warmer or darker than the landscape. At the center of interest—the break in the trees—there are two dark figures in cool dresses, plus the lightest figure in the painting, and two umbrellas that are the brightest notes on the canvas. And the whole painting is unified by the repetition of colors over the whole surface, like tiles in a mosaic. Prendergast's brushwork—in the closeup—produces wonderfully rich color. He dabs, scrubs, and drybrushes one mixture over another, leaving lots of gaps where the underlying color can shine through.

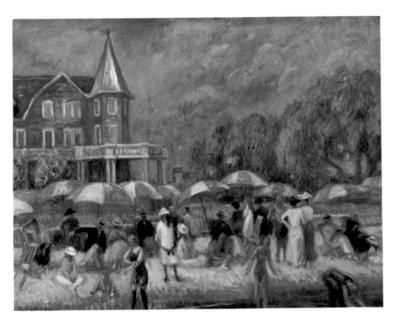

Beach Umbrellas at Blue Point by William Glackens, 1915, oil on canvas, $26'' \times 32''$ (66 \times 81 cm), National Museum of American Art, gift of Mr. and Mrs. Ira Glackens. Here's another frieze of figures outdoors, built around a contrast of complementaries. The blue sky and the orange umbrellas—plus the orange house—establish the basic color strategy. Glackens ties the painting together by carrying the orange down into the beach, up into the grass and trees, and throughout the figures. He then spots touches of blue among the figures and trees, so that the two complements are interwoven throughout this sunny pictorial design. The closeup shows Glackens's wonderfully loose brushwork. Although he does some mixing on the palette, he also does a lot of mixing right on the canvas, brushing one color into another, wet-in-wet. But he executes these mixtures with the fewest possible strokes—just barely blending the colors, while preserving their freshness.

6.Palettes andColor Schemes

In Chapter 2, "Colors for Oil Painting," I recommended a basic starter palette which you can work with until you develop your own personal color preferences. Now that you've conducted the color tests in Chapters 3 and 4—and perhaps experimented with the various methods of color mixing described in Chapter 5—this is a logical time to consider how to organize a palette that may suit your needs more precisely. And since your palette is inseparable from the color schemes you're going to create with it, I'm going to make some suggestions about color schemes as well.

Simplified Palettes

The old masters had far fewer colors available than we have now. Until the latter part of the 19th century, you couldn't walk into an art supply store and select your colors from racks of tubes by the dozen. Instead, painters made their own colors from the limited number of permanent pigments then available. Rarely using more than six or eight colors in a single picture, they produced an astonishing range of mixtures and color harmonies.

There's no special virtue in depriving your-self of the great variety of permanent colors now sold in the stores, but you can learn a lot by painting some pictures with a very limited palette. If you arbitrarily restrict the number of colors you allow yourself to use—and choose these colors with care—you'll be forced to push the potential of each hue to its maximum. Not only will you learn to get the most out of slight variations in a mixture, you'll also be forced to learn how to alter these mixtures by making subtle changes in the colors that surround them.

Perhaps the most extreme example is the palette that's supposed to have been used by Velasquez. Some scholars claim that his basic palette consisted of just four hues; a red-brown earth like burnt sienna or Venetian red; an earth yellow like yellow ochre; a black similar to our own ivory black; and white lead, which we now call flake white. Blue and bright red were set aside for special occasions, such as painting the royal robes of a princess or a cardinal. Those four basic colors seem terribly subdued, and I'm sure you wonder how Velasquez

could produce his lifelike color effects with such limited means. But he knew how to make the most of them.

If you look closely at the color tests you've done with yellow ochre, Venetian red, and ivory black, you'll see that they can function as muted primaries. Yellow ochre starts out as a kind of tan, but it grows yellower as you add more white. Venetian red is certainly as close to red as it is to brown. And black does behave something like blue; ivory black and yellow ochre produce a muted green, while ivory black cools Venetian red to a deep brown.

But how did Velasquez make these muted mixtures look so alive? When Degas was asked the same question about his own work, he said: "With grays." Surround Venetian red with a cool gray, and this red-brown earth suddenly blossoms as a vivid red. Surround a mixture of yellow ochre and white with the right shade of warm gray, and you suddenly have a cool yellow. Even that unpleasant, steely gray you get by mixing ivory black and flake white turns into an airy blue-gray (or even a delicate blue) in warm surroundings. Paint a portrait or a nude in the Velasquez palette and force yourself to learn how to vitalize a muted color by placing it in the right surroundings. Learn how to convert a gray into a color by placing the right warm or cool hue nearby.

You'll also discover that the slightest change in the proportions of a mixture will yield something entirely new. For example, ivory black, yellow ochre, and white give you anything from brown to gray to olive green, depending upon the percentage of each color in the mixture.

Having tried this most subdued of all palettes, you might go to the opposite extreme to try the three most vivid primaries you can buy. A really dazzling four-color palette would be cadmium yellow light, cadmium red light, thalo blue, and flake white. Brilliant in themselves, these colors also produce brilliant mixtures. The two cadmiums yield an equally stunning orange; thalo blue and cadmium yellow give you a vivid green. Having learned how to intensify the subdued colors of the Velasquez palette, you now have to learn how to hold down all these vivid colors so they won't clash. Even in the brightest picture, some colors must dominate and others must play second fiddle. So, this palette forces you to learn how to gray down an intense color without destroying its vitality.

It's also good discipline to invent limited palettes for particular subjects.

For painting the classic seascape of rocks, waves, foam, and sky, perhaps your limited palette should be dominated by cool colors. You could really get by with one blue (ultramarine, thalo, or Prussian); a bright, transparent green such as viridian or thalo; and an all-purpose brown, either on the cool side, like burnt umber, or on the warm side, like burnt sienna; plus the usual white. The blue and green, warmed with a touch of brown when necessary, give you a full range of cool tones for sea and sky. The brown, modified with blue or green, gives you the colors you need for rocks and sand, whether in light or in shadow. And combinations of blue and brown or green and brown give you a full range of warm and cool grays for the shadow areas on clouds and foam. If you feel the need for a hint of sunlight, add yellow ochre to this limited palette.

Think of limited palettes for different kinds of landscapes. For a Vermont landscape in summer, teeming with greens, the right palette might consist of two blues and two yellows to mix all those greens, plus a brown for relief. For a desert landscape, rich in warm colors, the most suitable palette might consist of an earth yellow, a red-brown earth, and a brown, with just one blue for a cool note when necessary.

Inventing restricted palettes-and learning how to get the most out of them-is a valuable challenge to your creativity. It's one of the best possible learning experiences, even though you'll probably want to use a more diversified palette later on.

Palettes for Landscape and Seascape

There's no reason why you can't keep two dozen tubes of color in a drawer and then select ten or twelve for a particular picture. Your choice will depend not only on the subject, but on the working conditions you anticipate.

In general, it's a good idea to take along

Indian Summer by Jasper Francis Cropsey, 1886, 71/8" \times 13" (18 \times 33 cm), National Museum of American Art, bequest of Martha L. Loomis. There are two delicate complementary contrasts in this color scheme. More obvious is the violet-vellow contrast of the distant shore, sky, and water. Less obvious is the fact that the artist has worked just enough blue into the mountains to suggest a blue-orange contrast with the warmer colors of the autumn foliage. You can see this more clearly in the closeup. Notice how Cropsey brushes an airy blue into the mountains where they meet the warm mixtures of the nearby shore. He then carries touches of this cool mixture into the wooded landscape, actually placing tiny touches of blue among the foreground foliage, not only to suggest gaps where the sky comes through the leaves, but to link the colors of land and sky. He also links the foreground and middleground with small touches of green. And the red hues of the trees are echoed in the figures at the lower left.

The Brook at Carversville by Edward Willis Redfield, oil on canvas, $27'' \times 32''$ (69 × 81 cm), National Museum of American Art, bequest of Henry Ward Ranger through the National Academy of Design. Although autumn gave Cropsey lots of bright color to work with (see page 134), Redfield must make the most of the dim colors of an overcast winter day. The landscape is a dialog between warm and cool neutrals. There are no dead grays here—no lifeless mixtures of black and white. As you see in the closeup, every neutral mixture contains a hint of a more vivid color: yellow, orange, blue, or violet. The houses and bridge are a varied patchwork of these colorful neutrals, too. The snow isn't a chilly gray, but dimly reflects the sunlight that filters through the clouds. (The artist told a friend that he always added a speck of red to snow mixtures.) And Redfield also adds sparks of hotter color to the dead leaves that hang among the branches.

fewer colors when you paint outdoors than when you're working in the studio. It's a nuisance to squeeze out fifteen different colors when you're working in tropic heat and fighting off mosquitos or trying to keep your collar up in a howling seawind. Within the protective walls of your own studio, you have the leisure to try out all the colors you want, though it's still a good idea to hold yourself down to a reasonable number of colors and not start squeezing out tubes indiscriminately.

If you like to paint both landscapes and seascapes outdoors, Harry R. Ballinger suggests a standard palette of clear, bright colors in his two excellent books Painting Landscapes and Painting Sea and Shore. Ballinger's all-purpose, high-key palette consists of ultramarine blue, cerulean blue, cadmium yellow pale, cadmium orange, cadmium red light, cadmium red deep, and alizarin crimson, plus zinc white. He also suggests having burnt sienna and yellow ochre available for occasional use. You'll notice that this palette stays away from subdued colorsthe only earth colors are considered optional and there are no greens at all. Ballinger assumes that you want to start out with the brightest possible colors and then subdue them when necessary. He also expects you to be creative about mixing greens and browns, rather than find them ready-made on the palette.

John C. Pellew, author of Oil Painting Outdoors, recommends an all-purpose palette of ten colors, including lots of earth colors, since he finds these everywhere in nature. He recommends cadmium yellow light, yellow ochre, raw sienna, cadmium orange, cadmium red light, burnt sienna, burnt umber, cerulean blue, and thalo blue. You'll see that four out of ten tubes are earth colors. Like Ballinger, Pellew doesn't include green but expects you to mix it. He points out that practically every warm color on his palette-except for cadmium red light and burnt umber-makes a beautiful green when mixed with one of the blues. Note that both Pellew and Ballinger leave out black. Even the brightest colors, such as a blend of cadmium orange, cerulean blue, and white, make beautiful grays.

Both of these are excellent all-purpose palettes. However, it's also possible to select a

palette that's specifically suited to landscape or seascape painting.

Since the natural landscape rarely contains powerful colors like the cadmiums, you could leave them out altogether and find all your warm hues among the earth colors that actually come from the soil itself. A full range of reds, yellows, and browns-which harmonize automatically since they're all earth colorswould include Venetian or light red, burnt sienna, yellow ochre, raw sienna, raw umber, and burnt umber. To broaden your range of yellows, so you can mix all those greens you're going to need in a landscape, add Naples yellow (which looks and acts like an earth color) and hold cadmium yellow light in reserve for notes of brilliant green when you need them. Just two blues complete the palette: ultramarine on the warm side and Prussian on the cool side. Prussian has a particularly "earthy" color of its own and has a special affinity, I think, for earth colors. If you want to broaden the range of cool colors in this predominantly warm palette, add black, and you really ought to try chromium oxide green, which harmonizes particularly well with the earth tones.

The palette I've just described is a fairly full one which you might find convenient for studio painting, but perhaps it's too extensive for working outdoors. The color selection can be tightened up to suit your taste. An abbreviated version of this palette might contain just the two blues, Prussian and ultramarine; one earth red-brown, such as burnt sienna or Venetian red; one subdued and one bright yellow, let's say yellow ochre and cadmium yellow light; a cool brown, such as burnt umber; plus black and white.

In contrast with the predominantly warm palette I've just described, a palette for marine painting might be dominated by cool hues. You may want three blues: a warm, transparent one, like ultramarine; a cool, transparent one, like thalo; and a cool, opaque one, like cerulean. You may also feel the need for a bright, transparent green, such as veridian or thalo, and a subdued, opaque green, like chromium oxide. Black would further extend your list of cool colors. Along the shoreline, the warm colors tend to be subdued, sandy and

rocky tones, so a handful of earth colors might be all you need: yellow ochre, burnt sienna, and burnt umber, let's say. For an occasional hint of red or pink in the sky at dawn or dusk, you might want to keep alizarin crimson in reserve. And for a cool subject like the sea, you may prefer zinc white to the somewhat creamier flake white.

For painting out on the rocks, with the surf blowing in your face, you could cut this palette down to a warm and a cold blue, like ultramarine and thalo; just one green, like viridian; yellow ochre and burnt sienna (which can be darkened to a colder brown); black; and white.

None of these is the "perfect" palette. What I really want to do is stir up your imagination and encourage you to experiment to come up with the right palette for you.

Palettes for Portrait and Figure Painting

Since portrait and figure painting are normally done indoors, you can have as big a palette as you like. But even if you keep dozens of tubes on hand, you'll probably use only a dozen or less in any one picture.

Some portrait and figure painters lean toward earth colors because this range of soft vellows, tans, browns, and red-browns seems inherently right for skin tones. Other painters prefer to mix their flesh tones from the brighter colors, occasionally resorting to earth colors for more subdued effects.

Everett Raymond Kinstler lists his palette in his lively book Painting Portraits. Laid out on the palette from light to dark, his colors include white, cadmium yellow pale, raw sienna, cadmium orange, cadmium red light, light red, alizarin crimson, burnt sienna, raw umber, cerulean blue, ultramarine blue, chromium oxide green, and black. As you can see, the palette contains four earth colors, plus an earthy green. These are balanced against the much brighter cadmiums. I also find it particularly interesting that he steers away from powerful blues, such as thalo or Prussian and sticks to blues that won't overwhelm the warm tones in his pictures-that dignified old workhorse, ultramarine, and the soft, clear cerulean, with its limited tinting strength.

In his comprehensive book on portrait painting techniques, Complete Guide to Portrait Painting, Furman I. Finck suggests a more limited palette of nine colors, then recommends others that might be worth having on hand. His nine basic colors are viridian, cobalt blue, burnt sienna, ivory black, yellow ochre, cadmium yellow light, cadmium red light, alizarin crimson, and white. Just two of these are earth colors, both of them useful in mixing various flesh tones, but he does expect you to mix many of your flesh tones from the other colors on the palette. Like Kinstler, he steers away from powerful blues, preferring a light, airy blue like cobalt for cool flesh tones, a blue that won't overwhelm the warmer tones nearby. Finck also suggests that you consider green earth (the most delicate of all greens); cerulean and ultramarine blue (the blues that Kinstler prefers); gold ochre for flesh tones; Naples yellow; cadmium orange; and rose madder, a more delicate relative of alizarin crimson which is sometimes useful for pink flesh tones.

Lacking modern colors such as the cadmiums-the bright yellows, oranges, and reds now most widely used-the old masters relied almost entirely on earth colors for their flesh tones. Nor did they have powerful cool colors such as thalo blue, thalo green, or Prussian blue. Thus, their typical palette for portrait and figure painting relied mainly on warm earth colors, supplemented by a few cool colors. A contemporary version of such an old-master palette might include Venetian red and burnt sienna for the red-browns; burnt and raw umber for the cooler browns; raw sienna, yellow ochre, and Naples yellow in the yellow-tan range; green earth (the favorite subdued green of the early Renaissance) or chromium oxide green; ultramarine for your warm blue; cobalt or cerulean for your cool blue; ivory black; and flake white (since the old masters used only white lead). And, like Velasquez, keep a tube of alizarin crimson around for special occasions, such as painting a bright red dress.

This "old-master palette" has another interesting feature which simplifies color mixing. Except for Venetian red and chromium oxide green, all the colors have roughly the same tinting strength. Thus, most of the colors can

The Gift by Ernest Leonard Blumenschein, 1922, oil on canvas, $40^{1/2}$ " × $40^{1/4}$ " (103 × 102) cm), National Museum of American Art, bequest of Henry Ward Ranger through the National Academy of Design. Placed against a background of shadowy foliage and dark, huddled figures, the standing figure in the pale cloak instantly becomes the focal point of the picture. The golden sunlight, flickering through the leaves, creates a kind of halo around the central figure—more evident in the closeup. The artist has observed the colors of the cloak with great care, recording the warm lights, cool halftones, and warm shadows. The gift—a striking piece of weaving that hangs from the hand—is important. Blumenschein dramatizes it by placing its cool color against the warm hue of the garment. Notice how bits of sky break through the leaves around the standing figure's head, explaining the cool, reflected light on the left side of his hood.

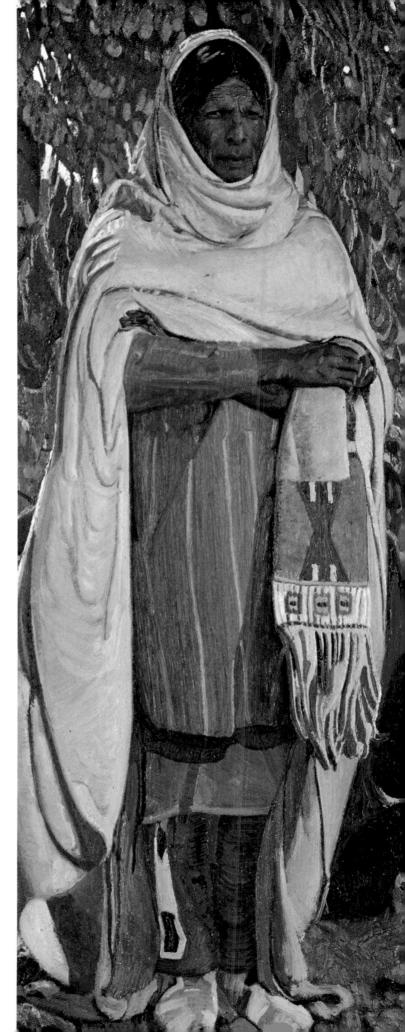

John Gellatly by Irving Ramsey Wiles, 1930–1932, oil on canvas, $79^{1/8}$ " \times $38^{1/2}$ " (201 × 97 cm), National Museum of American Art, gift of Irving R. Wiles. The figure of the great collector, clad in white, is placed against a dark background that becomes darkest around his head—the focal point of the portrait. Artists always love to paint white because, like snow, it reflects so many other hues. In the closeup, you can see that Wiles has discovered and emphasized beautiful blue and violet reflections in the shadows on the suit. He also picks up the warm note of the pocket handkerchief in the edge of the big reflection on the jacket, and again—unobtrusively—in the sitter's forehead where it meets the hair. Wiles watches for subtle changes in color temperature. He notes where the shadows turn warm on the trousers, for example, and he uses this tone to darken the lower part of the figure-so the "spotlight" remains on the upper part.

be freely intermixed without your worrying that one particularly powerful color will throw the mixture out of kilter. Nor is any of these colors so intense that it will leap out of the picture and leave all the others far behind. This is what might be called a balanced palette. The colors seem to have a natural affinity for one another when mixed *and* when placed side by side. This makes the palette very easy to control.

Colors for Underpainting and Overpainting

The ideal palette for underpainting should contain the maximum number of colors that can be thinned to beautiful, transparent glazes or semitransparent scumbles. These are either colors which are inherently transparent or colors which start out opaque but retain their brilliance when thinned to transparency.

A good palette for underpainting and overpainting might include cadmium red light, which is opaque and brilliant when it comes from the tube and stays brilliant when thinned to a glaze; a cooler, transparent red, such as alizarin or quinacridone crimson; cadmium yellow light, which also starts out opaque but makes a beautiful glaze; the transparent hansa yellow light; yellow ochre, which is opaque and essential for the solid tones of your underpainting; ultramarine for your warm, transparent blue; thalo or Prussian for your cool, transparent blue; a bright, transparent green, such as viridian or thalo; burnt sienna for a transparent red-brown; burnt umber, a cooler, opaque brown that thins to a good glaze; ivory black; and flake white.

Underpaintings are normally opaque (except for an imprimatura) and this is why flake white is so important. In combinations with any of these colors—even the most transparent—flake white produces dense, solid tones for underpainting. Yellow ochre is a valuable underpainting color for the same reason. And you may even want to add a few more of these dense, opaque colors for use in underpainting, such as Naples yellow, Venetian or light red.

It's worth experimenting with one of the socalled underpainting whites, but I think you'll be disappointed in an underpainting that relies just on zinc or titanium white. These cooler, less buttery whites look thin and pale in comparison with flake white or a good underpainting white.

Colors for Knife Painting

Passages painted with the knife look best when they're solid and opaque. It's possible to apply transparent color with the knife blade, but knife passages are inherently rather thick. Thick, transparent color loses its brilliance and turns murky. The key to bright, opaque color is a heavy-bodied white with a smooth, buttery, elastic consistency. Nothing beats flake white, though some of the "mixed whites" (prepared blends of several white pigments) come reasonably close.

In contrast to the palette of transparent colors I suggested for underpainting and overpainting, a palette for knife painting ought to contain a reasonable number of opaque colors. Since passages painted with the knife are valued most for their clarity of color, it's best to stick to the bright colors, the so-called high-key palette. Here's your opportunity to load up on the cadmiums, for instance, which fill this bill perfectly. So do the more powerful earth colors, such as Venetian red, Indian red, light red, and Mars red.

In choosing transparent colors, stick to the brightest colors with the greatest tinting power. These are the ones that hold onto their intensity when you add a substantial quantity of white to make them opaque. For example, a powerful, transparent blue like thalo or Prussian is more useful than cobalt, which has very limited tinting strength.

If you're going to paint whole pictures with the knife, a good palette would include cadmium red light, Venetian red, and cadmium orange at the hottest end of the color scale; cadmium yellow light, Naples yellow, and yellow ochre; a powerful, transparent blue like thalo or Prussian, plus ultramarine on the warm side, and maybe cerulean for an opaque blue; a powerful, transparent green like thalo; ivory black; and flake white. Except for yellow ochre, this palette consists entirely of bright colors (yes, black is a bright color) on the assumption

that you can produce all the subdued colors you need by mixing two or three bright ones.

Mixing Your Own Palette

So far, I've assumed that you're going to follow the almost universally accepted procedure of squeezing your colors directly from the tubes onto the palette. But it may surprise you to know that this wasn't the standard procedure of the old masters. On the contrary, many great painters of the past created all their mixtures before touching brush to canvas and set these mixtures on the palette.

Practically no one does this nowadays, but it's a procedure that might be worth reviving. The idea is to think out the complete color scheme of your painting in advance, create all the color mixtures you think you're going to need, set these out on your palette in some reasonable order, and then go to work on your painting. (You'll probably need two palettes for the job: one to create the mixtures and the other to hold the completed mixtures when you start painting.) Instead of making up your mind about colors as you go along on the actual painting, you isolate the problem of color and solve it separately-in advance. Before you start, you're forced to visualize the entire painting and come up with a plan of attack, so that nothing is left to chance.

You may argue that this highly planned attack was necessary for the old masters, who were painting big, ambitious pictures for kings and cardinals who demanded that certain deadlines be met. Does it make sense for the 20th century painter who values spontaneity and intuition? I think it does. If you make all your color decisions in advance and have exactly the colors you want on the palette before you start painting, then you're really free to indulge in the most spontaneous kind of brushwork and knifestrokes, without having to worry about your colors' going sour.

Working in this way also gives you a new sense of control over your color. Instead of wondering how things are going to look on the canvas, you'll know how they're going to look when you see them on your palette. Whistler insisted that his students premix their entire color scheme on the palette for just this reason. He demanded to see the palette before the student started painting, pointing out that the color harmonies in the picture could be no better than those on the palette.

Just once, try preplanning your color scheme on the palette itself. This could be a new and revolutionary learning experience for you. It could change your entire approach to painting.

Achieving Color Harmony

Every beginning painter wants to know how he can be sure that the colors in his picture "go together." He wants to know how to choose or mix colors that harmonize like the voices in a choir. rather than clash with one another.

This is a terribly difficult subject because there's so much disagreement about what colors "go together." Definitions of color harmony change from generation to generation and from one country to another. When I was an art student, no one would think of placing orange, red, and red-violet side by side in a picture, and I can recall laughing at a courageous girl who once wore these colors to school. But a decade later, this kind of color scheme became so popular-and is still so popular-that it now looks routine. For some reason, most of us are disturbed by a combination like red, green, and yellow; but in parts of Latin America and Eastern Europe, this is a favorite "harmony."

Nor am I sure that harmony is what you always want in a painting. There are times when you want colors to clash or look out of key, just for shock value or to communicate a certain emotional impact that you couldn't get with colors that peacefully coexist. For example, if you're painting a portrait of a fiery political leader who's at odds with the world around him, there's no reason why you shouldn't pick colors that are anything but harmonious.

But for the moment, let's assume that you can use some guidelines about what we currently consider harmonious color. Here are some useful rules-of-thumb.

(1) Colors side-by-side on the color wheel usually look good together. For example, if you're trying to find two colors that go well with red, look on either side of that red on the color

Along the Hudson by John Frederick Kensett, 1852, oil on canvas, $18^{1/8}$ " × 24" (46 × 61 cm). National Museum of American Art, bequest of Helen Huntington Hull. Kensett creates a feeling of great distance between the foreground and the horizon by dramatizing the value contrast between the dark trees and the pale mountains. He also relies upon value and color temperature to divide the mountains into two distinct spatial planes: the cooler and paler distant shapes; and the warmer tones at the edge of the river. The shadowy foreground, which looks cool at first glance, is really filled with warm color, as you can observe in the closeup. And the foliage is brushed over a sunny undertone that breaks through everywhere. The shadows on the rocks at the lower left are filled with warm reflected light. The artist works mainly with thin, fluid, semitransparent color that lets one hue shine through another.

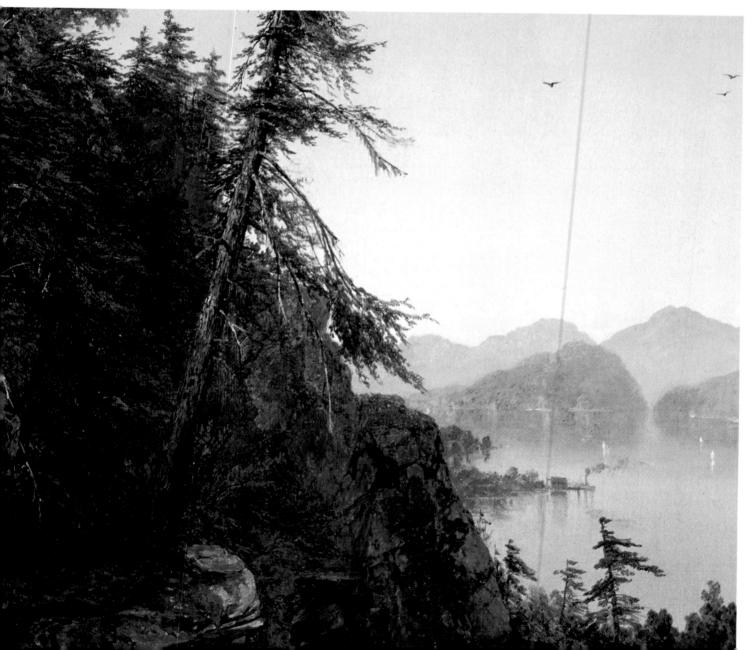

Tohickon by Daniel Garber, oil on canvas, 521/4" \times 56½" (133 \times 143 cm), National Museum of American Art, bequest of Henry Ward Ranger through the National Academy of Design. Garber divides near and far by placing his darkest values and his few really brilliant touches of color on the tree and grass in the foreground. The distant slope is both cooler and lighter, but it's an amazingly rich tapestry of color, one so filled with color that we see every hue in the spectrum in it. So much color can easily turn into chaos, but Garber knows how to control it. He keeps all the values quite close to one another so that no color leaps out at you. As you can see in the closeup, he weaves strokes of cool color throughout the trees and grass to unify the whole scheme and maintain a sense of distance. He interweaves warm and cool—and bright and subdued-strokes so that they mix in your eye and hold one another in place.

wheel. The nearest colors are red-orange and red-violet. The significant thing about these three colors is that they all have a common component: red. This is what makes them harmonious.

- (2) If you expand the rule that a common component makes colors harmonious, you can think up lots of other combinations. Chances are that blue, green, and blue-violet will go well together as they all contain blue. So will yellow, yellow-orange, and red-orange because they have yellow as a common component.
- (3) But if you follow this theory to its obvious conclusion, you're likely to end up with a lot of boring pictures, some painted in a narrow range of warm colors, and some painted in a narrow range of cool colors. All of them will lack that refreshing contrast that brings a picture to life. So, you've got to extend the rule and take some chances. Those warm color schemes need the relief of cool color and the cool schemes need some warm relief. If blue is your common component in a scheme of blue, blue-green, and blue-violet, maybe your picture needs some warm notes of red-violet or vellow-green, which also contain blue. Or maybe a picture dominated by yellow, yellow-orange, and red-orange could use a breath of cool air provided by yellow-green or blue-green, which should work since all five of these colors contain yellow. A good rule to remember is that a warm picture always needs some cool notes and a cool picture always needs some warm notes.
- (4) The simplest way to add a cool note to a warm picture—or a warm note to a cool picture—is to reach straight across the color wheel. Theoretically, at least, the right cool note for red is its complement, green, directly across from red on the wheel. But you've probably discovered by now that complements often look garish when placed side by side. Here are two of the best ways to make complements work together without looking corny. If you do want to place red and green, blue and orange, or yellow and violet side by side, be sure that one outweighs the other. Don't use them in equal amounts but have lots of yellow with just a spot of purple (or vice versa), lots of blue with

- just a small orange shape (or vice versa), and so on. Another way to harmonize complementaries is to "split" them. Instead of reaching straight across the wheel from blue to orange, let's say, you jump to either side of the orange and go for yellow-orange and red-orange. You play the blue off against both these "split complementaries" or you can pick just one of these almost-complementaries.
- (5) Broken color can be an extension of the common component theory. Let's say you've got two colors side-by-side and you're not happy with the way they work against one another. Perhaps you're bothered by an area of red that seems to fight an adjacent area of yellow. Try working a few subtle strokes of orange into the yellow and some more orange into the red-casually, unobtrusively, almost invisiblyand you've added a common component that brings them closer together. The impressionists and pointillists used this technique very effectively: if you'll look closely, you'll find flecks of sky color in the trees, flecks of tree color in the houses, and so on until the entire picture becomes a chain of interlocking colors.
- (6) A unifying undertone can often tie together colors that might otherwise seem to clash. A variation of the wet-into-wet technique is to coat the entire canvas with one wet tone—or perhaps two or three harmonizing wet tones—and then paint into this undertone, applying your colors rather loosely so that the underlying color keeps popping through. A toned ground or an imprimatura will do the same kind of job if you paint loosely enough and thinly enough. The undertone, whether wet or dry, becomes the common component.
- (7) The common component can also go *over* a dry painting whose color harmony worries you. A unifying glaze or scumble can be lightly brushed over the entire picture (or just over the offending areas); this has the effect of adding a common component to every mixture that's already on the canvas.
- (8) Perhaps the most effective way to tie disparate colors together is with grays. Even if they seem to go well together, too many bright colors in one picture tend to fight each other.

The eye needs rest and this is what grays provide. If a picture contains enough warm and cool grays-which ought to be interesting in themselves-you've got a harmonious setting for almost any bright color. And with the right gravs in between, almost any colors will work well together. Remember that bright colors look brightest not when they're jammed together, but when they're carefully placed in a subdued setting, like the robes of El Greco's cardinals, which look even more brilliant because of the gray backgrounds. A picture automatically becomes more harmonious if you save your most brilliant colors for the focal points of the composition, rather than spreading them around indiscriminately.

- (9) Color harmony isn't always a matter of the right color or the right setting for a color; it may also be a matter of values. If the colors of your subject or the colors of your painting seem out of whack, what you may really need is a slight adjustment in value relationships. A particular color of just the right hue may jump out at you because it's significantly lighter or darker than the adjacent color. It's the value contrast that disturbs you. All you need is to darken or lighten the offending color slightly so its value is closer to that of its surroundings.
- (10) The clash is sometimes a matter of color temperature. You may have the right combination of hues, more or less, but certain offending colors may be too warm or too cool in relation

to the surrounding colors. That green might need some more blue to move it back a bit; the orange might need a bit more red to move it forward.

(11) In the same way, disharmony can be corrected by a slight change in intensity. If two colors are fighting one another and you want to hold one of them down, reduce its intensity slightly so that the other color holds center stage; or you can intensify the other color. If they're both too bright, maybe they both need to be grayed down somewhat. They may clash simply because they're too bright, but they work together beautifully when their intensity is reduced.

I certainly can't claim that this list encompasses all the rules of color harmony. At best, it's a collection of tips. Remember that there's nothing sacred about the colors of nature; it's your right as an artist to adjust the colors of nature to make an effective painting. I hope these suggestions will give you the courage to do some audacious things, such as scumbling a light green over that hot shadow on your sitter's neck so the shadow harmonizes more effectively with the cool background; glazing some red-brown over your landscape to tie together all those different greens; or brushing a few strokes of hot color into the gray background of your still life so those apples and oranges in the foreground won't look cut off from the rest of the picture.

7. Observing and Painting the Colors of Nature

It's one thing to know how colors work on the palette and on the canvas, but it's another thing to put all this into practice when you're fact-to-face with nature. The ultimate challenge is to develop your powers of observation so that you can see the subtle nuances of color in the world around you. You must be able to translate these colors accurately into paint or transform them into hues that look right on the canvas, while remaining fundamentally true to nature. The painter's eye, after all, isn't a camera eye. The painter's first responsibility is to see what's there, but then he's free to render his subject faithfully, idealize it, simplify it, dramatize it, or distort it so that it seems truer to life than the most precise color photograph.

Observing Local and Atmospheric Color

Simply seeing what's there is harder than it may seem. What you know about the color of your subject often gets in the way of what you see. If your sitter is an ivory-skinned blond posing in the natural light of your studio window, you're tempted to paint her in warm, delicate colors even though her skin actually looks blue in the cold light of an afternoon in late winter. You know—or think you know—that a shadow on a white tablecloth ought to look gray, so you simply may not see the red reflection in the shadow of an apple.

In short, it's easy to confuse local color with what might be called atmospheric or environmental color. To refresh your memory, I'll paraphrase my definition of local color in Chapter 1: "The local color of an object is what you'd see if the object were removed from all outside optical influences, such as other colored objects, colored backgrounds, or colored lights which might distort the actual color or distract us from observing that color." Local color is usually what we *know* about our subject, even though it's practically impossible to see any subject in nature that isn't influenced by the colors of its surroundings.

Atmospheric or environmental color is what's *added* to local color by natural or artificial light, by dust or smoke or particles in the air, by shadows and reflections cast from nearby objects, by weather, by distance, by

lights and shadows within the texture of the object itself. Every color you see in nature is actually a mixture of the object's own local color and all the other colors added by atmosphere and environment. The skin tone of that blond sitter seated in the window is ivory plus the blue light coming through that window. And if she's wearing a green sweater, don't be surprised to see some green in the shadow under her jaw. If you then turn on the incandescent lights in your studio, you're adding still another component to the mixture: the warm light of your studio lamps will mix with the cold light coming through the window.

I'm not telling you that you've got to paint all these complicated color phenomena. Monet put them in, but Rembrandt usually left them out. Yet both were great painters. You may decide that these color phenomena are so fascinating that you want to record them. You can also decide to record just some of them. Or you can decide that all these atmospheric and environmental influences are hopelessly confusing; so the right course for you is to stick as closely as possible to the local color.

Whatever you decide to do about it, it's essential to start out by seeing what's there. If you think you're seeing local color when you're really seeing atmospheric color, you're in trouble. You're like the student in the painting class who looks at the ruddy cast shadow under the model's nose and paints it in like a red moustache, never stopping to think that it's a momentary light effect which he can render faithfully, subdue, or leave out altogether. Analyze the colors you see to clearly distinguish between local and atmospheric color, and then decide what to emphasize, what to de-emphasize, and what to leave out.

Color Perspective

The most familiar example of atmospheric color is atmospheric perspective. If you take a stroll in the mountains, you'll see that the nearby trees, shrubs, and rock formations are a lot stronger in color than those in the distance. In fact, when there are several ranges of mountains, one behind the other, each range seems to grow cooler and paler than the one before it. The range of mountains at the horizon is coolest and palest of all.

In Chapter 1, I pointed out that the warm colors in a painting seem to advance, and the cool colors seem to drop back into space. This happens not only in painting; it seems to happen in nature, as well. Those bright green trees, near where you're standing in the mountainous landscape, look a lot greener (warmer) than the distant trees, which look bluer (cooler). Distance seems to subtract the warm yellow from the trees, and those brown rock formations in the foreground look a lot warmer than the same rocks in the distance, which look gray even though they're the same kind of rocks.

All this happens because the blue sky isn't just above the mountains, like some painted backdrop in the theater, but all around you. The blue sky comes right down to the ground at your feet. You're walking through a sea of blue air, very much the way a fish swims through a sea of blue water. A nearby tree or rock doesn't look very blue because there are just a few feet of blue air between you and that tree or rock; but the distant mountains look a lot bluer because there are miles and miles of blue air between you and the mountains. It's as if you were looking at those mountains through an immensely thick block of blue glass.

Reading what I've just said, a physicist would probably be appalled by my hopelessly unscientific explanation. But the concept of a colored lens is a good one to remember. Whenever you look at any subject, imagine that the intervening atmosphere is like a colored lens-but you must decide what color the lens is that day.

Painting a distant object paler and cooler is a good way of pushing it back into space. But Turner and Rembrandt (in his rare landscapes) often broke the rules by beaming a bright light, almost like a searchlight, at some distant object that suddenly becomes the brightest and most dramatic thing in the picture. Degas, who's always full of surprises, constantly shakes us up by painting nearby objects in cool colors and placing them against hot, vivid backgrounds. Once you're aware that nearby objects tend to look warmer and brighter than distant objects you can then decide whether to stick with this rule or simply to ignore it.

Developing an Eye for Color

No book can possibly tell you how to paint everything. From moment to moment nature is constantly changing, and there are no set formulas for getting the "right" green for a spruce tree or the "right" pink for a baby's cheeks. All that a book—or a teacher—can hope to do is heighten your awareness of what you see.

In the rest of this chapter, I'll comment on painting various subjects. I can't tell you how to paint them; this is up to you. But I hope I can give you some insight into how an experienced artist looks at color, how he analyzes it, and how he translates what he sees into paint. These observations aren't rules and regulations but simply examples of the way an artist thinks. These examples are meant to stimulate you, to sensitize you, to make you aware of the profound difference between the painter's eye and the tourist's eye.

Trees and Greenery

Trees and other growing things are such common subjects that they should be easy to see clearly, but they aren't. Green, growing things are usually a mass of detail: mostly small elements such as leaves, branches, stalks, and blades. With all these tiny shapes flickering in the sun or blowing in a storm, it's hard to see their colors clearly.

Although trees and shrubs and meadows all consist of so many tiny shapes, you should try to find large, simple shapes among the chaos. If you can perform the mental trick of throwing a tree out of focus—or actually do it by squinting your eyes—you'll find that most trees consist of one or more blocky, circular, or conical forms. Like most solid forms, these have a lighted side, a shadow side, and a middle tone in between. Each of these tonal areas has its own value and color. The middle tone may be green, while the brightly lighted area could turn out to be yellow-green and the shadows blue-green. (This is no formula for painting trees; it's just an example of what to look for.) And don't forget

that trees against the horizon often contain gaps where the sky breaks through so there may be some flecks of sky color among the green.

Once you've isolated the planes of light, middle tone, and shadow—plus the flecks of sky, if there are any—it's usually best to paint these colors as flat, irregular shapes. Don't try to paint every leaf. If your brushwork is free and springy, following the movements of the forms, the tree will have the lively, irregular quality of a living thing.

The profuse detail of a meadow, full of grasses and weeds, simplifies itself into broad planes of color if you recognize that even a flat field is three-dimensional. The most regular meadow has curves and dips and clusters of growing things that suggest areas of light, middle tone, and shadow. Watch how bunches of weeds sway together in the wind, forming a solid mass. Look for slight changes in tone, indicating that the field may not be as flat as you think. Then exaggerate the three-dimensional character of these subtle shapes, assign them planes of light and shadow with colors of their own, and paint the field as a series of large, three-dimensional forms.

The secret is finding some hidden geometry within all the bewildering detail. It's usually there if you look closely enough. This geometry then becomes the key to designing your areas of color.

Spring and Summer Color

Spring and summer are the greenest seasons of the year in most parts of the world and are therefore the hardest to paint, simply because there's so *much* green. That's why beginners' landscapes often look like endless mountains of spinach. Avoiding this monotony is a challenge to your powers of observation and your knowledge of color mixing.

The first thing to recognize is that there are usually many different greens in a landscape. Each variety of tree has its own distinctive color. So have the different patches of growing things on hills and fields. Light and shadow also make for variety: greens in direct sunlight are very different from greens in the shadow of a hill or a cloud. Distance makes a difference,

too: remember that nearby growing things look warmer, while growing things on the horizon look a lot cooler.

The growth cycle of a tree also influences color. Trees leaf out at somewhat different times. Leaves often start out with a delicate green or yellow-green and then gradually darken as the weeks go on. This is why spring is much easier to paint than summer; not all the trees and shrubs turn solid green for a while. In any case, it pays to look for the subtle differences between the colors of trees that are just beginning to leaf out and those that are fully leafed out.

These are all things to observe, but you must also feel free to exaggerate and to invent. Having learned how to mix a wide variety of greens, you can introduce variety into the most monotonous landscape by creating light and dark, warm and cool, intense and subdued greens wherever your picture needs them. You can push one mass of foliage into the distance by painting it bluer and paler, while bringing another mass further forward by painting it warmer, brighter, and darker. You can throw sunlight on the focal point of your picture by introducing a note of yellow-green. You can subordinate another area by creating a cloud shadow that throws all the foliage into uniform darkness. Nor do all trees have to be green! You can invent a brown, dying tree, or a gray, dead one for a change of pace. And what's to prevent you from creating a field of red or yellow flowers for relief?

Autumn Color

The colors of autumn present exactly the opposite problem. In contrast with the possible monotony of a uniformly green, summer landscape, an autumn landscape runs the risk of looking like pure chaos. There are so many dazzling, hot colors-golds, oranges, violets, fiery browns-that the eye may look vainly for rest, and the painter may look vainly for a center of interest to save his picture.

Above all, don't cover your canvas with flaming colors from end to end. Just as a bonfire looks most beautiful when surrounded by darkness, your bright colors will have the most impact if you set them off against more subdued tones. A blazing autumn tree looks richest at that time of year when there's still some greenery around. So, consider introducing some notes of green as a foil for your orange or red or gold, even if the green trees are all gone by now. You can also surround your blazing center of interest with the subdued browns of other trees that have passed their peak of autumn color or even begun to lose their leaves.

Knowing that blue is the complement of orange, it seems logical to place all those growing shapes against a bright blue sky. That will work, of course, but John C. Pellew makes an interesting point in Oil Painting Outdoors: "I think the fall foliage looks best on gray days. The leaves are colorful enough; they don't need the sun to make them more brilliant." An overcast day, even a misty day, allows you to exploit the contrast between flaming foliage and a somber background; and a few patches of mist allow you to obscure certain trees that are fighting for attention.

Winter Color

Grays are the challenge of winter. Pellew reminds us that: "Treetrunks are gray, never brown-well, hardly ever. The beaches are silver-gray, the birch almost white, and the oaks dark gray-even black, when wet. Last autumn's fallen, faded leaves are all kinds of warm grays."

Yet these grays are never monotonous, never uniform. It demands a particularly discriminating eye to find all the different warm and cool grays in leafless treetrunks, rocks sheathed in ice, frozen ponds and streams, fallen leaves, and withered weeds. This is your chance to learn that almost an entire picture can be painted in grays and that a creative painter never tires of discovering new gray mixtures.

As you place your various grays on the canvas, these smoky tones reveal themselves as colors by contrast with each other. Try to place warm grays against cool grays, bluish grays against brownish grays, olive grays against yellow grays. A single treetrunk, like the peeling shaft of a birch, contains many shades of gray, where the bark is wet or dry or split.

Of all winter subjects, the hardest to paint is snow. The local color of snow is white, of course, but it never really looks white. It's helpful to remember that snow is crystallized water and that water mirrors the colors around it. Thus, snow changes color at different times of day and under different weather conditions. Snow in direct sunlight can look faintly golden. Out under a bright blue sky, shadows on snow pick up blue reflections. At sunrise or sunset, snow can look pink or violet.

Like a rolling meadow, a field of snow consists of flowing three-dimensional shapes. You have to look closely to see that there are planes of light and shadow that melt into one another so softly that they're visible only to the experienced eye. Watch for these planes so that you can introduce varied color into what *could* be a monotonous subject. In general, the shadow planes are cool and the light areas are warm. Reserve your touches of white for glistening highlights, just as you would on a face or a piece of fruit. Most of the snow you see will be a color, not pure white. Hold your white in reserve for emphasis.

Skies and Clouds

People talk glibly about "sky blue" as if there were just one basic sky color, usually something like cerulean or thalo blue mixed with some white. At midday, when it's clear and sunny, this pure "sky blue" is what you're most likely to see, but the color of the sky changes with the slightest alteration in the weather. And the time of day makes a big difference, too.

Put aside your preconceived notions about "sky blue" and study the sky as if you'd never seen it before. Is the sky a solid color or is there a gradation from one color to another as your eye moves from the horizon to the zenith? Even on the brightest, clearest day, there's often a faint grayish haze at the horizon.

If you have the patience to look at a clear, blue sky every hour on the hour for an entire day, you'll discover some interesting changes taking place. Although the sky seems clearest and brightest at midday, the intense sunshine bleaches out the color just a bit, while the diminishing light of the afternoon allows the full

richness of the blue to come through.

Nor does a sky have to be blue at all. An overcast sky can be anything from a pale gray to the leaden gray that precedes a storm. This grayness isn't necessarily uniform; there are often delicate, yellowish blushes and blurs where the sun is struggling to break through the grayness. Watch for these warm notes and make use of them to enliven a moody sky.

In the city, the sky is often a different color from the sky that you see in the open country. I suppose it's all the dust, smoke, and pollution in the atmosphere that produces such strange, warm tones. I've seen yellowish, tannish, or even reddish tones moving upward from urban horizons and mingling with the blue or gray above.

Feel free to make subtle alterations in sky colors to suit your picture. There are times when that "sky blue" will benefit from a hint of green or violet. As you may remember from your color mixing exercises, a touch of brown often deepens and enriches a blue mixture. And a yellow undertone introduces a suggestion of gold that makes the blue look even more atmospheric.

Once clouds enter the picture, the color problems of skies become even more complex and fascinating. A cloud isn't merely a white blur, any more than a tree is a patch of green. Clouds are three-dimensional masses with planes of light and shadow. Their gray undersides—the shadow planes—aren't necessarily a uniform gray, and they often contain warm and cool tones, as well as hints of brightness where the light tries to break through. The upper edges of the clouds—the lighted planes—aren't just pure white as it comes from the tube. More often, they're extremely pale grays, tinged with almost invisible golden, violet, or pinkish tones.

Painting clouds is something like painting snow: the light and shadow planes both contain *colors*. Clouds can be particularly colorful at sunrise and sunset—more about this a little later—but there are *always* suggestions of color within the white, even on the grayest days. Touches of pure white should be reserved for points of emphasis, such as a brilliantly lit edge where a cloud is struck by full sunlight.

Water

With the possible exception of human skin, water contains the most complex color effects in nature. Water contains not only its own colors but also various other colors which it picks up from its surroundings, both above and below.

The colors of the sky and the clouds are mirrored in a still body of water. Sky colors also influence a moving body of water, though this reflected color is fragmented into the broken, choppy shapes of waves and ripples. If the water isn't too deep, it's also influenced by colors that move up from the soil or rocks or growing things at the bottom. At different times of day, at different seasons, and in different kinds of weather the water is also affected by the color of the prevailing light. Objects in the water or next to it-such as rocks, ships, or wharves-add their color in the form of reflections. And the water may have a color of its own, whether clear as glass, laden with yellowish mud or reddish clay, or swimming with green microorganisms.

So, to interpret the color of water, you have to look all around it, as well as at it. Probably the strongest influence is the sky; there's almost always some suggestion of sky color in water, even if the lake or river is filled with mud. You also have to figure out the color of the prevailing light, whether it's the clear, blue light of a sunny day; the reddish light of sunset; or the gray-gold light of an overcast winter day. You may not be able to see bottom, but the color of the bottom works its way into the water anyway.

Having studied all these possible influences to see how much each one contributes to the color of the water, you're then free to decide what to leave out. In most paintings, it's important for the water to harmonize with the sky. So even if a running stream is yellow with silt, it's wise to introduce some sky color and exaggerate that color if necessary. If a harbor is positively glittering with shoreline reflections and the upside-down images of boats at anchor, there's no reason why you can't leave out some of these, or at least tone them down, to unify your picture. If a body of water contains more color phenomena than the picture can stand, you're under no obligation to record it all. The logic and unity of the picture come first.

Shoreline Colors

Perhaps the most dramatic colors in water occur at the seashore. Painting a seascape gives you a chance to observe moving and still water under a variety of color influences.

The color of the distant waves is normally related to the color of the sky. Oddly enough, the sea looks darkest at the horizon and becomes progressively lighter as the waves move to where you're standing on the shore. This is probably because the shadowy faces of the waves appear to be stacked closer and closer to one another as they grow more distant. This seems to violate the principle that distant objects become paler, but distant waves do look colder and grayer than nearby waves.

As the waves move toward us on the shore, they look brighter and more transparent; we see more of their lighted planes. We also see the light beginning to shine through them, so they seem greener, more transparent, and more intense because of that inner light. As a wave heaves up and begins to break, the light comes through it like sunshine through stained glass, and we see a particularly vivid green or bluegreen.

As the wave crashes and explodes into foam, that foam takes on its own shapes and colors. We're inclined to see foam as solid white, but it isn't. Most of it's in shadow, which isn't merely gray but picks up cool reflections from the water, some sky tones perhaps, and even some warmer reflections from the rocks over which it splashes. Very little of the foam is anything like white. The lighted areas of the foam may pick up some yellow sunlight, some blue from the sky, or some pink or violet from a rising or setting sun. Reserve your pure white paint for a few bright touches, if you see them there.

The water of the broken wave is a churning mixture of white foam and brilliant, transparent greens and blue-greens. As this water spills over rocks or rides up onto the beach, the color is strongly influenced by what's underneath. As the water moves further and further inshore-becoming as thin as a sheet of glassyou see more sand color and less water color.

It's tempting to paint sand as yellower than it really is. This temptation is particularly strong when your eyes are dazzled by bright yellow sunlight. But sand is most often a soft, grayish-tan. Try to avoid painting sand a hot color—like yellow or brown—but stick to a fairly muted tone so the sand will harmonize with the sea.

You can make the same mistakes when you paint rocks. Beginners usually make them too brown, while they're a lot closer to gray or graybrown. On a sunny day, the lighted top planes of rocks do look warmer and yellower than the shadowy side planes, but don't get carried away by this warmth. On a gray day, rocks look distinctly colder. Study the wet sides of rocks as the waves break over them. There are often interesting colors reflected in this wetness.

Sunny Days and Gray Weather

A bright, sunny day is a lot harder to paint than a gray day. The clear, intense light of a sunny day emphasizes the contrasts between the various colors in a landscape. But a gray day adds a bit of its grayness to each color you see, thus bringing colors closer together. The grayness becomes the common component—remember what I said about the common component in the preceding chapter when I talked about color harmonies—that unifies colors which might conflict on a brighter day.

For the sake of an obvious example, let's go back to that traditional landscape with the red barn and the green trees. In bright sunlight, the contrast between these two complementary colors is especially strong. In this powerful light, the barn and the trees also cast strong shadows that have their own insistent shape and color. The brilliant blue of the sky will fight for attention, too, and so will the sunstruck rocks and brightly lit clouds. You've got to decide which pictorial elements should win. Some of them have to be subdued, but so unobtrusively that the day still looks as bright as ever.

One way to subdue certain parts of the picture is to make subtle value changes, reducing the violent contrast between the light and shadow planes on buildings and rock formations and even on clouds. Make the shadows paler, and don't use quite so much white in the lighted planes. You can also make subtle changes in color temperature. That electric blue sky could be warmed up just a bit to make it less insistent and that bright red barn could be cooled down ever so slightly. A few warm notes would put the vivid green foliage in its place.

The grayness of an overcast day makes things a lot easier. Feel free to exaggerate this grayness wherever you please. You can add as much gray as you like to those green trees or that red barn, melting them far back into the distance. You can minimize the contrast between light and shadow planes, as well as the contrast between colors, by adding gray to make dark things lighter and light things darker.

But if you take a walk on a gray or rainy day and really keep your eyes open, you'll see that there's still plenty of color. The greens of the landscape look particularly rich during or after a rain. Autumn trees look even more vivid against a cloudy sky or half shrouded in mist. If you introduce grays in the right places, your bright colors will command more attention than they would on a sunny day.

Sunrises and Sunsets

The most spectacular color effects in nature are sunrises and sunsets. Practically everyone tries to paint these irresistible subjects—and practically every one comes up with a corny, embarrassing picture. Why do paintings of sunrises and sunsets usually fail? And what can you do about it?

The problem is almost always hot, heavy color. The painter gets carried away with those vivid reds and pinks and purples. He strives for maximum brightness, piling on the hottest colors he can manage, and then he wonders why his colors look so brassy, so heavy, so unconvincing.

If you spend enough time looking at sunsets, you'll see that their secret is not the intensity of the hot colors, but the contrast between warm and cool, between light and dark. Actually, those reds and pinks and purples aren't as

bright as you might think. Nor are they as hot as you might think. They look so vivid because they're intertwined with much cooler tones. Interwoven with the hot colors are pale blues, blue-greens, blue-violets, and even yellowgreens. And far above the flaming horizon, there's still a blue or blue-gray sky. The warm colors are also enhanced by the cooler, darker tone of the landscape. At sunrise and sunset, trees and hills and distant mountains have a blue-gray or blue-black tone that provides the perfect "frame" for the hot colors along the horizon.

In reality, sunrises and sunsets are rarely as hot and bright as most people paint them. The colors are generally paler and more delicate than they're painted. The experienced artist uses his hot colors sparingly and surrounds them with a cool sky and a shadowy landscape. I might add that the most beautiful sunrises and sunsets are often just a few streaks of red, pink, or gold breaking through the gray of an overcast or stormy sky.

Faces and Figures

So far, I've talked mainly about studying the colors you'll find outdoors. It's out in the world of nature that you'll find the greatest diversity of color effects. But perhaps I ought to conclude with a few pointers about painting people.

Certainly the most common mistake in painting people is making flesh tones too hot. We've all seen lots of student portraits and nudes in which the flesh is so red and beefy that the model looks like she's suffering from a painful sunburn. Beginners are inclined to make this same mistake whether the model is lightskinned or dark-skinned. Black models often come out looking a ruddy brown, like chocolate

Flesh is almost always cooler than you might imagine it. The light areas are usually paler than most beginners paint them, and the shadows are distinctly grayer. Whether your model is ivory-skinned or black or somewhere in between, your flesh tones will look most convincing if the shadows are cool.

Yes, there are warm notes in the skin, but they're localized. Noses, ear lobes, knuckles, and fingertips are often warmer than the rest of the body. These are only a few of the color variations you'll find if you spend enough time painting people. Skin tones are never uniform, but they constantly change as you scan the model from head to toe. The underside of the hand is a different color from the underside of the forearm, for instance. The back of the neck tends to be a different color from the front. Charles Reid, author of Figure Painting in Watercolor, says that he normally paints arms and legs a warmer color than the torso.

To paint a lifelike portrait or figure, you've got to give up your preconceptions about the way people are supposed to look. Everyone has his own distinct color and this changes constantly from one area of skin to the next. You can't just mix up a batch of "flesh color" and daub it all over the figure the way you'd paint a wall. You've got to study the model feature by feature and see what's really there. This is the toughest test of the painter's eye.

Bibliography

Ballinger, Harry R., *Painting Landscapes*. New York: Watson-Guptill, 1965.

—, Painting Sea and Shore. New York: Watson-Guptill, 1966.

Battershill, Norman, *Light on the Landscape*. New York: Watson-Guptill, and London: Pitman, 1977.

Betts, Edward, Creative Landscape Painting. New York: Watson-Guptill, and London: Pitman, 1978.

—, Creative Seascape Painting. New York: Watson-Guptill, 1981.

Blake, Wendon, Complete Guide to Landscape Painting in Oil. New York: Watson-Guptill, 1981.

—, *The Color Book*. New York: Watson-Guptill, and London: Pitman, 1981.

—, The Oil Painting Book. New York: Watson-Guptill, and London: Pitman, 1979.

—, The Portrait and Figure Painting Book. New York: Watson-Guptill, and London: Pitman, 1979.

Caddell, Foster, *Keys to Successful Color*. New York: Watson-Guptill, 1979.

—, Keys to Successful Landscape Painting. New York: Watson-Guptill, 1976. —, Keys to Painting Better Portraits. New York: Watson-Guptill, 1982.

Cherepov, George, *Discovering Oil Painting*. New York: Watson-Guptill, and London: Pitman, 1971.

Cooke, Hereward Lester, *Painting Techniques of the Masters*. New York: Watson-Guptill, 1972, and London: Pitman, 1973.

Corsellis, Jane, *Painting Figures in Light*. New York: Watson-Guptill, 1982.

Curtis, Roger W., edited by Charles Movalli, *Color in Outdoor Painting*. New York: Watson-Guptill, and London: Pitman, 1977.

Dunstan, Bernard, Painting Methods of the Impressionists. New York: Watson-Guptill, 1983.

Fabri, Ralph, Color: A Complete Guide for Artists. New York: Watson-Guptill, and London: Pitman, 1967.

Fiene, Ernest, Complete Guide to Oil Painting. New York: Watson-Guptill, 1964.

Finck, Furman J., Complete Guide to Portrait Painting. New York: Watson-Guptill, and London: Pitman, 1970.

Gruppé, Emile A., edited by Charles Movalli, *Gruppé on Color*. New York: Watson-Guptill, and London: Pitman, 1976.

—, edited by Charles Movalli, *Gruppé on Painting: Direct Techniques in Oil.* New York: Watson-Guptill, and London: Pitman, 1976.

Handell, Albert, and Leslie Trainor, Oil Painting Workshop. New York: Watson-Guptill, 1980.

Kinstler, Everett Raymond, edited by Susan E. Meyer, *Painting Portraits*. New York: Watson-Guptill, 1971.

Mayer, Ralph, *The Artist's Handbook*. New York: Viking, and London: Faber, 1970.

O'Hara, Eliot, Watercolor with O'Hara. New York: Putnam, 1966.

Pellew, John C., Oil Painting Outdoors. New York: Watson-Guptill, 1971, and London: Pitman, 1976.

Reid, Charles, Figure Painting in Watercolor. New York: Watson-Guptill, and London: Pitman, 1972.

—, Flower Painting in Oil. New York: Watson-Guptill, and London: Pitman, 1976.

Richmond, Leonard, Fundamentals of Oil Painting (previously published as Techniques of Oil Painting). New York: Watson-Guptill, 1970 and London: Pitman, 1969.

Robinson, E. John, *Marine Painting in Oil*. New York: Watson-Guptill, and London: Pitman, 1973.

—, Master Class in Seascape Painting. New York: Watson-Guptill, and London: Pitman, 1980.

Salemme, Lucia A., Color Exercises for the Painter. New York: Watson-Guptill, 1970.

Sanden, John Howard, edited by Joe Singer, *Painting the Head in Oil*. New York: Watson-Guptill, and London: Pitman, 1976.

Sheppard, Joseph, Learning from the Old Masters. New York: Watson-Guptill, and London: Pitman, 1979.

Smart, Borlase, Seascape Painting Step-by-Step (previously published as The Technique of Seascape Painting). New York: Watson-Guptill, 1969, and London: Pitman, 1965.

Strisik, Paul, edited by Charles Movalli, *The Art of Landscape Painting*. New York: Watson-Guptill, and London: Pitman, 1980.

Taubes, Frederic, Oil Painting for the Beginner. New York: Watson-Guptill, 1965, and London: Pitman, 1966.

Waugh, Coulton, *How to Paint with a Knife*. New York: Watson-Guptill, 1971.

Index

Acra. See Quinacridone entries.
Advancing color, 16
Alizarin crimson, 29
Along the Hudson (Kensett), 142
Artists of WPA (Soyer), 103
Atmospheric color, 14, 146–147
Atmospheric perspective, 147–148
Autumn colors, 149

Ballinger, Harry R., 136 Basic palette, colors for, 44 Beach Umbrella at Blue Point (Glackens), 131 Beaux, Cecelia, Man with the Cat (Henry Sturgis Drinker), 67 Bellows, George, Mr. and Mrs. Phillip Wase, Betty Wertheimer (Sargent), 106 Bierstedt, Albert, Sierra Nevada in California. The, 54 Black, alternatives to, 72; as a color, 72–73 Blacks, 40 Blenders, 112 Blending, 120–121; illus. of, 121, 124 Blues, 25–29; mixing, 56–60 Blumenschein, Ernest Leonard, Gift, The, 138 Bradbury's Mill Pond, No. 2 (Ranger), 23 Brands of colors, 20–21 Brights, 112 Bristle brushes, 112–113 Broken color, 121–129, 144 Brooding Silence (Carlson), 79 Brook at Carversville, The (Redfield), 135 Browns, 37–40; mixing, 69–72 Brushes, 84, 112-113; cleaning, 84 Burnt sienna, 34–40

Burnt umber, 34

Cadmium orange, 29 Cadmium red deep, 29 Cadmium red light, 29 Cadmium red medium, 29 Cadmium scarlet, 29 Cadmium yellow deep, 32 Cadmium yellow lemon, 32 Cadmium yellow light, 32 Canvas, 116 Caress, The (Cassatt), 91 Carlson, John Fabian, Brooding Silence, 79 Cassatt, Mary, Caress, The, 91; Sara in a Green Bonnet, 18; Spanish Dancer Wearing a Lace Mantilla, 19 Catskill Creek (Cropsey), 42 Cerulean blue, 28 Chase, William Merritt, Shinnecock Hills, 38 Chromium oxide green, 36 Cleaning: the brush, 53; the knife, 53 Clouds, painting, 150 Cobalt blue deep, 28 Cobalt blue light, 28 Cobalt violet, 36 Color behavior, testing for, 44–48 Color charts, of tube color, 25 Color harmony, achieving, 141–144, 145 Color mixing, nine principles, 81–85 Color perspective, 147–148 Color temperature, 14 Color test sheet, making, 53; illus. of, 52 Color wheel, 16–17, 101, 144; illus. of, 15 Colors: against other colors, 104–105; autumn, 149; cool, 105; correcting, 105–108; darkening, 100–101; developing an eve for, 148; figure painting, 137-141; for sim-

plified palette, 132–133; graving, 101–104:

intensifying, 101–104; knife painting, 140–141; landscape, 133–136; lightening, 144; loosely mixed, 88–89, illus. of, 88; mixing on the painting surface, 89–100; mixing your own, 141; overpainting, 140; portraits, 137–140; roughly mixed, illus. of, 88; seascape, 133–137; shorelines, 151–152; simplified palettes, 133–134; spring, 148–149; summer, 148–149; underpainting, 140; warm, 105; winter, 149–150. See also Painting.

Complementary colors, 16 Cool colors, 14, 16, 105 Cornish Headlands (Thayer), 35 Correcting colors, 105–106

Darkening colors, 100–101
Degas, Edgar, 133, 147
Developing an eye for color, 148
Dewing, Maria Oakey, Garden in May, 58
Dickinson, Edwin, Self-Portrait in Gray Shirt, 127
Dickinson, Sidney, E., Portrait of Paul P. Juley, 107
Dougherty, Paul, Sun and Storm, 118
Dover Plain, Dutchess County, New York (Durand), 114
Durand, Asher B., Dover Plain, Dutchess

Earth colors, 37–40 Elizabeth Winthrop Chapman (Sargent), 66 End of Winter (Twachtman), 111 Entrance to the Harbor (Ranger), 83

Drybrush, 124-125; illus. of, 125, 128

County, New York, 114

Faces, 153
Falls of the Schuylkill, The (Stuempfig), 62
Fiene, Ernest, 27
Figure painting, 97, 153; colors for, 137–140
Filbert, 112
Finck, Furman J., 77, 137
Fishing Boats at Gloucester (Twachtman), 75
Flake White, 41
Flats, 112
Flesh tones, 76
Forsythia and Pear in Bloom (Porter), 99
French ultramarine, 28

Garber, Daniel, Tohickon, 143

Garden in May (Dewing), 58 Gesso, 116-117 Gift, The (Blumenschein), 138 Girl Arranging Her Hair (Thayer), 126 Glackens, William, Beach Umbrellas at Blue Point, 131 Gold ochre, 33 Grades of tube colors, 21 Grand Canyon at Yellowstone, The (Moran), 39 Gray weather, painting, 152 Graying color, 101–104 Grays, mixing, 73–76 Green earth, 36 Greenery, painting, 148 Greens, 36; mixing, 65–68 Grisaille, 97

Hansa yellow light, 33
Hansa yellow medium, 33
Hassam, Childe, Marechal Neil Roses, 87; Ponte Santa Trinità, 43; South Ledges, Appeldore, The, 26
Her Leisure House (Wiles), 50
High Cliff, Coast of Maine (Homer), 27
Hills, The (Dickinson), 30
Homer, Winslow, High Cliff, Coast of Maine, 27
Hopper, Edward, Ryder's House, 31
Housatonic Valley (Wyant), 55
Hue, 13–14

Hair tones, 77–80

Impasto, 108, 117
Impressionism, illus. of, 124
Imprimatura, 92, 97
Indian red, 40
Indian Summer (Cropsey), 134
Inness, George, Sundown, 110
Intensifying color, 101–104
Intensity, 13–14
Interlude, An (Kendall), 46
Ivory black, 40

John Gellatly (Wiles), 139 Johnson, Eastman, Lord Is My Shepherd, The, 94

Kendall, William Sergeant, *Interlude, An,* 46 Kensett, John Frederick, *Along the Hudson,* 142 Kinstler, Everett Raymond, 137 Knife painting, colors for, 140–141 Knives, 113–116; cleaning, 84 Kroll, Leon, *Scene in Central Park*, 63

Landscape, colors for, 139–140

La Vachere (Robinson), 86

Light red, 40

Lightening colors, 100

Local color, 14, 73, 146–147

Lord Is My Shepherd, The (Johnson), 94

Loose mixtures, 124

Loosely mixed colors, 88–89; illus. of, 88

Luks, George, Polka Dot Dress, The, 122

Man with the Cat (Henry Sturgis Drinker)
(Beaux), 67
Manganese blue 28

Manganese blue, 28

Manganese violet, 37

Manufacturers' color charts, 25

Marechal Neil Roses (Hassam), 87

Margery and Little Edmund (Tarbell), 90

Mars black, 40

Mars brown, 40

Mars red, 40

Mars violet, 37

Mars yellow, 33

Masonite, 116

Mediums, 108-109

Melons and Morning Glories (Peale), 59

Midsummer Moonrise (Tryon), 78

Mistakes, correcting color, 105–108

Mixing color: blues, 56–60; browns, 69–72; grays, 73–76; greens, 65–68; loosely, 88–89, illus. of, 88; nine principles, 81–84; pinks, 64–65; off-reds, 64–65; on the painting surface, 89–97, 97–100; on the palette, 85–88; optically, 93; oranges, 64–65; reds, 60–61; roughly, illus. of, 88; violets, 68–69; yellows, 61–64; your own colors, 141

Monet, Claude, 129, 147

Moonlight (Ryder), 82

Moran, Thomas, Grand Canyon of the Yellowstone, The, 39

Mr. and Mrs. Phillip Wase (Bellows), 102 Mud, 72

Naples yellow, 33 Neutralizer, 101

Off-reds, mixing, 64–65

O'Hara, Eliot, 104

Olinsky, Ivan, Serviceman's Wife, The, 47

Opacity, 20

Optical mixing, 93; illus. of, 93

Optional colors, 48

Oranges, 29–32; mixing, 64–65

Overpainting, 92–93, 96, 129; colors for, 140; illus. of, 93

Oxhair brushes, 112

Paint texture, 117-120

Painting: clouds, 150; faces, 153; figures, 153; gray weather, 152; greenery, 148; skies, 150; sunny days, 152; sunrises, 152–153; sunsets, 152–153; trees, 148; water, 151

Painting knife, 45, 113–116; colors for, 140–144

Painting medium, 45, 108-109

Painting surfaces, 116–117; colors mixed on, 89–97, 97–100

Palette: cleanliness of, 85–88; size of, 85; type of, 85. *See also* Colors.

Palette knife, 53, 84, 113–116; colors mixed with, illus. of, 88

Peale, Raphaelle, Melons and Morning Glories, 59

Pellew, John C., 136, 149

Permanence of tube color, 17, 20

Permanent blue, 29

Perspective color, 147–148

Phthalocyanine blue, 28

Phthalocyanine green, 36

Pinks, mixing, 64–65

Pisarro, Camille, 129

Pointillism, 121–124; illus. of, 125

Polka Dot Dress, The (Luks), 122

Ponte Santa Trinità (Hassam), 43

Porter, Fairfield, Forsythia and Pear in Bloom, 99

Portrait of Paul P. Juley (Dickinson), 107

Portraits, colors for, 137–140

Prendergast, Maurice, Summer, New England, 130

Primaries, 16

Prussian blue, 28

Quiet Valley, The (Wiggins), 22

Quinacridone crimson, 31–32

Quinacridone red, 32

Quinacridone violet, 43

Ranger, Henry Ward, *Bradbury's Mill Pond*, No. 2, 23; *Entrance to the Harbor*, 83 *Rapids, The* (Schofield), 34 Raw sienna, 33

Raw sienna, 33 Raw umber, 37

Recording color, 49-56; illus. of, 52

Red-browns, 37–40

Redfield, Edward Willis, *Brook at Carversville*, The, 135

Reds, 29–32

Reid, Charles, 153

Rembrandt van Rijn, 120, 147

Robinson, Theodore, La Vachere, 86

Rough paint texture, 117-120

Roughly mixed colors, illus. of, 88

Rubens, Peter Paul, 120 Russian Tea (Wiles), 51

Ryder, Albert Pinkham, Moonlight, 82

Ryder, Chauncey Foster, Smugglers' Notch, Stowe, Vermont, 98

Ryder's House (Hopper), 31

Sable brushes, 112

Sara in a Green Bonnet (Cassat), 18

Sargent, John Singer, Betty Wertheimer, 106; Elizabeth Winthrop Chapman, 66

Scene in Central Park (Kroll), 63

Schofield, Walter Elmer, Rapids, The, 34

Scraping, 129 Scratching, 129

Scumbling, 92, 97; illus. of, 93, 128

Seascape, colors for, 133-137

Secondaries, 16

Self-Portrait in Gray Shirt (Dickinson), 127

Serviceman's Wife, The (Olinsky), 47

Shades, 17

Shinnecock Hills (Chase), 38

Shirlaw, Walter, Water Lilies, 71

Shoreline colors, 151–152

Sierra Nevada in California, The (Bierstadt), 54

Simplified palettes, 132-133

Skies, painting, 150

Smooth paint texture, 117–120

Smugglers' Notch, Stowe, Vermont (Ryder), 98

South Ledges, Appledore, The (Hassam), 26

Soyer, Ralph, Two Girls, 123

Spanish Dancer Wearing a Lace Mantilla (Cas-

satt), 19 Spinet, The (Dewing), 95

Spring, colors of, 148-149

Still life, painting, 97

Stroke-against-stroke, 121–124; illus. of, 124

Strontium yellow, 33

"Student colors," 21

"Student grade" colors, 21

Stuempfig, Walter, Falls of the Schuylkill, The,

Summer, colors of, 148–149

Summer, New England (Prendergast), 130

Sun and Storm (Dougherty), 118

Sundown (Inness), 110

Sunny days, painting, 152

Sunrises, painting, 152–153

Sunsets, 152–153

Surfaces for painting, 116–117

Tarbell, Edmund, Margery and Little Edmund,

Taubes, Frederic, 76–77

Terre verte. See Green earth

Tertiaries, 16

Testing color behavior, 44-48

Texture of paint, 117–120

Thalo. See Phthalocyanine entries.

Thayer, Abbott Handerson, Cornish Headlands, 35; Girl Arranging Her Hair, 126

Thick paint texture, 117-120

Thin paint texture, 117–120

Thioindigo violet, 37

Tinting power, 20

Tints, 17

Titanium white, 41

Tohickon (Garber), 143

Toned ground, 92–97

Transparency, 20

Trees, painting, 148

Tryon, Dwight William, Midsummer Moonrise, 78

Tube colors, behavior of, 16, 20; grades, 21

Turner, J. M. W., 147

Turpentine, 53-60

Twachtman, John Henry, End of Winter, 111; Fishing Boats at Gloucester, 75

Two Girls (Soyer), 123

Ultramarine blue, 25

Ultramarine blue deep, 25

Underpainting, 92-93, 96, 129; colors for,

140; illus. of, 93, 125–128

Underpainting white, 41

Upland Pasture (Weir), 115

Valparaiso Harbor (Whistler), 74 Value, 13–14 Van Gogh, Vincent, 117 Varnishes, 108–109 Velasquez, Diego Rodriquez de Silva y, 120, 132–133, 137 Venetian red, 40 Violets, 36–37; mixing, 68–69 Viridian, 36

Warm colors, 14, 16, 104
Water Lilies (Shirlaw), 71
Water, painting, 151
Waugh, Frederick Judd, Southwesterly Gale, St.
Ives, 119
Weather, painting gray, 152

Weir, Julian Alden, *Upland Pasture*, 115
Wet-into-wet, 89–92, 96, 121; illus. of, 89, 125
Whistler, James Abbott McNeill, *Valparaiso Harbor*, 74
Wiggins, Guy, *Quiet Valley, The*, 22
Wiles, Irving Ramsey, *Her Leisure House*, 50; *John Gellatly*, 139; *Russian Tea*, 51
Winter color, 149–150
Wiping, 129
Wyant, Alexander Helwig, *Housatonic Valley*, 55

Yellow ochre deep, 33 Yellow ochre light, 32 Yellows, 32, 33–36; mixing, 61–64

Zinc white, 41

		,	
			,